A FINE
SIGHT *to* SEE

A FINE SIGHT to SEE

Leading Because You Were Made for It

SOPHIE HUDSON

BETHANYHOUSE

a division of Baker Publishing Group

Minneapolis, Minnesota

Published by Bethany House Publishers
Minneapolis, Minnesota
BethanyHouse.com

Bethany House Publishers is a division of
Baker Publishing Group, Grand Rapids, Michigan

Printed in the United States of America

Library of Congress Cataloging-in-Publication Data
Names: Hudson, Sophie, author.
Title: A fine sight to see : leading because you were made for it / Sophie Hudson.
Description: Minneapolis, Minnesota : Bethany House Publishers, a division of
 Baker Publishing Group, [2024] | Includes bibliographical references.
Identifiers: LCCN 2023059687 | ISBN 9780764243349 (paperback) | ISBN
 9780764243936 (casebound) | ISBN 9781493448036 (ebook)
Subjects: LCSH: Christian leadership. | Christian women.
Classification: LCC BV652.1 .H83 2024 | DDC 253—dc23/eng/20240220
LC record available at https://lccn.loc.gov/2023059687

Cover design by Micah Kandros Design

The author is represented by Alive Literary Agency, www.aliveliterary.com.

Baker Publishing Group publications use paper produced from sustainable forestry practices and postconsumer waste whenever possible.

24 25 26 27 28 29 30 7 6 5 4 3 2 1

To Shawn Brower, David Conrad, Nicole Conrad,
Heather Mays, Liz Shults, and Bryan White

You are fearless leaders, faithful friends,
and some of the finest *see*ers I know.

Keep seeing. Keep leading. Keep going.

I love y'all.

CONTENTS

BECAUSE I HOPE SOME CONTEXT IS HELPFUL

EVERY BOOK HAS AN ORIGIN STORY, so I'm delighted to share that with this particular book, it all began on Southwest flight 1958 from Birmingham to Houston. I mean, it stands to reason, right? There was a pack of knock-off Chex Mix, upwards of two ounces of Diet Coke, and a 737 that, if I had to guess, was only a precious few years younger than I am. Clearly it was a scene perfectly set for some high-end literary magic.

I boarded my flight with my Bible in hand, mainly because I couldn't stop thinking about a passage from Exodus that I briefly wrote about in my book *Stand All the Way Up*, and I wanted to take a closer look at the life of Moses. In *SATWU* (so catchy!) I specifically referenced a part of Exodus 17 where Moses, Joshua, Aaron, and Hur led the Israelites in a battle against the Amalekites. I wrote five hundred or so words about it, and since then I've lost count of how many times I've returned to that passage. It has comforted me, challenged me,

humbled me, and more than anything, it has helped me understand what loving leadership looks like.

So, with only the empty seats beside me for company, I dove into the book of Exodus in its entirety. I didn't know what I was looking for. I didn't know if I would find anything. I just knew, in the strangest way, that I needed to do some deeper digging there.

Also, this is a good time for me to mention that if you are ever on a Southwest flight and want to increase your odds of having a whole row to yourself, I've discovered a pretty good strategy.

1. Take your Bible on the flight.
2. Open your Bible to the book of Exodus.
3. Pull out a pen.

I don't want to overstate it, but if you could bottle those three things, you could sell them at airport kiosks as Seatmate Repellent. Nobody's interested in the possibility of Exodus-adjacent small talk.

My absent seatmates had no idea what they were missing, though, because by the end of chapter 1, I was sitting up a little straighter. Midway through chapter 2, I was underlining and circling words like I was in the middle of an SAT prep course. And by the end of chapter 3, I was practically talking to myself: *Oh, there is something to see here all right, and I think I'm going to write about it.*

I was an English teacher for an obnoxious number of years, and one thing I always stressed to my students is that when you're reading something and certain words or phrases repeatedly pop up, *pay attention*. The repetition is almost always intentional and meaningful. I mean, maybe not so much when I use the word *y'all*, because I use the word *y'all* infinity times a day, but that's because I grew up in Mississippi and live in

Alabama, so you couldn't blow the word *y'all* out of my DNA with a stick of dynamite.

BUT OTHERWISE.

In the case of the book of Exodus, there was one word that jumped out at me over and over again: *see*. It's a common word—innocent enough, at least initially—but around the twentieth time it showed up in the first few chapters of Exodus, I was officially dialed in. And to my surprise, by the time I reached the end of my airplane reading and touched down in the Bayou City, the tally on some form of the word *see* or *looked* or *sight* was over sixty. I spent the rest of my weekend feeling blown away by the new-to-me discovery. Right there on flight 1958, the language of *seeing* was teaching me a new way of looking at something I'd been thinking about for years: leadership.

Suddenly—to me, at least—the book of Exodus was offering a whole new perspective.

The language was there all along, of course. I just didn't see it.

●　●　●　●　●

Over the course of the last five or six years, I don't think there's any topic that I've thought about more than leadership.

Well, let me qualify that. I've also thought an awful lot about cheese. But that's just because I love it and am always on the lookout for new and exciting cheeses. In terms of *substantive* topics, however, leadership has been my number one. Hands down. Not even a contest. You lose, cheese.

I've been a real nerd about it, honestly. I'm fascinated by how people in general—women in particular—use their voices and effect change in their everyday lives.

A year or so ago I spoke about leadership to a group of women at a church here in Birmingham, and afterward, I was

stunned by their reactions. "It's funny," one woman remarked, "because I am in charge of an office full of people at work, but I don't think of myself as a leader at all." A former student sent me a text after that same talk, and she echoed what other women had said, in so many words, throughout our morning together: "So often as women we think of ourselves as *serving* other people, but we don't identify as *leading* other people."

Of course we *know* that women lead. We see evidence of that every single day. But in our American churches—I'm thinking mainly of evangelical ones, but it applies in others, too—I'm not sure we always do a great job of *encouraging* women to use their voices to lead, to speak up and out about what matters to them. We remind women that God made them to serve, to nurture, to help, and to submit. (Do I have thoughts about our collective emphasis on that last one? I do.) We remind women to be modest and winsome. (For the record, I also have thoughts about this.)

Are those things inherently bad? Probably not. But it's interesting to me that in many churches, the discussion of leadership as it pertains to women falls by the wayside. Without a doubt there are women in every church who lead in all sorts of contexts, but we don't necessarily use the language of leadership to describe the ways they're using their God-given gifts.

And if I can be candid: it's kind of weird. Also, annoying.

Women lead inside the church. Women lead outside the church.

So we should be talking about how to lead well. Right?

● ● ● ● ●

Most of my books have been relatively cooperative on the getting-started front, but this one has been stubborn. Fussy, even. It's a rough estimate, but I feel like I've tried to write the first chapter about eighteen times. As a result I've been frus-

trated, and my writing struggles have even infiltrated my dreams. Granted, I understand that one of the most dreaded sentences in a conversation is some variation of *I want to tell you about my dreams*, but I need to ask you to bear with me on this one. Because there's been a bit of a pattern.

One common thread in my book-related dreams is that they have taken place in a room where I might be doing some teaching: an auditorium, a classroom, a sanctuary, you get the idea. Since I was a classroom teacher for many years and still do a good bit of speaking in churches and at retreats, I'm comfortable talking in front of groups of people; in fact, I really enjoy it. You might even say that I feel called to it.

But in my dreams—and there have probably been three or four of them since I decided to write this book—I stand in front of a group of people, and I can't make them hear me. Sometimes I can't make my voice project no matter how hard I try. Sometimes the audience makes so much noise that I can't talk over them. Sometimes people just walk away (to be clear, the people who leave are almost always pastors, so we'll have to break that down when we all meet for our group counseling session tomorrow afternoon). In one dream I ran to a nearby phone so I could call someone and let them know that the microphone in the auditorium wasn't working, but when I tried to explain the problem, I couldn't get my words out.

Every single time: *I cannot be heard, I cannot be heard, I cannot be heard.*

I know I have a voice. I just can't seem to make it work.

By the way, it's totally fair if you're reading this and thinking, *Um, I'm reading your book right now, and guess what? I CAN HEAR YOU.*

You make a valid point.

But the dreams have reminded me that I'm very much unlearning some things I internalized when I was working in vocational ministry, and I think it's important to loop you in on

that because it's deeply connected to the fact that sometimes women of faith (including me) have trouble believing that our voices are welcome. Or maybe we think we're disqualified before we even start to speak up.

So when I've tried to start this book—or even when I've spoken about this topic in churches—I've heard echoes of voices that have crept into my personal faith spaces over the years: *Women are helpers. It's a man's job to lead. Women don't have the authority that men do. But don't worry, ladies—we need you, too!*

Even when those kinds of remarks have been well-intentioned, they've stung. And in the most unexpected way, my weird book dreams have reminded me that I'm still working through some of that stuff.

Maybe you are, too. And here's what I know: within the body of Christ, we're going to land all over the place in terms of women's roles in the world and in the church. We can do our very best to be faithful to Scripture and still see things differently. Even when people subscribe to some of the ideas that have caused internal struggle for me—which is *totally fine*, by the way, because there is space for lots of viewpoints within this discussion—none of that changes the fact that women are children of God who have influence over other people. That feels like the biggest *duh* statement in the world to a certain extent, because OF COURSE, right? Maybe you're teaching teenagers or mentoring a college student. Maybe you're on the preaching team at your church. Maybe you're managing an accounting firm. Maybe you're in the thick of life with little kids. Maybe you're supervising a department at a hospital. Maybe you're considering a new and better strategy to channel your entrepreneurial spirit. Maybe you're creating, or casting vision, or trying to figure out the very best way to love a friend who is hurting.

You're leading.

And what I believe about the vast majority of believers—
regardless of how our theology informs our perspective on
women's roles—is that *we want to honor Jesus with however
he has entrusted us to use our voices, gifts, and influence for
his glory.*

Obviously, the specific ways that we lead may look different
depending on our backgrounds, our personal convictions, or
our denominations. So please know this: this is not a book
where I'm going to try to persuade you to make a jump to my
personal theology. I'm not here to win a debate, to split hairs
over Scripture, or to change your mind. There are a thousand
places where we could get bogged down in disagreement, and I
am interested in none of them. Managing my own walk with the
Lord is a full-time job, so I'm going to trust that your personal
perspective is rooted and grounded in love, and I'm going to
trust the work and conviction of the Holy Spirit in you.

I say that sincerely. My guess is that both of us hold Scripture
in high regard, but maybe one of us leans conservative and the
other leans progressive. Maybe one of us embraces complemen-
tarianism and the other lands fully in egalitarianism. Maybe
one of us holds to reformed theology and the other prefers a
lively dose of mysticism.

Maybe one of us believes that a cold-shoulder top is a fashion
staple that will never die, and the other knows that, for better
or worse, that trend is dead as a doornail.

I trust the work of the Spirit in you, my friend.

We're going to be just fine.

● ● ● ● ●

You might like to know that, in this book, we're going to
talk a great deal about the word *see*. We're going to do so much
*see*ing. We're also going to spend a whole lot of time in Exodus
(don't worry—we're only going as far as Mount Sinai, so we're

not going to get into any of the laws or tabernacle measurements, just in case you were wondering or panicking). We're going to hang out a little in Deuteronomy, too. I believe with everything in me that our time in these books will encourage and empower us to use our voices with humility and confidence. I believe we'll be better for it.

And if you're wondering why we're going to spend so much time in books of the Bible dominated by men as we discuss women's leadership—well, that's an excellent question. I have several answers that I'll lay out in a numbered fashion because I like to think of a list as a good and faithful friend:

1. Second Timothy 3:16–17 says, "All scripture is inspired by God and is useful for teaching, for reproof, for correction, and for training in righteousness, so that everyone who belongs to God may be proficient, equipped for every good work." So, you know, *that*.
2. We're meant to learn from everyone in Scripture, because, as Scot McKnight has written, "as we listen to God speak to us in our world through God's ancient Word, we *discern—through God's Spirit and in the context of our community of faith or the Great Tradition—a pattern of how to live in our world*."[1] We need the whole Bible, and we need everyone in it. We've never thought that the lessons from, say, Jonah's story are gender-specific. Moses' story isn't either.
3. We have the benefit of a lot of information about Moses, Pharaoh, and the Israelites. Makes sense that we would want to learn from them.

Also, while I don't have any intention of getting into the weeds with issues that people like to debate regarding women's roles in the world and in the church (there are people who have done this so much better than I ever could, and you can find a

list of some of the resources that have been instructive for me on pages 229–230), it may be helpful for you to know that I'm writing this book with three core beliefs firmly rooted in my heart and my mind. We see these truths repeatedly in Scripture, and since they're deeply important to our conversation, they'll inform the tone of our discussion in the pages to come.

1. **The Lord is kind.**
2. **The Lord esteems women.**
3. **The Lord loves his children with an everlasting love.**

So regardless of where we stand on 412,000 things that could potentially divide us, I am delighted that there's one area where we can be collectively challenged and unified: *using our voices to love and to lead.*

I can assure you that there is plenty of room for you at this particular table.

You, your voice, and your gifts matter so much.

And while this may be my nineteenth time to start this book, you know what they say: *nineteenth time's the charm.*

(They don't really say that.)

(We can pretend.)

A CLEAR LINE OF SIGHT

I'VE BEEN WEARING CONTACT LENSES since I was fourteen years old. I will never forget walking outside during my ninth grade PE class—an environment where I had previously needed to remove my eyeglasses lest they be damaged by a flying wiffle ball or whatnot—and marveling that I could see the leaves surrounding our school's PE field with such clarity. Now of course I wear multifocal lenses because 1) I am very elderly and 2) when I wear contacts that only help me see far away, I can no longer see up close. Considering that I think it's a great idea to be able to see my speedometer as well as the road in front of me, I went to my eye doctor five or six years ago and said, essentially, *HELP ME.*

Multifocal contacts were her solution, and I love them with all my heart. I used to spend my days clinging to my reading glasses with the fervor of a toddler who has identified one particular Cheerio as the item that must stay with her throughout the course of her morning, but now I only need my readers

when my eyes are tired. Granted, I am fifty-four years old, so my eyes are basically tired every day by lunch, but still. Multifocal contacts have been a joy and a wonder in my life.

I am suddenly very aware that I sound a little bit like a commercial during the afternoon news. Please forgive me.

I wear disposable lenses, which means that every night, after I wash my face and apply my beloved Sunday Riley C.E.O. moisturizer with a level of care and attention typically reserved for handling brittle historical documents, I remove my contacts and throw them away. Since my reading vision is still fine (this is one of the few perks of being profoundly nearsighted my whole life), I can do all my pre-bedtime reading without glasses. This feels like a little bit of a flex when you're in your fifties, and if you're thinking, *Gosh, if that's a flex, then your life must be sort of sad*, I'll just humbly ask that you let me seize whatever meaningless victories I can. They're hard to come by. Thank you for understanding.

Anyway, when I wake up in the mornings, with nothing in my eyes to help me see, the first thing I do is look out at the very blurry vista of our bedroom. It's like looking through an out-of-focus camera lens, and while I know that there's a chair over there and a tv over there and a sofa at the foot of the bed, I can't see any of those things clearly. Sure, I could put on my glasses, but I don't want to. As strange as it sounds, I like to ease into my daily seeing.

So, with my vision fully compromised, I make my way to the kitchen, fix my coffee, and take Hazel outside (Hazel is our dog, lest you think that we have a random boarder named Hazel whom I usher into the great outdoors every morning). If I have an early morning Pilates class, I'll get dressed right away and "put my eyes in," so to speak, but if I don't have anywhere to be, I typically wander through my morning routine lens-less. I'll walk back and forth to the kitchen multiple times and not care one iota that everything around me

looks like a modernist watercolor painting—colorful, with smudgy edges.

Without fail, though, I get about two hours into my day when a singular thought starts to overtake my mind:

I'm tired of not seeing.

So I put in my contact lenses. And I can see.

Would you look at that?

And while it might feel like a sharp turn to segue into talking about leadership right now, that's exactly what we're going to do. Because what I know about leadership is that if we're going to lead compassionately, effectively, and with as much integrity as possible, we must see things as they really are. We can't be blinded by whatever might interfere with our vision. Our clarity.

We need a clear line of sight. Up close, far away, all around.

It seems like a pretty obvious concept. But it's not always as easy as we think.

● ● ● ● ●

So here comes a sentence I never imagined I would write: *are you ready to jump into the book of Exodus, everyone?*

I know. It seems like it might be a grueling journey. I daresay, however, that we're going to have ourselves some fun. And please know that this is not going to be an exhaustive look at the Israelites' journey in the book of Exodus. That would require a multivolume series.

What we are going to do, however, is extract some of the lessons that Exodus teaches about seeing. About loving. About leading. I don't want to oversell it, but what we find there is a little bit of a master class.

In Genesis you can get the full background on how the Israelites wound up in Egypt, but if you'd prefer an easy, one-word summary, here you go: *famine*. All things considered, they

navigated the famine pretty well, mostly thanks to Joseph and his management of grain (Genesis 47:13–26). The Egyptians were indebted to Joseph for his good work in their country, and even after the deaths of Joseph and the rest of his generation at the beginning of Exodus, "the Israelites were fruitful and prolific; they multiplied and grew exceedingly strong, so that the land was filled with them" (Exodus 1:7).

However.

A new king—someone who hadn't known Joseph—came to power. And when the new king looked at the remaining Israelites who populated his country, he saw one thing.

A great big threat.

Pharaoh decided he would try to control the Israelites by oppressing them, but that plan was a no-go. Scripture tells us in Exodus 1:12 that "the more [the Israelites] were oppressed, the more they multiplied and spread."

The resiliency of the Israelites made the Egyptians "ruthless"[1] in trying to deal with them, and Pharaoh came up with a new idea: asking Hebrew midwives to kill male Israelites at birth. Interestingly, the two named midwives, Shiphrah and Puah, "are the first of a series of twelve women who appear in the opening chapters of Exodus . . . rhetorical counterparts to the twelve tribes whose freedom depends on the women's deeds as well as on the leadership of Moses."[2] The midwives wanted nothing to do with Pharaoh's command, however; in addition to the fact that they didn't seem to mind a little "civil disobedience,"[3] they feared God, and once again "the [Israelites] multiplied and became very strong" (Exodus 1:20).

That's two strikes, king.

Pharaoh, no doubt rife with desperation, upped the ante with a declaration to all Egyptians: "Every boy that is born to the Hebrews you shall throw into the Nile, but you shall let every girl live" (1:22).

Well. This feels extreme.

What Pharaoh didn't realize, though, was that he and his fear were about to encounter three women with some rock-solid vision who would change the course of history.

So, if you're not too busy, I'd love for you to join me for what will be a very informal recap of the events in Exodus 2:1–10. Perhaps we can have some refreshments afterward.

Here we go.

A Hebrew woman named Jochebed (Numbers 26:59) gave birth, and when she "saw that [her son] was a fine baby" (Exodus 2:2), she apparently couldn't bear to throw him in the Nile. So Jochebed did what most of us would want to do in a similar situation, and she hid her little boy. It's difficult to imagine what must have been going through the minds of the child's parents after he was born—much less how they managed the logistics of, you know, *hiding an infant*—but they were no doubt terrified, considering Pharaoh's decree. We also don't know exactly why they so boldly violated Pharaoh's strict order, but one commentator speculates that they hid him "by faith," which "must mean that they received some revelation that he was a child of destiny."[4]

Maybe, to a certain extent, they had a glimpse of what was down the road.

When Jochebed realized she could no longer keep her baby hidden, she put him in a basket lined with tar and "placed it among the reeds on the bank of the river" (2:3). The baby's sister, Miriam, was nearby, standing "at a distance, to see what would happen to him" (2:4). In this case the Hebrew word for *see* is *yāda*, which indicates a depth of understanding that goes beyond physical sight.[5] Miriam's watchful eye over her baby brother turned out to be heroic.

Because it was just about this time that a third seer—a third *leader*, I would add—entered the chat.

Pharaoh's daughter had come to the Nile to bathe, and when she spotted the papyrus basket with an infant inside,

she sent one of her attendants to bring it back to her. The baby was crying—on-brand for a three-month-old in a basket on a river—and when Pharaoh's daughter saw him, she felt compassion. She also recognized that he was a Hebrew child, but at that moment, her father's mandate didn't matter. There was a distressed baby in that basket, after all. A helpless human being.

Miriam, from a distance, saw every bit of what was happening and quickly approached Pharaoh's daughter to see if she could help by finding a Hebrew nurse for the child. According to one source, "if [Miriam's] words were not according to the careful plan and instruction of her mother, then her inward prompting must have come from God—not a moment too soon or too late, with not a word too many or too few!"[6] When Pharaoh's daughter agreed, Miriam quickly retrieved her very own mother—who was then paid to take care of her very own son. Later, when the boy was grown, his mother took him to Pharaoh's daughter, who adopted him.

She named him Moses.

You've probably heard of him.

The days between placing their child in a basket to sending him to live in the palace with Pharaoh's daughter must have exceeded every dire expectation that Moses' parents had considered when he was three months old and his mother took him to the river. After all, he was able to grow up at home and at his "mother's knee . . . [so] his early impressions of the God of his fathers [and mothers] would be of a real, true, living God, who spoke, and acted, loved and cared for His people."[7]

Jochebed, Miriam, and Pharaoh's daughter remind us how *seeing* can usher in unexpected grace at a critical time. As Matthew Henry writes, "God often raises up friends for his people even among their enemies. Pharaoh cruelly [sought] Israel's destruction, but his own daughter charitably [took pity on]

a Hebrew child, and not only so, but, beyond her intention, [preserved] Israel's deliverer."[8]

Pharaoh may have been blinded by fear. By hatred.

But Pharaoh's daughter took time to see. Just like Jochebed saw her baby boy. Just like Miriam saw her baby brother.

The compassionate care of *seeing* delivered Moses—who would one day lead the Israelites in the direction of their own deliverance—from the waters of the Nile.

Not a blind eye in sight.

● ● ● ● ●

So. Speaking of blind spots.

(I understand that we weren't *really* talking about blind spots, but this is something I feel like we need to talk about, so thank you for your patience with the non sequitur.)

As women, as believers, and as leaders, it's important for us to consider if there are parts of our lives where we may not be seeing things clearly. Where we might be a little shortsighted about our need for deliverance. Or maybe it's not even that spiritually serious. Maybe it's just that we can't see where and how we might need to change.

Back in 2016 I began to realize that I wasn't seeing things clearly in several areas of my life, and all the contact lenses in the world couldn't fix it. There was no one definitive moment—at least not that I can remember—but in some of the places where I was actively leading other people, I was increasingly convinced that I hadn't been seeing things for what they really were. It was almost as if I had preferred a version that I'd modified, edited, and tweaked in my head because it was a much more palatable way of looking at my circumstances. Of tolerating them. Of justifying them, even.

It was a coping mechanism that worked for a long time until I realized that I was exhausted by every bit of it. I also realized

that I was living with anxiety that was dialed up to a level best described as *stun*.

I wrote about this period of my life in *Stand All the Way Up*, but if you'd like a CliffsNotes version of my Personal List of Challenges that prevented me from seeing clearly, here's a quick overview: habits, complacency, denial, and—more than anything else—fear. Fear of change, fear of loss, fear of man, fear of being misunderstood.

I think lots of folks who have immersed themselves in church life and church culture experience something similar. It's not formulaic—of course not—but there are likely some common denominators.

Here's what happened with me: gradually I started to realize that my life of faith, at least as I had known it up until that point, was due for a pruning. In addition to the fact that I felt like I couldn't see things clearly, I had come to realize that some leadership structures that had been a huge part of my faith and my work were creating internal conflict I couldn't ignore. What had once seemed woven together—pleasantly overlapping—had become tangled. Knotted. Suffocating, even. I realize this might sound a little vague, and that's on purpose. I would never want to be hurtful or discouraging to people and places I still value so much. The point is that the process of sincerely addressing my blind spots, the ongoing challenges, and the ways I was motivated by fear—both in my faith and in my work—was heartbreaking. It was jarring.

But here's what I know now: if we're going to lead with love, my friends, we have to see situations clearly. We have to make sure we're not blinded by fear, pride, self-righteousness, or anything else that interferes in our relationship with the Lord and our ability to care for other people well. Because if we participate in perpetuating what's comfortable over what's right, we compromise our ability to really and truly lead.

Digging through all of that is some humbling, refining work.
But do you know what I believe with my whole heart?
It's *necessary* work.
It's *clarifying* work.
And, no doubt, it improves our vision.

WE'VE ALL BEEN TO MIDIAN

I HATE TO BE A DOWNER, but I think we need to talk about shame and regret for a minute.

Just as you were hoping, right?

But here's the reality: shame and regret tend to boss us around and hold us back from stepping up as leaders in our spheres of influence. So if you'll permit me to make a very impromptu metaphor: *I find that it's helpful to deal with our baggage before we start traveling with it.*

It's also good to deal with our baggage so we're not tempted to hide inside it.

(I'm not saying that the metaphor would necessarily hold up in a court of law, but you get the idea.)

I've written about this before in my book *Home Is Where My People Are,* but in case you haven't read it and would prefer an abbreviated version of the idea at hand: I was a mess in my early twenties. All my teenage years of good girl-ing were mostly a lot of behavior modification, and my early twenties

brought the freedom to let down my good girl guard and make some questionable decisions in a variety of settings. Certainly I knew right from wrong—even if I sometimes didn't act like it—but I was shakier in the areas of pride and consequences. I wanted to live however I dang well pleased, and I wanted to be free from accountability.

So, if I could write a letter to my younger self, I would say this:

Dear Soph,
 That is not how life works. Thank you for your time.

 Best,
 Your Future

Much like many muleheaded youngsters, I felt like I excelled at my chosen way of living. I dodged, I weaved, and I told people what I thought they wanted to hear. I had no intention of changing my ways because, hello, I was KILLING THE GAME.

But eventually, about the time I was twenty-five or twenty-six, I started to feel a little something called remorse—lo, maybe even conviction—and gradually I tried to dial down the selfishness, not to mention recklessness. I also realized that I needed to grow up and become A (Mostly) Responsible Human Being. Of course I continued to make mistakes and wrestle with my pride (Lord, have mercy—I still do). But the difference was that some genuine humility started to seep its way into my character, and that changed how I responded when I messed up. I was quicker to admit when I was wrong. Less prone to manipulate. More likely to listen.

What I didn't anticipate, though, was how my transition into working in ministry spaces (I got a job working in a Christian school in Baton Rouge after David and I married—this story is

also in *HIWMPA*, which I'm pretty sure should be pronounced hi-WUM-pa) would make me feel like I had to hide the rebellious parts of my life instead of sharing those stories with people who might need to hear them. I was increasingly confident that I wanted to serve the Lord however I could—*except with that stuff*. After all, I was a Kind, Newlywed Teacher. Doing my best to love my students. Trying so hard to figure out what it meant to reacquaint myself with functional, everyday faith. Feeling conflicted about why certain struggles seemed to constantly ebb and flow. Wondering most days how I, of all people, had managed to get a job in a Christian school. Leading high school students with as much enthusiasm as I could muster.

Functionally, I guess, I was as visible as I could be.

But internally, I was doing some world-class hiding.

I would love to tell you that there was a quick fix, but it took some years for me to figure it out. None of that, however, changes the fact that Baton Rouge turned out to be a spiritually significant part of my life. Of course our time there held its share of struggles and heartbreak, but mostly it was a place that brought us all manner of joy. Some of that was because of my three-year stint at the Christian school where I never expected to be; the relationships there marked me forever. Some of it was our next-door neighbors, the Boudreauxs, who were also newlyweds and always up for a very fancy dinner at Jason's Deli on Corporate Highway. Some of it was being introduced to the wonders of boudin and rice dressing and Lebanese food. For us as newlyweds, Baton Rouge gave us our first house, our first dog, and our first church home.

But in retrospect, I think the most significant part of Baton Rouge—personally, at least—was something that never occurred to me until just a few days ago.

It was, in many ways, my personal Midian.

And I'm guessing that, in one way or another, you may have spent some time in Midian, too.

• • • • •

In Exodus 2, Moses made a pretty significant mistake.

To be clear, maybe *mistake* isn't a strong enough word. Moses killed someone. And murder isn't exactly an uh-oh situation.

But when Moses saw a fellow Hebrew being beaten by an Egyptian, he was overcome by anger. He "looked this way and that, and seeing no one he killed the Egyptian and hid him in the sand" (2:12).

Sometimes what we're looking for is permission to do the very thing we shouldn't. Sometimes we convince ourselves that as long as no one else can see us, we're totally free to do whatever we want.

Obviously, Moses knew that what he did was wrong, otherwise he would have had no need to make sure that no one was looking. He would have had no need to hide the dead body. Maybe it's overstating the obvious, but typically when we do something that's morally right, we don't worry about what will happen if someone bears witness to our virtue.

To Moses' horror, though, he realized the very next day that people had seen what he had done. He walked up on another fight, and the man in the wrong asked if Moses was going to kill him like he had killed the Egyptian. Moses was stone-cold busted, and Exodus 2:14 tells us that "Moses was afraid and thought, 'Surely the thing is known.'"

I don't know if you've ever experienced that level of guilt or panic, but I can assure you that it typically arrives with some cold sweats and what I can best describe as nausea-on-demand. Basically, there are only three possible responses, and

for different reasons, all of them are terrifying: 1) confess, 2) deny, or 3) run.

Moses chose door number three. Even if it wasn't the wisest option, it was an understandable one considering that Pharaoh had found out what Moses did and wanted to kill him as a result.

Moses opted to get the heck out of Dodge. Or Egypt, as it were.

He fled to Midian—neither Egypt nor Israel, a bit of a no man's land—and I'm gonna tell you something that's super interesting to me: the first thing Scripture tells us about Moses' time in Midian is that when he got there, he sat down by a well.

Why do I find this so fascinating?

Well, here's what strikes me about that imagery: Moses was for sure sitting in the consequences of a choice he made. He was exiled, essentially, from all that was familiar to him. However. The (metaphorical) land wasn't barren, and it wasn't dry, and it wasn't without provision. While Moses might not have believed it if anyone had told him, the Lord was going to heal him, prepare him, and equip him in the unexpected place where he found himself.

Of course his decision to murder someone was a bad one. There's no denying that. I'm not trying to put some shiny spin on the darkness of our own hearts and the gravity of our bad choices. But in his self-imposed exile in Midian, Moses no doubt gained a whole new perspective about what it felt like to be a stranger in a strange land—much like his Hebrew brothers and sisters in Egypt.

Interestingly, there's no mention of Moses *seeing* anything after he arrives in Midian—and I've wondered if that's because he literally used his sight to justify his sin, so the Lord had plans to use that time in Midian to help Moses figure out how

to use the gift of sight appropriately and redemptively. In light of, you know, *the murder.*

Regardless, one thing is for sure: the time Moses spent in Midian was not without significant purpose.

The same is true for us.

● ● ● ● ●

This may feel like a Captain Obvious statement, but I've been a woman all my life. And for the last seven years that I worked in a school setting, I worked exclusively with teenage girls. So while I would never claim to be an expert on anything—except for maybe peanut butter and also the late '80s TV show *Moonlighting*, which, while both captivating topics, really have absolutely nothing to do with Moses or seeing or leading or any of our thematic concerns in this book—I have learned a thing or eight about how lots of women navigate the various and sundry challenges of life.

Certainly we are, in general, a fantastic assortment of humans.

We are also, in general, humans who are likely to remember our mistakes and our regrets with a level of unclouded recollection that would make Nobel Prize–level anthropologists rife with envy. Many of us have no problems with exhaustively chronicling the most unsavory moments in our personal histories.

We can't be sure what the future looks like, but we can see in the rearview mirror with astounding clarity. Whether it's stuff that we know other people saw us do or stuff we prayed with our whole hearts that no one saw us do—maybe most especially our mamas—we've put every bit of it on a personal highlight reel that we might not ever stop watching. It's sort of like the latest Pixar movie that shows up at your local multiplex and never seems to leave theater #7, only there's no popcorn and

no peanut M&Ms and *oh my gosh why would anyone ever want to watch this I am so embarrassed for this person oh wait I am this person.*

In my case, Baton Rouge was where my Highlight Reel-O-Shame made its world premiere, and I found myself living in a strange in-between. On one hand I was working in ministry, figuring out what it meant to love kids and teach them and build healthy relationships in that particular context, and on the other hand I was constantly re-litigating decisions I made when I was younger, regretting how I handled situations where I should have known better or done better or at the very least admitted that I needed someone to help me. For maybe the first time in my adult life, I didn't just look at my own sin; I grieved it.

I was teaching in a Christian school by day and questioning how I ended up in ministry by night.

I did this for the better part of ten years. Seriously. A decade. So while I may have arrived in my Midian after I moved to Baton Rouge, I packed up Midian and carried it with me when David and I decided to relocate to Birmingham.

So much uncertainty. So much second-guessing. So much shame.

And, thankfully, so much I couldn't see yet.

It took some time for me to work through all of that, and here's what I know now. I thought the Lord was punishing me with alternating doses of guilt and doubt—particularly in terms of my own fitness for ministry—but what he was really doing was so much more kind than I could even begin to recognize. He was healing me. Restoring me. Teaching me that I was not the central character in the story of my life. Reminding me that I wasn't who I used to be because he is who he has always been. Continually pointing me to his grace, his mercy, his sufficiency. Shifting my vision from me and myself and my Very Stupid Decisions to him and his people and his glory.

I don't want to over-spiritualize what was actually a difficult, soul-baring process, and I'm not trying to reduce ten-plus years of pretty deep questioning and doubt to a quippy Instagram square to share with all your friends.

I just want to remind all of us that sometimes our tendency as women is to fix our eyes on our mistakes, our regrets, and our shame with laser-like precision, and doing that keeps us from moving forward in the ways the Lord has made us to see the world around us, love the people around us, and use our voices for good.

For sure there are times when we have to make right what we got wrong. For sure we want to be women who don't let our personal pride interfere with our personal accountability. For sure there are times when we have to make better choices because we've learned hard lessons and we know better now.

After all, self-awareness is a vital component of a healthy life. We can't love people well without it. I would even give a solid understanding of our own propensity for sin a 10/10 with a solid thumbs up. It's essential if we want to avoid self-righteousness. But living in a well of our own shame doesn't help anyone. It muffles our voices, limits our reach, and hinders our forward progress.

Considering all of that, remind yourself of this: Midian's a fine place to land for any (sometimes delayed) repair work that the Lord deems necessary. And what we can trust with our whole heart is that while we're there, the Lord will settle what needs to be settled. He will prepare us for what's ahead.

In Moses' case, a man named Reuel—also known as Jethro—invited him to break bread. Moses eventually married Reuel's daughter Zipporah. Moses came to understand what it was like to be "an alien residing in a foreign land" (Exodus 2:22)—a puzzle piece of empathy that was going to be much needed for reasons that Moses could never have anticipated.

For forty some-odd years, Moses tended his father-in-law's sheep. He kept the flock (Exodus 3:1). He learned to lead.

And the biggest assignment of his life was right around the proverbial corner.

You know, a corner where a bush was on fire.

• • • • •

This past spring a friend of mine was dealing with some personal stuff that was making her feel worried and overwhelmed, so I invited her over for supper. I didn't have much to offer as far as being able to solve her problems, so I offered the ministry of squash casserole, black-eyed peas, and collard greens. I realize it's not everyone's experience, but my mama taught me to never underestimate the perspective-giving power of a well-cooked vegetable. In certain circumstances, fried okra can make a way. I believe it with everything in me.

My friend and I had just finished supper when our conversation turned to a ministry project she had offhandedly mentioned a few months before. As we nursed our bowls of warm blueberry cobbler, I asked how the project was going, and after some *hmm*ing and *well*ing, my friend confessed that the project basically scared her to death.

It took a few seconds for me to decide if I should change the subject or ask a follow-up question. I opted for the follow-up.

My friend launched into what was essentially a dissertation about why she wasn't qualified to tackle the ministry project. At one point I think she said something like "Oh, you don't understand what happened back in 1998," and while I very much understood that she was Dead Dog Serious about what she was sharing with me, I couldn't help but grin as she finished prosecuting the case against herself. We may have been sitting in my kitchen in Birmingham, but my dear friend was smack-dab in the middle of a visit to Midian. I think she even found

the courtroom there, because she had absolutely put herself on the witness stand.

Her past? Crystal clear—with twenty-times magnification. Near photographic recall.

The limitless possibilities for using her voice and her story—mistakes and all—in the ways that God has gifted her? Blind as a dadgum bat.

Since I too have lived that Midian life, I hope you know that I have so much compassion and understanding for how my friend was seeing herself. And the longer we talked, the more I could see all the little and big ways she had put herself in exile, so to speak, and made Midian her home. She has absolutely continued to use her gifts, but she has put limit after limit on the *how*. Since she's found herself guilty in the court of her personal opinion, she has established all manner of parameters about doing this but not that, saying yes to one thing but not another, all because she has decided that it makes sense to punish herself for some very relatable, very common, and—sure—very dumb mistakes she made twenty-five years ago.

I don't think this is an unusual reaction to shame, especially when our mistakes have lived in the dark. When something has been largely unseen, it's easy to believe that it will be the end of us when it comes to light. And listen—there absolutely can be consequences, and I don't want to ignore how we may have hurt other people when we acted carelessly or selfishly or maybe even lawlessly.

That's why we don't need to walk through Midian alone. It took me way too long to realize it (and I was living in Birmingham when I finally realized that I would likely not make it out of Midian if I continued to travel by myself), but journeying together brings perspective, it brings wisdom, it brings clarity, and ultimately it brings healing.

That's all a very long-winded way of saying, *Do not despise your Midian, my friends.*

Also: *maybe ask some people to visit you there.* I think you'll be surprised by how much you need their company. I'm not saying that spending time there is always *enjoyable*, necessarily, but my goodness it's instructive. And regardless of what's ahead, healing is always helpful.

I would never presume to speak for Moses, of course, but I'm inclined to think that he would agree.

SOMETIMES THE BUSH WHISPERS, SOMETIMES IT BURNS

MOST OF THE TIME I write in my office at our house. The word *office* feels a little fancy, honestly, because what we're really talking about is our fourth bedroom that's connected to our primary bathroom. There's a sign on the door—handwritten by first grade Alex Hudson—that says, "BooMama, Inc.—Where Books Are Typed," so there's a real air of professionalism to the whole space. My office was likely a nursery when our house was first built, a convenient location for parents to check on a sleeping baby in the middle of the night. Considering the amount of pouting and crying I've done in that room as I've worked to make books take shape, the nursery origin story feels fitting and right.

Today, though, I'm writing at a house in Highlands, North Carolina. I'm with my friends (and fellow writers) Melanie and Erin, and since we all have manuscripts due this fall, we thought it might be fun to get away for a week and crank out

some words together. Yesterday we made great, fast progress on our trip from Birmingham to Highlands until we hit north Georgia, where the curves on the mountain roads slowed us down to a snail's pace. The last hour of the trip felt like it took just as much time as the previous three, and when we finally climbed out of Erin's car—a little dizzy and discombobulated from the twists and turns of our drive—it was a tiny bit jarring to realize that we were (finally!) right where we were supposed to be.

This almost immediately reminded me of Moses.

(Have I been immersed in the book of Exodus for a little too long? PERHAPS.)

For forty years Moses lived in a place that he never expected to be, and while his arrival in Midian was strange enough, the *staying* must have been something else. My guess is that Moses probably wouldn't have set up a merch booth with T-shirts that said "MIDIAN: 40 YEARS-O-FUN," but it would be interesting to know how he grew to feel about the place of his self-imposed exile over those four decades. Sure, it was where he was meant to be—where he needed to be, even—but was he fond of it? Did he grow to love it? Did it ever feel like home? Did he think he would stay there forever?

Moses' life in Egypt ended after he murdered an Egyptian and had to flee to Midian to save his own life. And forty years later, his life in Midian ended when he was leading his father-in-law's flock "beyond the wilderness" (that's Exodus 3:1 if you're keeping score at home) and an angel appeared to him in a burning bush.

Interestingly, from the time Moses arrived in Midian until the end of Exodus 2, the only instance of a word loosely connected to *see* is in Exodus 2:25 when "God *looked upon* the Israelites, and God *took notice* of them" (emphasis mine).

But at the beginning of Exodus 3, in verses 2 through 4, that changes:

There the angel of the LORD appeared to him in a flame of fire out of a bush; he looked, and the bush was blazing, yet it was not consumed. Then Moses said, "I must turn aside and look at this great sight, and see why the bush is not burned up." When the LORD saw that he had turned aside to see, God called to him out of the bush, "Moses, Moses!" And he said, "Here I am."

Did you catch all of that? If I could show you my Bible, you would see a series of circled words: *appeared, looked, look, sight, see, saw, see.*

Isn't it interesting that there's so much *see*ing preceding a literal call from God? Moses looks, wants to see more of the sight, and then when God sees that Moses turns to see, he calls his name.

Matthew Henry writes, "If [Moses] had carelessly neglected it as an *ignis fatuus—a deceiving meteor*, a thing not worth taking notice of, it is probable that God would have departed, and said nothing to him; but, when he turned aside, God called to him."[1]

Moses saw God's sign. And God called Moses.

For now, let's do our best to appreciate how the act of seeing bookended Moses' time in Midian. The sight of an Egyptian fighting a Hebrew led Moses to murder the Egyptian, and the realization that he had been seen killing the Egyptian made Moses flee to Midian. Forty years later, the sight of a burning bush was about to lead Moses right back to Egypt.

Sight changed Moses' life as an infant, as a forty-year-old, and then as an eighty-year-old.

If I may be so bold: I think there's something to see here.

* * * * *

One morning in 2010ish—I think in February—we had a delayed start at school because of weather. It was a classic

Birmingham ice storm day, which is to say that forecasts in-
dicated we would have an ice storm but lo, it only rained. So
school was starting late that morning, and as I was getting
ready, I was praying and asking God about the writing part
of my life. I had been blogging for about five years, and while
I thought I might want to write a book, I didn't want to step
outside whatever boundary lines the Lord established for me
(in pleasant places, no less—don't you love some Psalms-y
humor?). I didn't want to move forward with a book without
his blessing, because I still saw myself as a full-time Midianite
who would bring shame and dishonor on the kingdom of God
if I dared venture from my blogging territory.

Yes, that sounds very dramatic and over the top, but fear
had bossed me around for so long that it was difficult to hear
any other voice.

I don't even know if I expected a clear answer as I prayed
that morning. I had spent so many years waiting for God to
pull the rug out from under me—feeling like I was forever on
the verge of embarrassing him in some way—and I was still
trying to make my peace with how in the world I had man-
aged to land in a life of ministry. Plus, if I did write a book,
I wasn't sure that I had anything to say, especially since I had
spent my blogging years writing about bacon and television
and blue jeans and my hair. I loved to document the more
lighthearted parts of life, but I didn't know how that might
go over as a whole, actual book. As you might imagine, this
seemed like a hindrance to jumping into the book writing
process.

So as I put on my makeup and got myself ready for the day
ahead, I talked to the Lord as I moved around our house. I
wasn't paying attention to much of anything around me, but
when I walked past our front door—which has two sidelights—
I looked outside and saw something that stopped me in my
tracks.

Our house sits at the bottom of a steep hill and a long, equally steep driveway. That chilly morning, when I glanced through a sidelight, I saw fifteen or twenty birds at the top of the driveway, just standing there like they were waiting for me to notice. It was the most mesmerizing sight, almost like a flock of birds decided to make some home visits, and our house was next on their list.

For a minute or so it felt like the birds and I were in a staring contest, but then, almost as if one of them whispered *GO!*, they started walking down the driveway toward the house. To use a phrase from my childhood, IT WAS BIZARRO. I couldn't think of any other time in my life when I had seen birds on a stroll, but make no mistake: those birds were strolling. *Ambling*. If one of them had opened a parasol, it would not have surprised me.

And in that way that you know that you know that you know, I sensed that the birds were meaningful—that they were connected to my prayers about writing a book. This struck me as strange, but I ran with it. And since I am me, I also assumed that the birds were probably some variety that sang one time and then died or something. Or, you know, like, KILLER BIRDS.

I wasn't immediately sure what kind of birds were marching in the direction of my front door—I am not in fact an ornithologist or even a bird enthusiast—so I did my best to make mental notes about their distinct markings. Considering that the birds' pace could best be described as *unhurried*, I was able to get a good look at them. I stood stock-still for a few more moments before I remembered that modern technology would enable me to identify the birds, so I walked directly to my computer, pulled up Google, and typed slowly and deliberately into the search bar: "birds with bright orange chests."

It took upwards of one whole second to find out my bird visitors were American robins. And I'll never forget what I read next: *these birds are known for their cheerful voice.*

As I stared at my computer screen, I experienced an immediate, deep knowing, and I heard these words in my heart: "*Sometimes the world just needs a cheerful voice.*"

For over ten years Midian had been the home of my heart.

But on that bleak, gray morning when a bunch of orange-breasted birds marched down my driveway, I realized that, for whatever reason, it was finally time to move.

● ● ● ● ●

This isn't a book about calling (I don't think it is, at least; feel free to email me if you disagree), but there are a couple of things about Moses and his encounter with the burning bush (and the God of Israel) that I want to mention because I think they're super relatable and applicable to where many of us find ourselves.

Moses went to Midian because of his certainty that his sin was exposed: "Surely the thing is known" (Exodus 2:14). He also heard that Pharaoh wanted to kill him, which would definitely have been a deterrent to staying put in Egypt. What with wanting to continue to live and all.

Why Moses *stayed* in Midian for forty years isn't quite as clear. My guess is that he assumed Pharaoh's desire to kill him was still in play—that he wouldn't be safe if he went back to Egypt. Maybe he thought he had trashed his reputation back at home, and he didn't want to face that particular music. But I also wonder if there was another factor: maybe Moses got comfortable where he was.

As the kids would say, *that hits deep*.

Midian wasn't Moses' planned destination, but I imagine that over time it was, you know, *good enough*. He had a wife there. A family. A father-in-law who loved and trusted him. He had meaningful work tending sheep, and his memories of life in Egypt likely dimmed with each passing year of his self-imposed exile.

Regardless of why he stayed, a couple of things become clear in Exodus 3. First, God purposed every bit of Moses' time in Midian; in fact, *The Expositor's Bible Commentary* says that "[God] waited to see how sensitive Moses was toward the insignificant things of life before he invested him with larger tasks."[2] Second, the burning bush was a game changer, an undeniable sign that something new was afoot.

Given all of that, it's interesting to consider that the burning bush would have ultimately been irrelevant if Moses hadn't "turned aside to see" (Exodus 3:4).

I understand that maybe this is a niche interest, but I'm pretty much endlessly fascinated by how other people experience the Lord speaking to them. For some people it happens when they're praying or reading Scripture. For others it's almost always when they're outside in nature, or maybe when they spend time in worship. There's no manual for the daily rhythms of faith, of course, but I find it endlessly intriguing how God communicates so specifically, so intentionally, and also so differently with his children.

I almost always hear God so deep down in my heart that it's almost my stomach (listen, I don't know anatomy, so if that's not physically how things are laid out, just know that I did my best here). I've never tried to explain this before, but here goes: I don't hear any sort of audible voice, but it's like an unexpectedly confident *understanding* just drops into my body. An *aha* moment, only bigger. And it happens in my gut, not in my head.

A couple of my friends have mentioned that God speaks to them through repeated patterns; maybe something comes up over and over in conversations, or they realize that a certain idea keeps popping to the surface—and they know they can't run from it. My mama, Ouida, almost always experienced the conviction and clarity of the Holy Spirit during her prayer time, and I can say from experience that when the Holy Spirit made

something clear to Ouida Sims, she received that message with enthusiasm and obedience.

Just like in any relationship, communication with God gets easier to discern with time and experience. And sometimes there's a physical component that precedes the spiritual, almost like God's teeing us up to know that fresh revelation is on the way. Maybe it's a sunset that's unexpectedly stunning or the cleansing rhythm of a summer rain or the sight of a baby wobbling before she takes her first steps. So I can't help but wonder: if Moses hadn't noticed the burning bush, would God have called his name? At least one commentator thinks Moses' sight was essential to his calling: "God didn't speak to Moses until He had Moses' attention."[3]

I mean, on a much more insignificant scale, would I have had such clear assurance about writing a book if I hadn't first noticed the birds?

So here's a thought, and please, by all means, do with it what you will: so often we feel stuck—maybe in Midian, maybe not—and we long to hear from God. We wait for him to tell us what to do next.

But maybe—just maybe—we need to consider our *seeing* as well as our *hearing*.

Maybe seeing evidence of God's work in the world is connected to knowing how to participate in that work.

Moses saw the burning bush.

Then God called Moses' name—and told him to set his people free.

● ● ● ● ●

Just because God makes our next steps clear doesn't mean we'll feel like we're ready.

Just because we hear his voice doesn't mean we won't think *DEAR LORD OF MY LIFE, YOU ARE MAKING A*

COLOSSAL MISTAKE TO INCLUDE ME IN THE TASK AHEAD.

Take a look at Moses after God calls his name (twice!): "[he] hid his face, for he was afraid to look at God" (Exodus 3:6).

God's holiness and our humanity seem so very incompatible at times, don't they?

But after Moses hid his face, God shared his plan to get the Israelites out of captivity and "bring them up out of [Egypt] to a good and broad land, a land flowing with milk and honey" (3:8).

Even still, Moses second-guessed his involvement in the Israelites' deliverance: "Who am I that I should go to Pharaoh, and bring the Israelites out of Egypt?" (3:11).

God had a promise, though, to assure him: "I will be with you" (3:12).

It's not so different with us, really. Sure, you and I are probably not going to be involved in leading God's people out of captivity on the scale that Moses was, but in our own everyday efforts, we do have opportunities to point the people around us to "a good and broad land." Maybe you're an architect whose integrity and kindness reflect God's character to your clients. Maybe you're the neighbor who all the neighborhood kids love to visit because 1) you have the best snacks and 2) your house is a place where they know their whole selves are welcome. Maybe you're a softball coach with a unique ability to create a team environment where discussions about faith happen organically and often. Maybe you're a college student with a gift for connecting with teenagers and helping them see the specific ways God is working in their lives.

God doesn't need a single one of us to achieve his purposes. That was true even in the book of Exodus. God *chose* Moses to lead, but he could have delivered the Israelites on his own. Even now, though, he invites us to join him in extending love and compassion and healing and mercy to a hurting world. He

invites us to use our voices to offer leadership and hope and grace and direction. Doing that work is a gift and a privilege.

So at the end of the day, the time we spend in Midian isn't punishment. Midian is *preparation*, my friend.

Who are you? You're a uniquely gifted child of God.

And however God invites you to use those gifts, one thing is for sure: he will be with you as you figure out what that looks like.

Watch and see.

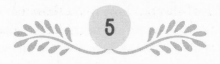

A GOOD, HARD LOOK IS HELPFUL

Big Ideas & Modern Concerns

WE'VE MADE OUR WAY through three chapters of Exodus, my friends.

This is, incidentally, more than I ever dreamed I would write about this book of the Bible, but here we are. And if you'll indulge me, we're going to take a brief break from Exodus to break down some Big Ideas & Modern Concerns (we'll do this in a few future chapters, too). That means it's time for me to grab my pom-poms and do a little cheerleading in relation to the awesomeness of the gifts God has given you.

No need for alarm or for contacting a chiropractor. There won't be any herkies or toe-touches, but I may close this thing out with a brief dance routine if it's all the same to you.

I'm also aware that for some of you, cheerleading might not be necessary. You're living and loving from such a deep place of security and confidence that you could look all of us straight in the eyes and say, in so many words, *Here's what I'm bringing*

to the table—and I require neither your acknowledgment nor your affirmation.

If that's the case, WELL DONE, you. Also, I would like some of that injected in my veins.

I mentioned earlier that I worked with teenage girls for a long time, and while I believe with my whole heart that women have all sorts of strengths, seeing and acknowledging how God has gifted us is not always one of them. I would often try to name the gifts I could see in my girls at school, and while they were mostly delighted to be affirmed, they would sometimes look at me like *I cannot believe you even noticed that; I don't think it's anything special.* It's not just teenagers, either—because I have found the same to be true in many of my conversations with adult women. We have a sense that we're naturally inclined in certain God-given ways, but we assume that everybody else is walking around with a similar set of skills. Nothing to see here, thanks.

I have a few theories about why this happens more often than it should.

First theory.

As women we carry a lot of people's emotional and phys-ical needs. That might be in the context of family or work or church or wherever. We could talk all day about why it might not be healthy for us to take on all of that, but the fact of the matter is that it falls under our purview more often than not. And in the middle of looking out for everybody else, we don't have a whole lot of margin or even energy to sit around and consider what gifts the Lord has given us and how we might cooperate with him to use those gifts to love and lead in a hurting world.

Second theory.

For years our church cultures have stressed that women are the caregivers, the nurturers, and the hospitality providers. For some of us, this may very well be true. But it's not true for all

of us (don't mind me over here RAISING MY HAND). I spent years trying to figure out how to dodge duty in the church nursery—and feeling sort of weird for only having one child on top of that—before I finally realized that I'm just not a person who enjoys a lot of young children. That doesn't make me heartless, and it doesn't make me less than. I love people, and I specifically love any opportunity to encourage women and teenagers. But there was a time in my life when I was so focused on what I wasn't good at doing that I failed to see that, as my friend Melanie says, I HAVE OTHER GIFTS. That's precisely how I know that we can waste a whole lot of time trying to fit in a box that was made for someone else. Walking in a different direction—finding another box—takes intention, and it takes some courage as well.

Third theory.

Women—and this is true more often than not in our churches—are often expected to be deferential and charming. I happen to think this expectation is a pile of hot garbage, but again, it took me some years to realize that and then express it. I hope with everything in me that this mindset is changing, but the fact of the matter is that most of us worship in spaces dominated by male leadership, so I don't know, y'all. An outspoken woman is all too often regarded as a renegade—someone who needs to be managed and controlled. My hope is that when Gen Z makes up the majority of church leaders, they'll collectively link arms and announce that it's time to invite more women to the table.

That being said, I realize that some of us may prefer things just like they are, and I certainly don't want to be dismissive of anyone's convictions. So where I think we can agree is that regardless of where we land about the expectations that are put on women in faith spaces, most of us can see that empowering women to use their voices and their very unique abilities isn't always a top priority in the modern-day church. Whether it's

intentional or not, we're oftentimes cast as supporting characters, and that's problematic in terms of being encouraged to exercise the fullness of our gifts. We may get to use them, but we don't necessarily get to lead with them.

For my last six years at school, I had the great honor of working for and with my friend Shawn. Shawn was our Upper School principal, one of the best leaders I have ever known, and as the brother of three sisters (not to mention the son of an incredibly gifted mama), he was not even a little bit bothered by being in the company of opinionated, strong, outspoken women. I hadn't worked with Shawn for very long before I realized that I could bring my whole self to conversations with him—maybe most especially when we disagreed—and good grief that dynamic meant the world to me. Shawn wasn't one bit bothered by my feistiness; honestly, he seemed to respect it.

One day Shawn and I were planning for a meeting with someone who I knew would most definitely not appreciate my feistiness, and as Shawn stood up to leave my office, I said, "Don't worry. I'll do my best to be appropriately deferential in our meeting this afternoon."

He laughed, and as he walked to my door, I said, "By the way, the number of meetings where *you've* had to worry about being *appropriately deferential*? ZERO POINT ZERO."

I'm pretty sure he cackled.

And I'll tell you something else: he didn't disagree with me.

● ● ● ● ●

This is going to date me, but I'm not sure that matters because, well, *so does my face.* Back in the '90s there was a big push in churches for members to identify their spiritual gifts. When I took the quiz—and I was probably in my early twenties at that point—I'll never forget that at the top of the page, it said SPIRITUAL GIFTS INVENTORY. All caps. I couldn't wait

to find out what it told me; I had never thought about having spiritual gifts, much less inventorying them.

It's been about thirty years since I first encountered the SPIRITUAL GIFTS INVENTORY, but I still remember some of the specifics about my results. For one thing, my score for the gift of administration was abysmal. This was not at all shocking since I have never enjoyed processes or details, and I don't ever need to be in charge of managing anything because that is mind-numbingly boring and also I am terrible at it. Thank you for the confirmation, INVENTORY.

Also, my score in mercy revealed (unfortunately) that I was going to be a real disappointment to my mama and all that she held dear. Mama never missed an opportunity to help someone, care for someone, bandage anything that needed to be bandaged (my personal nightmare), and just flat-out immerse herself in someone else's heartache or tragedy if it meant she could potentially love them back to life. This is not and has never been my gift. Even now I can't be in the same room if my own child is throwing up. I can only tell you that God made me this way. Please direct any complaints or comments to him.

I vividly remember that I scored pretty high in wisdom, and I think it made an impact because that was news to me. It was a good thing that SPIRITUAL GIFTS INVENTORY couldn't see some of the decisions that I had been making on the weekends, or it would have rescinded that result.

I think there was something in there (or maybe it was a quiz I took later, I'm fuzzy on that detail) about mediation, conflict resolution, and seeing all sides. Even in my twenties I was well aware that I wasn't one to land aggressively on any side of any issue, so I was delighted to see that quality listed as a gift. I had pondered why I struggled to take hard stands and seemed to be able to see everyone's perspectives, but what I assumed was a weakness turned out to be a strength. Fantastic.

Here's what I remember the most, though. My top score was exhortation. I hit it out of the park, if I do say so myself (maybe the fact that I'm using the language of competition is a good indicator that I need to dial it down on the pride), and it's been my top score anytime I've done any kind of assessment about gifts. For whatever reason, it's the sturdiest batch of hard-wiring in my personal gifts makeup.

Now I'm not necessarily saying that you need to run out and take a spiritual gifts quiz (or SPIRITUAL GIFTS INVENTORY, for that matter), but I do think it's helpful to clearly identify, see, and name the areas where God has graciously entrusted you with natural abilities. You don't have to take a quiz to know that, though. You could just do some self-reflection, talk to some honest friends, and then make a list.

Some of you are probably wondering *Oh my word—do I really need to make a list?!* Well, if seeing yourself and your gifts clearly is an issue for you, I SAY YES. As women we have a strange (and sometimes annoying) affinity for minimizing what we're inherently good at doing. I'll never forget one time when I casually mentioned to my friend Heather—who is so administratively gifted I'll praise the Lord for it right now—that I was trying to figure out some new paint colors for my house. Heather hit a few keys on her computer, turned the screen in my direction, and revealed the most exquisite Pinterest board where she had meticulously categorized shades of white paint by their undertones.

It was a stunning sight. When I finally picked my jaw up off the floor, Heather and I picked out a color for my kitchen cabinets in approximately thirty seconds. I expressed my awe and wonder at what Heather had created, and her response was something along the lines of *Oh, it's nothing—just something I threw together one weekend.*

My reaction? *NO MA'AM. DO NOT MINIMIZE THIS. YOU HAVE BEEN GIFTED AND EQUIPPED BY THE LORD IN MARVELOUS WAYS.*

So, if we want to be responsible stewards of our voices and our leadership, we have to 1) embrace the gifts that are ours, 2) stop minimizing them, and 3) try to gain some understanding about where and how to use what we've been given. I mean, I could do my best to follow Heather's lead and serve the Lord by lovingly leading people in an administrative capacity, but there's a strong chance that wouldn't go well for anyone. I would be miserable, the people around me would be frustrated, and I doubt that God would get any glory whatsoever unless it's the moment when I would be unceremoniously fired and people would be relieved of their misery.

The ways God has designed you and gifted you? They matter so much. Your God-given strengths are the places where your voice has the most authority and influence—and where your leadership will make the most difference.

Author Jerry Bridges reminds us of the significance—the wonder, really—of God's willingness to work through us:

> In all our trials and afflictions, [God] sustains and strengthens us by His grace. He calls us by grace to perform our own unique function within the Body of Christ. Then, again by grace, He gives to each of us the spiritual gifts necessary to fulfill our calling. As we serve Him, He makes that service acceptable to Himself by grace, and then rewards us a hundredfold by grace.[1]

It's totally understandable, by the way, if you feel like your gifts aren't quite ready for public consumption. Maybe they need a little coaxing. A little refining. A little training.

But to get that process started, you have to *see* them.

You have to name them.

And then the fun starts, because you get to figure out how God wants you to use them.

●　●　●　●　●

Some of you—and probably not our type-A friends, because y'all are like *got it, made my list, know my gifts, already using them, thanks for checking in*—might be wondering *okay, Ms. Exhorter, how exactly do I figure out how to put my gifts to work in a way that enables me to lead for the good of others and the glory of God?*

This is such a great question. And I wish I knew the answer.

You're really second-guessing my high score in the area of wisdom right about now, aren't you?

I just think, to some extent, there's trial and error involved. And maybe not *actual* error. Maybe it's more like trial and *that ain't it.*

So while I don't have a *definitive* answer, I do have a few suggestions. I hope these will be helpful or, at the very least, not unhelpful. And I'll just go ahead and number these so you at least feel like you've been looped into an impressively organized situation.

1. **Look back at what you loved to do when you were younger and how that might connect to the specific gifts God has given you.**

 Did you love to play preacher? Did you organize your neighborhood's four-event version of the Olympics? Were you the kid who faithfully set up a lemonade stand so you could raise money for whatever cause had seized your interest and compelled you to help?

 So many times the clues to our most natural leadership outlets are buried in our childhoods. When I was in elementary school, I fell in love with reading, writing, and laughing with my friends. Occasionally my interests would ebb, but mostly they grew over time. My love for reading and writing evolved into a love for teaching English. Then blogging. Then writing books. Laughing with my friends eventually evolved into a pretty nerdy

preoccupation with relationships and what makes them healthy. Then working with teenage girls and helping them navigate their daily challenges.

It's not always the case, but so many times our childhood interests connect to the gifts God is developing in us. Also, the fact that God does that is pretty awesome.

2. Look at what lights you up in the here and now.

I'm not sure if you're aware, but adulthood can be a bit of a grind. There are these things we call *responsibilities* that cut into our fun time, and if we're really dialed into our careers, we can get downright preoccupied with everything connected to that. We're constantly trying to navigate expectations with bosses and coworkers, and this can leave precious little time for personal reflection.

Then, if we're parents, we can get way more invested in our kids and what the kids are doing and what the kids are loving than we are in thinking about *how might I use my God-given gifts to share the love and light of Jesus with a hurting world?* Or you might be so consumed by taking care of your elderly parents that there's not much room for anything else.

A couple of things about that. The first is to give yourself so much grace. We can't do everything at once, and it's unwise to try. You may be tapped out on the time front right now. Respect that margin. The second is this: remember that as we show up and work and lead at our jobs and in our families, we're absolutely using our gifts and our voices for God's glory. You don't have to find something new. Your ideal use-your-voice scenario may happen down the road, but you still get to use your voice right here, right now—wherever you are.

3. Look (and listen) for unexpected confirmations.

Sometimes we're so swamped that we struggle to discern what God wants us to do. There's just too much noise and too many obligations and too much on the dingdang calendar to sit anywhere in silence and get before the Lord to try to determine the next right ministry move. If that's where you're living right now, I get it. During my son's elementary and secondary school years, I was juggling and balancing more than maybe I should have been, but there wasn't a clear off-ramp to a road where I could move at a slower pace.

During that time I discovered that paying attention to unexpected affirmations and confirmations was incredibly helpful. Decision-making was often stressful for me because sometimes it felt like there weren't enough hours in the day to thoughtfully consider different opportunities that would pop up. So when people I trusted would affirm something they saw in me (particularly when it was something I couldn't necessarily see in myself) or when they would confirm something the Holy Spirit had impressed on me, I took that stuff to heart. I didn't just hear them; I listened.

This practice was especially helpful when I was transitioning from my English teacher job to my Dean of Women job and again when I began to wonder if it was time to leave school altogether. There were also countless smaller decisions over the years, and the unsolicited insight of other people was invaluable.

And by the way, here's a beautiful part of getting older. Now that I'm in a different season of life—I don't work at school, our son is in college, and my schedule is a lot looser—I try to be quick to affirm my younger friends when I see their gifts in action or when I sense the Holy Spirit wants me to encourage them in

a specific way. My prayer is that it might help them in some of the ways that other people's unexpected encouragement helped me.

You have beautiful, needed gifts, my friend. It's not arrogant or boastful to clearly identify them. And once you see them, connecting those gifts to your voice, your life, your work, your leadership, your loves—well, it's the biggest blast you will ever have.

Oh, and by the way, consider this my end-of-chapter dance routine.

I may not be able to do a toe-touch anymore, but know that in every way I can, I am cheering you on.

FEAR WILL FLAT-OUT BLIND YOU

WHEN I WAS A LITTLE GIRL, I was a real scaredy-cat. I was scared of the dark, scared of monsters, scared of dogs, and scared of the nighttime sounds at my Mamaw and Papaw Davis's farm, where frogs, crickets, and coyotes seemed to have access to megaphones based on all the racket they made after sundown. That wasn't all, either. After a clown popped a balloon in my face at a rodeo when I was four, I was all the way done as far as clowns, balloons, and rodeos were concerned. I have had no need for any of those things since 1974, thank you so much for your concern.

I was also terrified of the opening credits when there would be a *CBS Special Presentation* on TV (I just watched a three-second clip of this on YouTube for the first time in years, and I'm happy to announce that I still felt the need to run). One time I heard Jean Stapleton from *All in the Family* use her real voice instead of her Edith Bunker voice, and it freaked me all the way out; I would turn down the volume of the TV anytime I saw her speaking in a non-Edith context. I didn't

like playing hide-and-seek because sometimes people (namely my cousin Benji) would jump out and scare me, and the one and only time I have ever visited a haunted house, I fell trying to run for the closest exit and ripped the knee of my striped capri pants.

Because I spent so many years on high alert for sounds and shadows and things that went bump in the night, I fully understand how fear can transform a rational, thoughtful person into an unreasonable, panicked person. I say it all the time, but fear is a garbage motivator, and even though I've mostly worked my way through my childhood fears (STILL DON'T LIKE CLOWNS, WILL NEVER LIKE CLOWNS), there are days when I feel like fear grabs me by the throat and I turn into a completely different version of myself.

The most likely culprit in these scenarios is fear that I've done something wrong and therefore I'm going to disappoint people and as a result I will be isolated and alienated from all I hold dear—sort of like a relational prison only in wide open spaces where everyone hates you.

I think you'll agree this is very logical.

A second fear possibility is that I have committed to do something that I should have never committed to and I need to decommit and therefore I'm going to disappoint people and as a result I will be isolated and alienated and you get the idea—it's really the exact same terrifying set of consequences.

A third possibility is that I hear a very loud noise with mysterious origins and then convince myself that my untimely death is imminent.

A fourth possibility is an incurable skin condition made up of nothing but raised repetitive circles, and unfortunately, I'm not going to be able to talk about this one very much or else I'm going to need a sedative.

I don't have a fifth possibility right now, but just give me a minute and I'm sure I can come up with something.

So even now, at fifty-four years old and with a lot more healing regarding my fears than when I was a four-year-old in a rabbit costume at the rodeo, I understand how the stuff that scares us can make us want to change our minds, alter our courses, and panic like we're getting paid for it. I understand how fear rears its ugly head with no invitation whatsoever. And I understand how fear holds us back. After all, my Midian years? Chock-full-o-white-hot-fear. You likely have felt the same at some point in your own life.

Maybe you've battled fear of being inadequate. Fear of being seen as an impostor. Fear of being found out. Fear of failure. Fear of personal tragedy. Fear of looming disaster. There's sort of an infinite number of fear-related possibilities.

But ultimately, here's the very annoying rub: you and I weren't created to live fearfully.

You and I were created to live free.

Maybe let's just sit right here and think about that for a minute.

● ● ● ● ●

Moses lived in Midian for forty years, so when God told him that he was going to go back to the land of Pharaoh and lead the Israelites out of captivity, Moses had some thoughts about why that wasn't necessarily going to work for him. And while I understand that it's probably not the best idea to place a wager based on the events in the Word of God, I would bet you one hundred dollars that all of Moses' objections were rooted in a single four-letter word: F-E-A-R.

Initially, Moses asked God the "who am I?" question—we talked about that in chapter 4—but our friend Moses still wasn't at ease about his new assignment. In Exodus 4:1, he brought another potential speed bump before the Lord: "But suppose they do not believe me or listen to me, but say, 'The LORD did

not appear to you.'" The Lord assured Moses multiple times that he really would come through for all involved, and then Moses finally got down to brass tacks in verse 13: "*O my Lord, please send someone else*" (emphasis mine).

Anybody been there?

Now first of all, I would like to remind you that we can certainly disagree with God. He can one-hundred-percent handle our questioning, our fear, and our belief that there's someone better suited for the job. He can handle every single one of our very complex (and fearful) feelings. That being said, I also think it's good to remember that in the end, we will likely lose that fight. Because he's God. He's more patient, more stubborn, more wise, and more persuasive than us. While we can certainly run, we cannot hide, and ultimately most of us will land on the side of obedience because, well, *God*. You're welcome for this encouraging public service announcement.

Second of all, it might be helpful to dig into a specific area of the Lord's provision to Moses that more than equipped him to lead the Israelites. The Lord gave Moses a few very specific gifts so he could demonstrate God's signs and wonders, and the first gift was a staff. When Moses threw the staff on the ground, it became a snake, and when he picked up the snake by its tail, it became a staff. This was no doubt an impressive party trick that was sure to wow even the most cynical Israelite.

(I know it wasn't really a party trick.)

(And that staff eventually came through in some important ways out in the wilderness.)

The next gift was a leprous hand, which, to be clear, does not initially seem like a gift. In fact, you might be tempted to think that Moses drew the short end of the stick at the white elephant Christmas party. But what God enabled Moses to do was to transform his hand by putting it in his cloak and then pulling it back out. Hand went in the cloak, then came out

leprous. Leprous hand went back in the cloak, then came out "restored like the rest of his body" (Exodus 4:7).

On top of all that, God offered a generous bonus gift. He told Moses that if the Israelites didn't believe the transformations of the staff or the leprous hand, Moses should take water from the Nile, pour it on the ground, and "the water . . . [would] become blood on the dry ground" (Exodus 4:9).

Moses saw two of those three gifts in action—because God made him practice them—but he didn't trust that those gifts were enough. Moses offered yet another reason why he was the wrong person for the job: his lack of oratory ability. "I have never been eloquent," Moses said, ". . . I am slow of speech and slow of tongue" (Exodus 4:10). In the end, the Lord didn't love Moses' resistance; in fact, "the anger of the LORD was kindled against Moses" (4:14). Even still, the Lord showed great kindness to Moses by promising to give him a helper who was strong in the areas where Moses was weak: Aaron, Moses' brother.

Eventually, Moses relented, at least for the time being. He stopped asking questions and offering reasons why God's plans were flawed. Maybe he felt convicted to do what the Lord was asking. Maybe he determined that resistance was futile. But in fairly quick order—at least as far as we can tell as readers—Moses began the process of leaving Midian. Moses asked his father-in-law, Jethro (aka Reuel), for permission to go back to Egypt, and Moses' wife, Zipporah, in a particularly memorable passage of Scripture, circumcised their son since that was something she and Moses had failed to do (God, for the record, was ticked about this oversight). As a result of Zipporah conducting an impromptu bris, God spared Moses his wrath, and man oh man, if that isn't a reminder that before we jump into an unexpected assignment from the Lord, we need to make sure we have taken care of anything the Lord has asked us to address when we've been tucked away in Midian, aka a season of repentance, recovery, and healing.

Then, in the last bit of preparation before Moses began the journey of the next forty years, he met his brother in the wilderness, where he taught Aaron everything the Lord had taught him. He dotted his i's and crossed his t's, as it were, and those two brothers emerged as an Official Deliverance Duo.

And after all the ups and downs—the challenges, the questions, the doubts, the hemming, the hawing—Moses saw that God fulfilled his promises. Moses went before the elders of the Israelites. His brother, Aaron, did the speaking and "performed the signs in the sight of the people," just as God had said (Exodus 4:30). The Israelites believed what they saw and heard from Moses and Aaron. They trusted the news that God "had seen their misery" (4:31).

Back in Exodus 3, God enlisted Moses because he had "heard [the] cry" of the Israelites (3:7) and wanted Moses to lead them to "a good and broad land" (3:8). Even though Moses' fear gave him a run for his money, the end of Exodus 4 gives cause for celebration because ultimately Moses followed through with the initial phase of his assignment from the Lord. Moses—with some help from Jethro, Zipporah, and Aaron—ushered in the beginning of God's plan to deliver the Israelites from captivity.

Also worth noting is that there were twelve women who had been instrumental in Moses' life so far: Shiphrah and Puah, the Hebrew midwives who resisted Pharaoh's decree; his mother, Jochebed; his sister, Miriam; Pharaoh's daughter; his wife, Zipporah; and Zipporah's six sisters in Midian. Preparing for the work of deliverance takes a team.

And as Carol Meyers reminds us, "Moses is . . . hardly a passive recipient of the divine mandate; rather he is a person responding to a daunting challenge with human doubt."[1] He made a decision—despite his limitations, hesitations, and fears—to trust what the Lord told him and showed him. That didn't mean that Moses' participation in the journey of

deliverance wouldn't get rocky, of course. But it does occur to me that Moses' fear could have really jacked up his participation in God's very good plan. Fear could have stopped Moses in his tracks and convinced him to stay in Midian forever.

It's worth considering, even now, that if we don't keep our eyes focused on the One who prepares us, gifts us, and calls us, we too might find ourselves tempted to let fear have the final word.

* * * * *

As I've been working on this book, I've been hyperaware of lots of things.

Maybe the first one of those is how much I enjoy using the word *things*.

It's been the case with every one of my books. Can't stop won't stop.

But the primary piece of awareness raising its hand at the back of my brain is that when you're writing a book where you're alternating personal stories with lessons from the life of Moses, it's easy to wonder if readers will think that you're somehow comparing your life to Moses' life.

Maybe that sounds a little ridiculous now that I've actually typed it. But ridiculous or not, I'm still going to offer some clarification so that the persistent nag I feel about this will settle down and know that I attempted to settle it once and for all.

I am in no way trying to set up a comparison that emphasizes how much Moses and I have in common. I understand that Moses is a true Bible hero who demonstrated courage and leadership on a scale that literally changed the world, and I understand that I am a writer who lives in the suburbs of Birmingham, Alabama, where I enjoy access to four different grocery stores within a two-mile radius and drop in to my local

Anthropologie at least once a week to see what's new and cute in the store.

Are Moses and I both children of God? Sure. Both loved by God? Absolutely.

But at the risk of overexplaining, I want to explicitly say that I am more than aware that in this particular literary endeavor, Moses is our teacher, and you and I are the students. My stories are just my way of sharing how I'm learning some of the lessons that Moses' life teaches us.

Given that, a bit of follow-up, because even if we know God has made something clear to us, that doesn't mean that fear goes away.

After the birds showed up in my driveway, I very much felt like God had settled my question about whether I should pursue writing a book. What happened next was pretty simple: eventually I had an idea for a book, so I found an agent, signed a book contract, and wrote said book. The time span from birds-in-driveway to book-in-bookstores was about two and a half years, and I don't know that there was a single day during that particular stretch when I didn't feel at least briefly but significantly terrified.

By the way, I know that as a lifelong Southerner who is the product of two lifelong Southerners who were the products of four lifelong Southerners, I am genetically prone to hyperbole. But that is not an exaggeration.

I was scared of so many things, so in the interest of clarity and maybe even some low-level entertainment, here's a brief round-up. I was scared that

I wouldn't be able to write the book,
I *would* be able to write the book, but it would be dumb,
I would hurt someone's feelings with what I wrote,
the Amazon reviews would be terrible,

my students would make fun of me because look at this terrible book their teacher just wrote,

someone who had secretly hated me for years would piggyback on the book's release and publish a document entitled SOPHIE HUDSON, I HAVE SOME GRIEVANCES, and

—this is the one I felt the most deeply—God was setting me up so that he could humble me in a very public way.

That last one? Pretty telling, huh?

And that brings me to a couple of things I want to mention about us and our fears. I do hope this will be helpful and encouraging.

First, I think it's worth asking ourselves what our fears ultimately reveal about how we view God. In my case, the belief that God was somehow setting me up was really an indication that even though I had chosen to believe him, I didn't fully trust him. It was actually on the other side of that first book that I worked out that piece of my faith puzzle—when I was able to clearly see his character and his trustworthiness in a whole new light—and ironically, I think that was likely one of the main reasons why I needed to write that book.

So I'm just wondering: do you also have a fear-based belief that God is setting you up to let you down? Or that something terrible will likely happen if you use your voice in a new (and maybe vulnerable) way? Do you hold on to the possibility of failure with a death grip? Is it a worst-case-scenario festival in your head?

Consider what lies you're telling yourself, and as my friend Angela once told me, replace those lies with the truth. The Truth. The TRUTH.

Second, over the last six or seven years I've gotten pretty angry with fear. It's a terrible boss and a horrible way to live. It

changes us in ways that aren't helpful. It makes us manipulative. And what I've grown to realize is that the primary issue with fear is not that we're afraid. That's a normal human condition we have to learn to overcome. The primary issue with fear is not even that it can deter us from using our leadership, our gifts, and our voices to participate in the joy-filled work of pointing people in the direction of the kingdom of God.

The primary issue with fear is that it makes us preoccupied with ourselves. Our feelings. Our safety. Our reputation.

The late Tim Keller wrote a short book called *The Freedom of Self-Forgetfulness*, and while I'll resist the urge to summarize the book's message, I do want to say this: if the majority of your fears about leading with the gifts and the voice that God has given you center on your inadequacy, your sin, your failure, your limitations, Keller's words will be so helpful.

There's one passage in particular that offers so much insight into how fear affects us. Keller writes this:

> [M]aybe . . . you believe the gospel; maybe you have done so for years. But . . . every day you find yourself being sucked back into the courtroom. . . . All I can tell you is that we have to re-live the gospel every time we pray. We have to re-live it every time we go to church. We have to re-live the gospel on the spot and ask ourselves what we're doing in the courtroom. We should not be there. The court is adjourned.[2]

Living in the grip of fear holds us (and holds us back) in countless ways, but maybe the most damaging thing it does is compel us to contest the sincerity and validity of our faith.

It's a toxic, destructive habit. Lord willing, we'll walk away from it and break the cycle.

It may take some time. And what Moses' life shows us is that even when we're afraid, the clear call of God is reason enough to move forward, to pay attention to the signs he has put in

front of us, and to begin using our gifts and our voices in the unique opportunities the Lord has entrusted to us.

He sees you, you know. Just like he saw Moses. He has prepared you. Just like he prepared Moses. He trusts you. Just like he trusted Moses.

Odds are that your assignment isn't quite as, you know, *epic*, but I imagine we're all pretty grateful that we don't have any nations to lead.

Pay attention to what he's been up to in your life. It's on purpose.

You have absolutely nothing to fear.

7

WHEN YOU JUST CAN'T SEE IT

I HAVE A CONFESSION.

The first part of my confession is that Pharaoh really gets on my nerves. Like, I don't like him at all.

And the second part of my confession is that for the last couple of hours, I've been battling the temptation to make a list of all the pharaohs I've known.

I mean, not actual kings of Egypt, of course. I'm talking about leaders whose arrogance and shortsightedness have, in my opinion, complicated my life—and in some cases, my faith—by prioritizing power over people. By refusing to see image bearers all around them through a lens of compassion and care—and then justifying their callousness in Jesus' name.

(I realize, objectively, that making a list is a terrible idea.)

(But still, IS ANYONE INTERESTED? I WILL EVEN AL-PHABETIZE IT.)

True story: I actually took a break from writing earlier today so that I could clear my head and talk to the Lord about my admittedly unwise wishes. I went to the gym, hopped on a

treadmill (it is currently 427 degrees in Birmingham, so going for a walk outside is a rare combination of cardio paired with a death wish), and I was approximately seven minutes into my walk when clarity rolled in like a summer storm.

You know who else can be a little Pharaoh-y? Me.

I think that's maybe why I dislike him so much, honestly. He's relatable for some really uncomfortable reasons.

And while I know that Moses is our biblical touchstone for this book, I also believe that we'd be wise to examine our hearts for any pesky traces of . . . Pharaohism? Pharaoharty? I AM UNSURE OF THE TECHNICAL TERM.

I spent the rest of my walk this afternoon thinking about times when I've had an opportunity to lead and my inner Pharaoh has reared its very controlling head (not to mention when I've been blind to how my actions might have affected other people). I'm going to share my top three, but rest assured, there is neither a crown nor a sash associated with winning this contest, which obviously no one would ever want to enter.

In third place we have my first year as a classroom teacher. I was what you might call *hellbent on control* (why? because I was terrified, and remember: fear is a garbage motivator), so on the first day of school I greeted my students with a double-sided copy of approximately forty-eight classroom rules. *Clear your throat at your peril, everyone.* I didn't have the experience or wisdom to know that any enjoyable classroom experience prioritizes a spirit of respectful freedom, so I opted to be a total pain in the neck who wanted everything *just so.* And when things would go off the rails (has anyone met teenagers? has anyone met a twenty-three-year-old first-year teacher?), I would respond by losing my temper and heaping blame on anyone in my immediate vicinity. I'll never forget one day, after I had completely *lost my ish*, as the young people like to say, when I walked out in the hall with a student I had every intention of dressing down. She had the courage to speak up to me and say,

"Hey. Miss Sims. You can't yell at children and think that they'll respect you." It was a word fitly spoken, and while it took me a long time to fully understand it, I've never forgotten it.

In second place: parenting. Specifically, junior high parenting. I've never been big on the whole helicopter mom vibe, but there was something about Alex's seventh and eighth grade years that just freaked me out. Have mercy at the arbitrary rules and nonstop management on my part. I hate to admit it, but I surpassed the helicopter phase and became a straight-up drone mama (I WILL TRAIL YOU INCESSANTLY AND BUZZ YOU TO LET YOU KNOW YOU'VE FAILED). Since Alex moved to my campus in seventh grade and his teachers were my coworkers, I think I felt a strange sense of responsibility for his behavior. No mistakes, no knocks to the family name, no revelations about his character that wouldn't line up with who people might expect him to be. This was a horribly self-centered perspective on my part—a terrible way to lead—and shame was my favorite tool in my personal parenting toolbox. One night when I was trying to help eighth grade Alex study for a Spanish test it got *muy feo*, my friends—my parenting rock bottom. Afterward I finally admitted to myself—and to Alex— that our dynamic wasn't working for either of us. I promised to love him better by backing off my tendencies to control and manage. That pivot in our relationship was so necessary and so helpful because, good grief, I was about to run that sucker right on into the ground.

And in first place—feel free to use your book for a drum roll— the early days of my life in ministry when I was deeply drawn to certainty. This made me hyperjudgmental of other believers who, to my way of thinking, at least, simply didn't understand all the ways they were wrong, and in my opinion the world needed to conform to my very correct belief system. I became especially critical of the denomination I grew up in, and I directed a good deal of that criticism at my sweet mama. I wanted her to

understand all the "unsound doctrine" I had learned as a child, and I made sure to chronicle all the ways I was getting it right as an adult (particularly in terms of my new understanding of theologies connected to the school where I worked). My level of arrogance was gross, really, and while Mama was always patient with me, that doesn't change the fact that I was a real jerk to her, to my husband, to lifelong friends, and to a few students I taught during that time. I wasn't communicating from a place of love or compassion; I was talking down to people and making sure they understood how much they didn't know. Thankfully I eventually realized that my deep need for certainty was rooted in fear (there it is again!), but GAH. Mean, mean, mean.

So there you have it. My personal Pharaoh-y Hall of Fame. If we sat here long enough, I could offer you countless additional instances.

I'll spare you. You're welcome.

● ● ● ● ●

It was all going so well. Until it wasn't.

At the end of Exodus 4, Moses and Aaron finally made their move. They went to the Israelites, they demonstrated the signs and wonders (well, Aaron did), they shared all the words God wanted them to share (well, Aaron did), and something wonderful happened: "The [Israelites] believed." Not only did they believe, "they bowed down and worshiped" (4:31).

Given the immediate buy-in from the Israelites, it's interesting, to put it mildly, to see the sequence of events after Moses and Aaron carried out the next part of their assignment and approached Pharaoh. They delivered God's message word for word: "Let my people go, so that they may celebrate a festival to me in the wilderness" (Exodus 5:1).

When he responded, Pharaoh established that he was a real *no* man. He said that 1) he did not know the Lord, and 2) he

would not in fact let the Israelites go. Then, after Moses and Aaron repeated their message, Pharaoh ordered that 3) there would be no more providing straw for the Israelites to make bricks—they could simply gather straw themselves, and oh, by the way, they needed to produce the same number of bricks as they had been.

So in addition to being a *no* man, Pharaoh also put the *p* in *petty*.

In *Believer's Bible Commentary*, William MacDonald notes that "Pharaoh was making an impossible situation for the Jews . . . stubble [was] a poor substitute for straw."[1] Pharaoh no doubt knew this, but he had labeled the Israelites as lazy, and he reasoned that more work would prompt them to "pay no attention to deceptive words" from Moses and Aaron (Exodus 5:9).

The result of Pharaoh's impulsiveness and imperiousness? A good old-fashioned interpersonal train wreck. Pharaoh's taskmasters sent Israelite supervisors to share Pharaoh's message with their people, and when brick production didn't meet normal standards because the Israelites were having to gather all that stubble, the taskmasters beat up the supervisors. The supervisors went to Pharaoh and said, essentially, WHAT IN THE WORLD, but he reminded them that they were "lazy, lazy" (5:17) and refused to change his demands. Frustrated, the supervisors then went to Moses and Aaron to make sure they knew that their words to Pharaoh had started a big mess, at which point Moses went to God to express his outrage.

None of this mattered one iota to Pharaoh, who seemingly remained content to tell everybody what he was not gonna do and what they could do as a result. His resistance and anger were contagious, though; everyone at the mercy of his whims was madder than a wet hen.

And our buddy Moses? He was riddled with doubt, he was frustrated, and to his credit, I guess, he felt free to air his grievances in Exodus 5:22–23: "O LORD, why have you mistreated

this people? Why did you ever send me? Since I first came to Pharaoh to speak in your name, he has mistreated this people, and you have done nothing at all to deliver your people." He had barely ventured into this new assignment from God, but he was all the way done. According to Tony Evans, Moses had (already) "forgotten that God told him that Pharaoh's heart would be hard, that freedom would be won only by God's mighty power, and that it would be a fight to the death."[2]

If you like a wrap-up, here's how things were going at the end of Exodus 5: everybody was ticked, everybody was pointing fingers, and everybody resented Pharaoh's dumb, arbitrary rules.

What a mess.

What a time.

● ● ● ● ●

Do you know what makes me the saddest about every one of the personal Pharaoh-y situations I mentioned? I was a person who professed faith in Christ. But my actions—my preoccupations with power, control, and being the most right— communicated much the same as Pharaoh did the first time he spoke to Moses and Aaron: "I do not know the LORD" (Exodus 5:2). Intellectually I was a believer, but some remaining pieces of my hardened heart were running the show.

A couple of things I want to be sure to say:

1. We're going to get it wrong sometimes. We just are. We can ascribe the most noble motives to our intentions, and those intentions can still be misguided. That's why we have to be willing to ruthlessly inventory what's taking up space in our hearts and minds. We have to ask ourselves hard questions: *Would Jesus cosign what I'm saying? Do my actions reflect the character of Christ? Am I "rooted and grounded in love" like it says in*

Ephesians 3:17? Does Scripture support my perspective? Is fear bossing me around in any way?

And—here's a real kick in the pants—*Do I lack perspective on this because I live in an echo chamber where no one sees things differently than I do? Have I somehow created an environment where people are reluctant to challenge me?*

I get that it's a real bummer, but Pharaoh-y tendencies can sneak up on us if we're not careful. And if I could be so bold as to paraphrase the wise words of Ice Cube: we have to check ourselves, lest we wreck ourselves.

2. It's heartbreaking when we realize that we've willingly followed leaders who proclaim Jesus publicly but privately (or who knows—maybe publicly, too) behave more like Pharaoh. So often that behavior stays hidden until something jarring brings it to light, and whoa Nellie is that ever a tough thing to reconcile. So, in the event that you find yourself in a situation (at church, at work, etc.) you thought was healthy but is actually controlling, shaming, or unloving, remember that you don't have to stay there. You get to leave. Surround yourself with trusted people who will offer wise counsel. Talk to the Lord about it. But do not discount the toll of sitting under persistently unhealthy leadership, particularly in faith communities. Something I recently read resonated with me strongly: "Opposition from *within* the ranks of God's people is often harder to bear than persecution from *without*."[3]

 Man oh man—this is the truth. Take care of yourself. There are too many good leaders to stick with bad ones.

We all have some Pharaoh in us. But as much as we can help it, we don't want to live from that place of Pharaohcity.

(Okay, that one is legitimately my favorite.)

(I'm so glad we settled that.)

● ● ● ● ●

For the last year or so I've been using a new-to-me translation of the Bible, mainly because every few years I like to mix it up. Over the course of the last fifteen-ish years, I've used the NIV, then the ESV, then the CSB, and now the NRSV.

Why do I feel like I need to sing "and Bingo was his name-o" right now?

Anyway, a few minutes ago, I noticed something in the NRSV translation that made me smile. I'm gonna call it a headline even though that might be the wrong terminology, but what I'm referring to are the words that are in bold above certain passages of Scripture. It was the bolded words above Exodus 6:1–13 that caught my attention:

Israel's Deliverance Assured

I mean, things were pretty grim at the end of Exodus 5, what with everybody being completely exasperated and all, not to mention that Moses questioned God's whole plan. But even before Exodus 6 officially begins, we can clearly see that there's reason for hope.

Because what does God promise Moses? That Moses will *see*.

"Now," the Lord says, "you shall see what I will do to Pharaoh: Indeed, by a mighty hand he will let [the Israelites] go; by a mighty hand he will drive them out of his land" (Exodus 6:1).

That statement is enormously encouraging to me because it throws all of the chaos of Exodus 5—and, you know, *our present day*—into sharp perspective. We can use our voices to proclaim freedom to captives, just like Aaron did—or we can use our voices to stall and intimidate, just like Pharaoh did.

Regardless, though, we can count on this truth: **when God starts something, nobody can stop it.**

Oh, we can question it. Deny it. Complicate it. Refuse to participate in it. Try to sabotage it. Maybe even derail it for a bit.

But he will have his way. He will achieve his purposes. And if we don't believe that, just wait. We will see. He will show us.

This reality should be enormously humbling to us. Comforting, too. Because when the Lord is clear with us about how to use our gifts and our voices to lead people in the direction of his love and freedom, he's not going to jump ship or abandon the mission. Even if we get furious with everyone involved and make a bunch of arbitrary rules and act a fool and do our best to blow it all up, we're not going to stop him from achieving what he intends to achieve.

Yes, Pharaoh is for sure the Big Bad in Exodus—no doubt about it—but his opposition is ultimately light work for the Lord. It would only be a matter of time before Moses would see the mighty hand of God move exactly as God had promised.

Also, don't miss this. In Exodus 6 Moses remained a fairly hesitant participant in God's plan. According to Matthew Henry, "Much ado there was to bring Moses to his work, and when the ice was broken, some difficulty having occurred in carrying it on, there was no less ado to put him forward in it."[4] In more modern verbiage, Moses was still riding shotgun on the struggle bus. Moses listened to God's reassurances that we see in the first ten verses of Exodus 6, and he passed along what God said to the Israelites. But when they were largely uninterested in what Moses had to say after the whole straw and stubble fiasco, Moses used their rejection—plus the fact that he wasn't great at speaking—as reasons why God shouldn't send him to speak to Pharaoh (6:11–12). God, however, was resolute, and in verse 13, he charged Moses and Aaron with going to Pharaoh again and demanding that he set God's people free.

Exodus 6 ends with a chunk of genealogical history, which honestly feels a little bit like a sharp turn to me. However, Henry offers some insight when he notes that this family tree actually "comes in here to show that [Moses and Aaron] were Israelites, bone of their bone and flesh of their flesh whom they were sent to deliver."[5] Furthermore, another commentary states, "Everything in the list suggests that God's choosing of Moses had nothing to do with natural advantage or ability. . . . Moses' calling and election of God were a gift of grace and not based on rights and privileges of birth."[6]

Whether Moses liked it or not—whether he felt qualified or not—he was God's man for the job.

And whether we like it or not, there will be times when the good work God has given us feels more than a little bit maddening. When we're frustrated by the assignment at hand. When we've had it with other people. When we've had it with ourselves. When we wonder if God's going to come through on his end of the deal.

However, none of that changes one crucial fact: you're God's woman for the job.

Just you wait. You'll see.

THE THINGS THAT PLAGUE US

THE LAST FEW YEARS that I was a classroom teacher, I taught eleventh grade English, and here's what you might not know: *eleventh grade English is dreamy.* In the state of Alabama, the curriculum for junior English is twentieth- and twenty-first-century literature, which offers, in my opinion, the best of all the reading. I don't know that I had a runaway favorite, but I can tell you that when it was time for us to read *The Great Gatsby, The Glass Menagerie,* or *The Crucible* (HAS ANYONE READ THE CRUCIBLE LATELY OH MY GOSH IT HOLDS UP), I would feel downright giddy about getting to share those stories with my students.

Even better, my experience with teaching eleventh grade English was that it prompted really good classroom discussion because of how the subject matter tied into modern-day issues in ways the kids understood.

However.

There was one very famous poem that intimidated the fire out of me from a teaching perspective. It took us a whole week

to cover it, and without fail, I would dread how much time and effort it took to get buy-in from my students. I knew that the week would essentially feel like we were all trying to catch a whale with a fishing line, and because of the complexity of the language and the themes, I often felt like I was in over my head before my students and I had stuck our collective pinky toe into the analytical waters.

What's the poem, you're wondering?

"The Love Song of J. Alfred Prufrock" by T. S. Eliot.

The word *daunting* comes to mind.

I mention it not because we're about to jump headfirst into the psyche of Alfred Prufrock but because I realized a couple of nights ago that I have developed "Prufrock"-esque feelings of Teacher Dread about the next part of the book of Exodus.

You know, the part with all the plagues.

Even that last sentence is more complicated than I expected, because I realized in my reading that there's some debate about referencing *multiple* plagues in Exodus. This was news to me—having heard the term *plagues* all my life regarding Pharaoh and the ten consequences for his disobedience—but according to Carol Meyers, "the exodus account itself as well as other biblical texts use 'signs' and 'wonders' for what postbiblical tradition calls plagues." She goes on to explain that "the latter term . . . connotes horrific and extensive loss of life, a condition that does not obtain for all nine events."[1] The single plague, according to Meyers, is what we normally consider the tenth one—the death of all firstborn children in Egypt, right down to the livestock. It meets the criteria for a plague because of the widespread death.

So, to sum up: what we have in Exodus 7–12:34 are nine signs-and-wonders and one official plague. In *The Message*, Eugene Peterson uses the term "strike,"[2] which is also used in parts of the NRSV. We'll use that, too, from time to time—just to keep things interesting.

I also want to be sure to say this before we launch ourselves into the land of gnats and boils and flies and whatnot. If I only had one day to teach "The Love Song of J. Alfred Prufrock," I would focus on the big picture: what in the world happened, then big ideas and real-life application. That's exactly the approach we're going to take with the next five chapters of Exodus. There's a lot there, I'm not a Bible scholar, this is not a commentary, and we just don't have enough room and time for super in-depth analysis. If you'd like a deeper dive, though, I recommend Carol Meyers's volume on Exodus in The New Cambridge Bible Commentary series. It's thorough and thought-provoking.

Our structure is going to be a little different in this chapter, too, just because we have a lot of ground to cover in a short period of time. That means we're going to be a little less story-focused and a little more text-focused. I hope that's okay with you.

As you likely already know, there's all manner of danger and destruction ahead. There are also some fascinating lessons about leadership.

And like my favorite Eliot poem, this chunk of Scripture is also daunting—for sure—but I believe we're up for the challenge.

●●●●●

I only recently thought about this, but at the beginning of Exodus 7, Moses and Pharaoh were running on similar tracks: both leaders, both responsible for large groups of people, and both recipients of specific information from God about what they were supposed to do next.

How they responded to God, though, was where those tracks parted ways.

Moses, for the record, had been playing both sides to the middle ever since he left Midian, mostly going along with what God asked but refusing to use his actual voice and perfectly content to let Aaron speak instead. The beginning of Exodus 7 marked a big change on the horizon, though, because God told Moses, essentially, *Hey, dude—we're not doing that anymore.* After Moses tried once again to use his poor speaking abilities as a reason why Pharaoh wouldn't listen to him, the Lord said, "See, I have made you like God to Pharaoh. . . . You shall speak all that I command you" (7:1–2).

The Lord rightly anticipated that the next time Moses and Aaron visited Egypt's leader, Pharaoh would want the brothers to put God's power on display for him. God told the two brothers that when that happened, Moses would tell Aaron to throw the staff and it would turn into a snake. They did just as he said, but Pharaoh was unmoved and summoned his sorcerers, who "did the same by their secret arts" (7:11). Never you mind that Aaron's staff "swallowed up" all of theirs (7:12); it was still a nothing doing situation for Pharaoh.

So, since Pharaoh's heart was hardened (more about this in just a bit) and he refused to listen to Moses and Aaron (again), well, from that point forward, it was on like Donkey Kong. The first strike—water turned to blood—was on the way.

Now, maybe it's a sign of my age, but there's something about this whole exchange that makes me want to put my finger right in Pharaoh's face and use my best, most intimidating mom voice to speak to him through clenched teeth. *What are you even thinking?!* I want to ask him. *There's no way you can be this stubborn—this prideful—and get away with it!* His willfulness is even more infuriating, I think, because *he still had a chance.* Yes, God had been direct with him, but up until the staff-turned-into-a-snake encounter, God had also been merciful. However, in the same way that God laid down a hard boundary with Moses at the beginning of Exodus 7,

he was about to lay down the first of several hard boundaries with Pharaoh.

There has to be a point when enough is enough, right?

The beginning of Exodus 7 definitely strikes me as God's *I've had it, kids, and I am pulling this car over on the side of the road* moment. Moses and Pharaoh both found themselves at a crossroads of obedience, and we know how it played out: after reminders about what their leadership should look like, Moses (finally!) did exactly what God asked him to do, and Pharaoh (again!) said thanks but no thanks.

Both men's reactions to God's clear, individualized instructions fill me with a little bit of fear and trembling from a leadership perspective. While neither path was easy, one ultimately led to increased peace in a leader's relationship with his creator, and one didn't. In the events leading up to Exodus 7, both men, to some degree, preferred clinging to their functional idols over fully surrendering to God's will. Since I was not in fact close friends with Moses and Pharaoh, I can't make an authoritative list of those functional idols, but I can make some guesses based on what the book of Exodus tells us: pride, fear, control, arrogance, shame, and power. Assign those as you see fit.

And remember this: even now, thousands of years later, Pharaoh remains an object lesson in the hard consequences of prioritizing our idols over leading people with love, of choosing selfish desires over preferring the interests of others. We can tell ourselves that our actions—or our lack of action—won't affect other people, but we're wrong. And if we're having trouble seeing why that's true, well, the book of Exodus would like to have a word.

We may very well find that as we use our voices to love and lead, we end up at a similar crossroads—one road marked by obedience, and the other road marked by doing what we want, when we want, with our favorite idols along for the journey.

If we don't get anything else out of Exodus 7 as leaders, we need to for sure get this: no matter which road we choose, there will be consequences—and we need to consider which consequences we're willing to live with.

Think about it this way: before we arrive at an unexpected intersection, it's good and helpful to have already settled which way we intend to go.

• • • • •

Starting in Exodus 7:20, consequences roll in fast and furious for Pharaoh and the Egyptians.

The first strike was water turning to blood. Specifically, the Nile River turned to blood, and all the fish died. Can you even imagine the smell?

The second was frogs. In the river, in the palace, in ovens—you name it.

Third? Gnats. Like, every single piece of dust became a gnat. In technical terms, that's a whole lot of gnats.

Fourth: flies. Swarms of them. Inside and outside.

And the fifth was diseased livestock.

In every one of those first five strikes (signs-and-wonders, not technically plagues), Scripture tells us that Pharaoh's heart either "remained hardened" (7:22), "hardened" (8:15, 32), or "was hardened" (8:19, 9:7). Honestly, the first time I read all the way through Exodus, I saw the repeated mentions of Pharaoh's heart being hardened and thought, *What the what, God?*

I mean, if God was going to dictate the condition of Pharaoh's heart—as he said back in Exodus 7:3—then were the signs-and-wonders just a display of power? If there was no hope for Pharaoh to see things God's way, then why did the Egyptians have to suffer?

This is where we can all be so grateful for people who study ancient languages and help out the rest of us with things like, you know, verb tenses. Let's consider Tim Mackie's words:

> You walk away from chapter 7 thinking God was hardening Pharaoh's heart from the first, which isn't what the text says. . . . God gives Pharaoh five opportunities to repent and humble himself. And five times Pharaoh hardens his heart.[3]

Initially, at least, Pharaoh hardened his *own* heart. But after those first five signs-and-wonders, what we see is God saying to Pharaoh, essentially, *If a hardened heart is what you want, I'll make sure you have it.*

God wasn't finished with signs-and-wonders, either. There were boils (this is my personal worst-case scenario for a sign, a wonder, or an everyday occurrence), thunder and hail, locusts, and darkness. In Exodus 10:7 even Pharaoh's officials tried to get him to change his mind and just give up already: "Do you not yet understand that Egypt is ruined?" There were even a few instances where it seemed like Pharaoh might relent (9:27–28, 10:8, 10:24), but no dice. Finally, in Exodus 10:28, Pharaoh made his position crystal clear to Moses: "Get away from me! Take care that you do not see my face again, for on the day you see my face you shall die."

It's no surprise that in the back half of signs-and-wonders, God left Pharaoh to sit in the consequences of his own choices, not to mention his hardheartedness, indifference, and pride. Like any boss or parent knows, there's a point when, as the person in charge, you sometimes have to say, *Okay—I guess I'll just leave you to it. Woe be unto your remaining delusions of resistance.*

In Pharaoh's case, that's exactly how he arrived at Strike Ten: A Certified Plague.

The Bible Project's overview of Exodus says that "even though God knew Pharaoh would resist his will, God still offered him many chances to do the right thing. Eventually Pharaoh's evil [reached] a point of no return."[4]

• • • • •

Even in light of the gnats and the boils and the locusts and whatnot, it's easy to look at what happens next in Exodus and think *well, that escalated quickly.*

However, it actually took a whole lot of *No can do, God* from Pharaoh to get to the point of DEFCON Plague. Interestingly, Scripture tells us that the Israelites had "favor in the sight of the Egyptians," and "Moses himself was a man of great importance in the land of Egypt, in the sight of Pharaoh's officials, and in the sight of the people" (Exodus 11:3). Henry notes the remarkable turnaround in how the Egyptians viewed the people they had oppressed: "Even the people that [had] been hated and despised now came to be respected; the wonders wrought on their behalf put an [honor] upon them and made them considerable."[5]

So once again, Moses relayed God's plan to Pharaoh: "Every firstborn in the land of Egypt shall die, from the firstborn of Pharaoh who sits on his throne to . . . all the firstborn of the livestock" (Exodus 11:5). And just in case the Israelites were concerned that their firstborns were in jeopardy, God had a plan to assure them they would be untouched. You're probably familiar with the history of Passover, but in case you're rusty in parts, here's a quick recap. God instructed all of Israel to sacrifice a lamb on the fourteenth day of the month, then to take some of the lamb's blood and put it on the lintel and the doorposts of their houses. God said that he would pass through Egypt to sacrifice all firstborn Egyptians, but "when I see the blood, I will pass over you, and no plague

shall destroy you when I strike the land of Egypt" (Exodus 12:13).

By the way, has anyone picked up on all the language of *seeing* in Exodus 10, 11, and 12? Moses said he would never see Pharaoh's face again. The Egyptians saw Moses as an important man. The Israelites had favor in the sight of the Egyptians. God saw blood and passed over a Hebrew home. But Pharaoh—to the detriment of his country and his family—never seemed to see anyone or anything other than himself.

Not surprisingly, God did as he said he would, and every firstborn in Egypt was killed—including Pharaoh's son. As Tony Evans reminds us, "Pharaoh had led his nation to cruelly enslave Israel and rebelliously despise Israel's God. As a result, Egypt was drinking the cup of God's wrath."[6] And finally, after ten strikes that had to have felt like hell on earth, Pharaoh relented. He called for Moses and Aaron and gave word that they and the Israelites could leave to go worship the Lord—and they could take their flocks and their herds with them (Exodus 12:31–32).

His final words in this encounter? "And bring a blessing on me too!" (Exodus 12:32).

My reaction to that remark might be a little skeptical, because I tend to think, *Eh, same song, different verse, Pharaoh.* Others, however, see Pharaoh's parting words as a sign of belief in the God he had denied for so long, and Henry perceives some self-awareness from Pharaoh: "Those that are enemies to God's church are enemies to themselves, and, sooner or later, they will be made to see it."[7]

Regardless, after more than four centuries in Egypt, over 600,000 Israelites were suddenly free to go. The wilderness would bring its own challenges, but we don't have to jump into all of that just yet. Plus, this is a great time to remember our two Big Leadership Lessons from the signs-and-wonders (and one official plague): obedience and humility.

We discussed how Moses eventually got it right with his obedience. He said everything God wanted him to say, and he said it with his very own voice. Yay, Moses! Good job!

Obedience was a tougher road for Pharaoh, and even if we give him the benefit of the doubt and say that he sort of, kind of understood it when he released the Israelites and asked for a blessing, that doesn't change the fact that power and control were far more important to him than anything resembling healthy leadership. This is precisely why Pharaoh is such a cautionary tale for leaders. His pride ran the show for way too long, and as you'll see in Exodus 14, it made an encore appearance when Pharaoh was like, *wait a minute, I should have never let these guys go.* But I'm getting ahead of myself.

As leaders, we must be willing to ask ourselves hard questions—and to let other people lovingly check our motives. No matter where we're leading—home, work, community, ministry, wherever—there's one critical question that needs to be before us (I mean, not literally, but in our heads, you understand) every single day: *Do I truly, humbly see—and understand—how my words and actions affect other people?*

We might wish it weren't so, but there are real, lasting consequences for what we say, how we say it, what we do, what we cosign, and who we publicly support. Granted, we might not necessarily have to deal with a house full of frogs if we choose to be hard-hearted, but we need to be accountable. It's impossible to lead well if we're swimming in a pool of pride and entitlement.

I mean, you can always choose to swim in the functional idols of your choice, of course. Free country, etc. But here's the bottom line: Pharaoh may have had the power and the title and the money and the influence, but unfortunately, he was also the actual worst.

We don't want to be that guy, ladies.

Wherever God is directing you to love people is exactly where you want to be. Listen to his instruction. Trust him. Obey him. Follow him.

(I can't promise it, but I think this is also a pretty good strategy for AVOIDING THE BOILS.)

Get low. Stay humble. Look up.

You just can't beat the view.

WHEN YOU SPY SOME BRAND-NEW TERRITORY

Big Ideas & Modern Concerns

WE'RE GOING TO PUMP THE BRAKES once again and stop our forward progress through the first twenty chapters of Exodus so that we can talk for a minute about why it can be so difficult to trust God with new opportunities and also adventures.

And listen. This may not be challenging for you, a courageous individual. But as a certified second-guesser, I have a knack for standing stock-still when God unexpectedly opens new doors in my life.

I will explain.

I may not be the most, um, *skilled* person when it comes to working with young children, but I can tell you without a bit of hesitation that being Alex Hudson's mama when he was a little kid is one of the best things I've ever gotten to do. It was challenging for sure—I may have mentioned that building

97

relationships with teenagers is a much more natural process for me—so I was way out of my comfort zone as a preschool and early elementary mama. But good grief, just thinking about Alex in his early years makes me smile. He was a certified nugget, chock-full of personality and so fun to be around.

That's still the case, by the way. He's just a six-foot-two nugget now. Please don't tell him I said that.

Now, lest you think that I am looking at my earlier days of motherhood through rose-colored glasses, I can assure you that potty training, trying to teach Alex how to use scissors, and helping him learn to read are experiences that have left both of us with enduring, incontrovertible proof that patience was not and will never be my superpower. I was used to giving instructions in a high school English classroom, which usually went something like *I said it, kids followed through, check that off the list*. The dynamics work a little differently when parenting a small child, and that is most definitely one of the reasons why early motherhood felt like such a deeply humbling learning curve for me.

I have to say, though, that there was one part of my early parenting life that continues to provide the sweetest memories: the conversations right before bedtime. If you've ever loved a child who seemed to save all their questions for those moments nestled between story time and finally falling asleep, you can likely relate. Alex liked to snuggle, so after he selected the two or fourteen books he wanted me to read to him, he would attach himself to my side—almost like we shared a set of snaps that extended down to his toes—and lean back against my right arm. For the thirty or so minutes when I would relay the adventures of Larry the Cucumber or Little Bear or Mr. and Mrs. Beaver, little Alex peppered me with questions.

Mama, what's a con-suh-quence?

Mama, did you ever lie?

WHY DID YOU LIE, MAMA?

Mama, are some lions really nice or do all of them RAAAAAAAAWR?

Mama? RAAAAAAAWR! Did that scare you, Mama?

All those bedtime questions led to discussions that fluctuated between silly and serious, and while I don't remember most of them, there are a few that have stayed with me for the better part of fifteen-ish years. One of them has been playing on repeat in my mind the last several weeks.

When the writing part of my life started to gain a little traction, Alex was in early elementary school. I was blogging almost every day, and I was also doing some freelance magazine work. My main job was teaching high school English, but the opportunities to write were creatively fulfilling and also a whole lot of fun. It was incredibly humbling to get to do something I had loved doing for most of my life, and there were many days when I alternated between feeling unworthy to walk through the doors God had opened and then feeling overwhelmed by God's kindness.

Well, one night, as I read to Alex and then tucked him into bed, I was thinking through some of that. I was standing up to leave his room when he asked me a question: *Whatcha thinkin' about, Mama?*

Alex has always had a strange ability to tell when something is on my mind. I've decided it's because I do something weird with my mouth and my eyes when I'm preoccupied, but regardless, it's the most maddening thing when I'm trying to act like all is well and fine and good and then he calls my bluff.

It was no different when he was seven. So I sat back down on his bed and told him—in the most age-appropriate way I could come up with right there on the spot—how I felt incredibly grateful for the writing work I'd been able to do, but I struggled with feeling like I didn't deserve any of it. There was a moment when I thought, *Gah, maybe this is a little heavy for a first*

grader, so I tried to course correct by sharing An Encouraging Life Lesson. Something to lighten the mood, you understand.

"Here's the thing, buddy," I began. "It's so fun to have something you love to do. For me that's writing and teaching. And being able to use the gifts God has given you to love people and serve Jesus—all I know is that it is the most fun you will ever have. So when God opens new doors, you want to be able to walk through them and trust him with whatever's next. I guess I look like I have something on my mind because God has opened some new doors, and I'm trying to figure out if I have any business on the other side of them."

That long-winded answer seemed to satisfy the first grader, and he quickly fell asleep.

By the way, you might be delighted to know that I just asked Alex if he has any recollection of that conversation, and no. No, he does not. So clearly it only impacted one of us.

HOWEVER.

I continue to stand by what I said. Even though I was still making my way through Midian when I offered that impromptu bedtime perspective to Alex, I absolutely believe that when we use our voices and gifts for God's glory, that experience will be joyful. It will be life-giving. When we know who we are in Christ, how we're gifted, how to recognize opportunities for us to lead people with our gifts, and—this is big—we also know the Giver, well, those are huge pieces in the puzzle of a joy-filled life, my friends.

That doesn't mean it's easy, though. That doesn't mean that there won't be challenges and letdowns and maybe even some regrets.

And that doesn't mean we won't think *WHO? ME? I'M NOT SO SURE ABOUT THAT* when we know God's pointing us in a new direction.

● ● ● ● ●

A few chapters ago I speculated about why Moses may have been reluctant to leave Midian and head back to Egypt. We can't know for sure what was going through his head, but we can see based on how he responded to God that he wasn't entirely sold on the idea of shifting into something new. He was eighty years old, after all—with forty years of life in Midian firmly under his belt.

Then Moses was reluctant to confront Pharaoh and follow God's instructions to get the Israelites out of Egypt. Eventually he relented, of course, but we definitely have seen a pattern where God opened new doors for Moses, so to speak, and Moses' reaction was akin to *Um—I'm not so sure that I'm ready for whatever might be on the other side.*

So before we return to Exodus to see what happened next in Moses' journey with the Israelites, I want us to think about how we respond when we know what our gifts are, we're using our voices, we're leading as best we know how—and God makes it clear that he wants us to move into something new.

(For the record, I've done some very informal polling on Instagram, and as best I can tell, approximately three out of ten people actually enjoy change. That means that seven out of ten people approach change with some degree of wailing, teeth gnashing, and singing sixteen choruses of "And I Am Telling You I'm Not Going" from *Dreamgirls.*)

(Change has a public relations problem, methinks.)

So. How do we embrace the new thing well? Whether we're moving out of Midian or moving out of Egypt or moving to something new and different?

Earlier in the book I mentioned my friend Heather, who I've known since her daughter Caroline and Alex played four-year-old soccer together. My enduring memory of that soccer season is that Caroline was a goal-scoring machine while Alex excelled at looking for planes and examining grass, but the real win was that our families got to meet each other. We've been part of each other's lives ever since.

Heather and I worked together for the last seven years I was at school, and we left our jobs there at the same time. Heather wore several different hats during her tenure, but the last few years, she was an assistant principal in charge of curriculum and instruction. Anyone who worked with us would tell you that Heather is incredibly gifted administratively and interpersonally; she listens and communicates so compassionately, so intentionally, that it's almost impossible to walk away from a conversation with her without feeling seen, heard, and understood.

Heather would be the first person to tell you that the way she loves and leads is "no big deal," but I'm here to tell you that she's wrong about that. I have sat with her in meetings where the dynamics between people were complex—sometimes tense—and Heather's gift in those situations was to remain completely free of judgment while offering sincere, empathetic insight that helped us to resolve the issues at hand. I'm a few years older than Heather, but on more than one occasion I've thought, *Yeah, I'm pretty sure I want to be her when I grow up.*

Hanging out with Heather has become one of my favorite hobbies now that we don't work together, and not long ago we went to a Pilates class before we did a tiny bit of shopping and settled in for a long lunch at a restaurant we both love. We had just taken our first bites from the pimento cheese platter when I remembered something I had wanted to ask her:

"Hey—did you ever take one of those spiritual gifts quizzes when you were younger?"

"Yep—in my twenties," Heather replied. "I was administrative and teaching."

"IMAGINE THAT," I said and laughed.

Heather is now an assistant principal at a local elementary school, and I'll never forget one day last year when she told me that she loved working with younger kids more than she could have ever imagined. This moment etched itself in my memory

because 1) as you know, I am sort of afraid of little kids and 2) it felt like such a big change from Heather's years of working mostly with teenagers.

Since we were talking about gifts—and since Heather is someone who has led so beautifully in her personal life and in her career—I decided to do a little impromptu research.

I trust you understand that *research* is a generous term, because really it was a conversation over some pimento cheese and hummus.

"So," I began—very officially, of course—"how would you say that you've handled transitions with using your gifts and your voice and all that stuff? Because you've been in education for a long time, but in the last couple of years you've transitioned from working with teenagers to working with little kids."

Heather thought about that for a few seconds.

"You know, I think I just want to be able to take care of students, teachers, and families, so when my roles in education have changed, taking care of people has always been my priority."

I dipped a piece of carrot into pimento cheese as I listened.

"I started working as a school administrator when I was thirty-one, fresh off maternity leave and convinced that I wasn't qualified. But God has hard-wired me for connection—which I never really saw as a gift. But I knew I could connect with people, and I knew that I could connect people to each other. I guess that taught me that when unexpected doors open, I can trust that God has a reason behind it. I can walk through to the next thing, even if I start scared."

"So you learned to trust that he's going to fill your gaps," I said—then I paused. "And that's true even when you're working with kids?"

Heather nodded and grinned. "For one thing, I have the bandwidth for working with little ones now that there aren't

any little kids in my own house. Plus, I had just forgotten how elementary aged children are delighted about *everything*. You get so much daily interaction with them in a school setting, and they seek you out for it. I guess maybe I have the perspective that if I have an impact, it is going to be relational, and there was just an opportunity to love more people in an elementary school setting."

As Heather continued to talk, her voice filled with emotion.

"What has become important to me as a leader—and it's so important to me that children feel this—is the idea that it's okay to fail. It's okay to need help. It's okay to ask for help."

"So you're a safe place," I said.

"Almost *all* of my job is being a safe place. And I want every interaction that kids have with me—every single one—to feel restorative. Working with this age group, it's my sweet spot. I wouldn't have missed a single piece of the road, but this is where I hope I'll finish it out."

"I don't think you have any idea how fortunate those kids and teachers are to have you," I said.

"I don't know about that," Heather answered.

I do.

* * * * *

It would be lovely if we had access to some sort of formula for figuring out when it's time to transition into a new expression of the gifts God has entrusted to us. But based on my own experiences—as well as my conversations with Heather and other trusted friends who are committed to living and working in ways that reveal the heart and character of Jesus—I do think there are some common denominators that help us understand whether a new opportunity might be connected to our God-given purpose.

BEHOLD. A LIST.

1. I'm not entirely sure that I'm qualified, but I'm willing to start scared.
2. I feel affirmed—by past experiences, by people I trust, by prayer, by my own convictions—to pursue this new thing.
3. I believe that I can put my God-given gifts to good use in this new thing.
4. I believe that I can take care of people, improve people's lives, and genuinely love people in this new thing.
5. I believe that I can serve, lead, and love with joy in this new thing.
6. I can't predict exactly what might be ahead, but I know I don't want to miss it.
7. As best I can discern, there will be an increased measure of personal peace on the other side of this open door.

This isn't an exhaustive list, of course. And I'm certainly not saying this was part of Moses' evaluation when he was considering what God had asked him to do with the Israelites. We'll never know the specifics of that because nobody bothered to chronicle Moses' thought process for us. WHERE DO I FILE A COMPLAINT?

Bottom line: Is change hard? Yes. Is change sometimes scary? Yes. But good grief, change can also be so good. So worth it.

Recently I've been watching a show called *The Bear*, and I will wholeheartedly admit that episode seven of season two of *The Bear* made me full-on ugly cry. This is also a great time to mention that the language in *The Bear* is atrocious, so if you're bothered by all the iterations of the f-word, you may want to pass on the show and just stick with the f-word free summary I'm about to give you.

Another also. If you're a person who hates a spoiler and you think you may eventually watch *The Bear*, just skip this

very last part of the chapter and know that I'll see you soon in chapter 10.

Until then, my friend.

Episode seven focuses on a character named Richie, also called "Cousin" by the show's main character, a gifted chef named Carmy. Richie, while loyal, faces one battle after another: he's on the outs with the woman he loves, he's resistant to change, he's hot-headed, and he alienates people. He's forty-five and can't seem to get his act together. He isn't sure where he belongs.

For reasons Richie doesn't quite understand, Carmy arranges a week-long internship for Richie—a *stage* in restaurant terms—at Carmy's former place of employment, a restaurant that's regarded as "the best . . . in the world."[1] Richie wants nothing to do with it. He doesn't want to wear the restaurant's required chef's jacket, and when his first task is to polish forks, which he does with zero intention or care, he thinks his stage is because Carmy wants to punish him for being "ancillary"—a support person.

As he moves through his stage week, though, something remarkable happens. Richie notices the work of other so-called ancillary people. The excellence. The consistency. The attention to detail. He sees how every supporting staff member respects the bigger purpose of their role at the restaurant. Over the course of several days, Richie begins to appreciate the accountability, time management, and integrity that's required for the restaurant to operate at such a high level of excellence.

One night Richie shadows the restaurant's expediter, whose job is complex, intense, and intimidating. Richie stands in the background for a while, watching the expediter's every move, and then—well, something magical happens. Richie says, "I think I see the pattern," and as he starts to understand what the expediter is doing, it lights him up. Richie becomes a participant, not just an observer, and this gift isn't lost on him. He

immerses himself in being an integral part of a team instead of a jaded lone wolf, and it's transformative.

It brings a level of joy to Richie's life that he's been missing for a long time.

As Richie wraps up his week of staging, he's not so afraid of change anymore. He realizes that doing something he loves gives him opportunities to connect with people. To care for them. And when it's time for him to go back to Carmy's restaurant, he's ready to embrace his role with enthusiasm and a deep sense of purpose. He's ready to lead.

Change was an enemy—until it snapped him out of the complacency he'd lived with so long that he couldn't even see it.

Let's learn from Richie, everyone. Change may not be our favorite, but change is inevitable. So let's practice trusting God as he leads us to new places, teaches us new things, and asks us to use our gifts and our voices in unexpected ways.

It just might lead to the best, most joy-filled leadership adventure we never planned to have.

LOOK AT WHAT GOD HAS DONE

AFTER I WROTE *STAND ALL THE WAY UP* back in 2019, I suspected that David and I had some decisions to make. I absolutely loved my work with the girls at school, but I was beginning to question how much longer I was supposed to stay there. I worked with amazing people, not to mention a boss I would follow off a cliff, but I also had a strange, strong sense that the school chapter of my life might close sooner as opposed to later. Saying good-bye to my work at school seemed like a terrifying option to me (we can tackle that topic in a future break-out session entitled "Perhaps My Job Has Become An Idol"), but I also struggled to envision what it would look like to stay at school long-term.

For several years I had known that some issues that matter deeply to me would likely never be a priority where I worked (and listen—that is their prerogative; I would never expect the school or the church over it to accommodate me speaking out about what they don't support or believe). But did that mean I needed to quit? Was I growing disillusioned or jaded about some of the trickier behind-the-scenes dynamics in ministry?

Was I doing a disservice to the writing and podcasting side of my life by holding on to my responsibilities at school? Was it foolish to think that I could continue to juggle as much as I had for the last several years?

Clearly, I had some questions. I was hoping to find some answers.

In the summer of 2019, my friend and literary agent, Lisa, asked if I'd be interested in attending a writers' retreat focusing on ministry that goes the distance. The retreat, scheduled for late winter, was going to be in Orange County, California, so I checked with Shawn to make sure the dates didn't conflict with anything major at school. We worked out the calendar piece, I said yes to Lisa, and in late February of 2020, I hopped on a plane to southern California with all my unresolved questions about school and what might be next.

There were only about twenty of us at the retreat, and the first night, we enjoyed the most lovely, leisurely meal around a couple of large tables. After we cleared our plates, the delightful (and brilliant) Emily P. Freeman, our retreat facilitator, asked everyone a couple of questions. We broke off into smaller groups for discussion, and when Emily checked in to follow up on something I'd said earlier in the evening, we started talking through some of the school-related questions that had boarded the plane with me in Birmingham. After ten or so minutes of conversation, Emily—one of the all-time great question askers—clasped her hands and looked me straight in the eyes.

"What would it take," she asked, "for you to have peace?"

My answer was immediate.

"I would have to leave."

I called David the next morning and told him that we needed to figure out an exit strategy for my job.

To his credit, he said, "Okay. Let's figure it out." Which was really a much more encouraging response than OH MY GOSH WHAT ARE YOU TRYING TO DO TO US AND HOW DID

YOU JUST THROW A MONKEY WRENCH ALL THE WAY
FROM CALIFORNIA TO ALABAMA?

On some level I had never seriously believed that I would leave my job. But Emily's question went straight to the heart of my internal conflict. I adored the kids at school, but for several reasons, work-related peace had been difficult to come by. Telling David that we needed a plan felt like a big step—and it also felt like something had shifted in my heart.

Leaving wasn't an *if* anymore. It was officially a *when*.

And I couldn't imagine what life would look like if I really did walk away from a place I had loved so much.

●　●　●　●　●

When the Israelites started to leave Egypt, it must have been a sight to behold.

Egyptians rightly feared that further harm might be on the way (and after what they had endured during the signs and wonders, who could blame them for that?), so they "urged [the Israelites] to hasten their departure from the land" (Exodus 12:33). Given that, preparations to get the heck out of Egypt were hurried, and in addition to the mass of humanity—men, women, and children—there was livestock. There were kneading bowls filled with dough that didn't have time to rise before the Israelites' departure (12:34). There were clothes and jewelry from the Egyptians, who "let [the Israelites] have what they asked" (12:36).

Keep in mind that the Israelites had been enslaved *for a minute*. As I have recently learned, determining the *exact* number of years of their slavery in Egypt is a research rabbit hole, and should you choose to make that journey yourself, I pray that the Lord will bless your efforts. But for the sake of our time together, we're going to go with a rough estimate of four hundred-plus years.

So after being enslaved for over four hundred years—with every part of life determined by Egyptian reign—the Israelites

111

were suddenly free. Free from Pharaoh. Free from slavery. Free to go. Free to move. The prospect of liberation must have been a wonderful feeling.

And, without a doubt, it also must have been unsettling.

The reality, then and now, is that when you live inside a certain system for a long time, you grow fully familiar with that system's flaws and shortcomings. You figure out how to survive inside it. In the Israelites' case, they were living in a system that was oppressive and abusive, so they had a heaping dose of trauma on top of everything else they were dealing with. However, there's a strange paradox where we can grow almost comfortable inside spaces that aren't healthy for us—even when we logically know that we would be better off somewhere else. I can't pretend to understand the depth of this phenomenon from the Israelites' perspective, but I very much understand what it's like to prefer the devil I know over the one that I don't. Even in our everyday struggles, breaking free of what holds us can often feel like a whole lot of work, so we content ourselves with staying put.

Of course, it's important to note that for those four hundred years, the Israelites didn't have a choice about staying put. Slavery decided that for them. But I think we can all appreciate that as relieved as they must have been to finally get to leave Egypt behind, their emotions were likely complex. When you're accustomed to being bound, the transition to freedom can rattle you. Maybe even overwhelm you.

Together, though, the Israelites started their journey—as a group that likely numbered in the hundreds of thousands. And interestingly, the first thing the Lord wanted Moses to teach them had nothing to do with the chain of command under Moses or survival skills in the wilderness. The first thing the Lord wanted Moses to teach them was *how to remember*.

When the Israelites arrived at Succoth—their first destination after leaving Rameses—they celebrated Passover with the

Feast of Unleavened Bread. God had given Moses detailed instructions, and the Israelites "baked unleavened cakes of the dough that they had brought out of Egypt" (Exodus 12:39). Henry writes that "though these [cakes] were of course insipid . . . the liberty they were brought into made this the most joyful meal they had ever eaten in their lives."[1]

The unleavened bread connected the Israelites to the land where God brought about their deliverance, and "the Feast . . . [connected] mind and action. Memory and worship."[2]

The journey ahead would be a long one for the Israelites, and the human tendency for forgetfulness, particularly regarding the Lord's provision and mercy, would no doubt show itself. So as Moses gave the people instructions for the Feast of Unleavened Bread, he reminded them of what God had promised to do for them and that they should "keep this observance in this month" (Exodus 13:5). Moses went on to share how the Israelites should celebrate the Feast with their families going forward:

> You shall tell your child on that day, "It is because of what the Lord did for me when I came out of Egypt." It shall serve for you as a sign on your hand and as a reminder on your forehead, so that the teaching of the Lord may be on your lips.
>
> Exodus 13:8–9

Only a couple of days before this first Feast of Unleavened Bread, the Israelites had been slaves. But then they were free.
God did that.
And he wanted them to remember.

⬤ ⬤ ⬤ ⬤ ⬤

In the interest of overexplaining, I want to tell you that I've done a little second-guessing about how to illustrate the overlap

in our Old Testament and current day Venn diagram. Clearly my story about deciding to leave my job is borderline insignificant compared to the magnitude of the Israelites leaving Egypt. But as much as I've debated with myself, I'm sticking with my original instinct because in the weirdest way, the Great Big Leaving in Egypt has given me some perspective about my Little Leaving here in Birmingham. Maybe it'll do the same for you and your Little Leaving(s), too.

A week after I returned home from California—and a week before we all went home for COVID—David and I sat together during a school assembly I had asked him to attend with me. It was the first time we had done that in all my years at school, but I felt particularly convicted that whatever the message was going to be that day, we needed to hear it side by side. Those forty-ish minutes were enormously confirming in terms of moving forward with our exit plan, and as David and I talked through what that would look like, we both landed on the same idea: I would leave my job when Alex graduated from high school in two years.

Then, not even a week later, school shut down, and what we thought would be a two-week break turned into—well, *you know*. You lived through it, too.

Like most of us, I spent the first part of the lockdown worrying about COVID and trying to figure out how to be productive at home. Over time, though, our family settled into a rhythm of working and going for walks and cooking and meeting friends outside and not living at a stress level set to CAN ANYONE HEAR MY HEART BEATING OUT OF MY CHEST. Of course we wouldn't have ever chosen the circumstances that led to us being home—no one would—but in spite of the difficulties, it turned out to be five of the most instructive months of my life.

When I returned to school the following August, the pace of doing pretty much everything differently made for workdays

that felt like Cuckoo McChaos. We started the school year at a sprint and didn't slow down until Christmas. My anxiety was through the roof, and in January I realized that every time I pulled into the parking lot, I couldn't take a deep breath. It's hard to explain—because my years at school brought me so much happiness—but it was almost like my body was saying *Hey. You have to get out of here.*

And then, one morning in late January—for no discernible reason—I looked up from my computer, checked my (way too high) heart rate on my watch, and spoke out loud to a completely empty office: "I don't belong here anymore."

The very next week—the first week in February—I was on a late afternoon Zoom with my podcast partner and ride-or-die friend, Melanie, and our business manager, Retha. I thought the purpose of the call was to set some yearly goals, but in the last ten minutes of our call, Retha very nonchalantly said, "Hey, Soph—I have some questions for you. Write them down, and then you and David can talk about them."

I grabbed a notepad and a pen. The first two questions were related to staying at school another year—Retha had certainly been privy to all my thoughts and feelings about that—but when she asked me the third question, it was like she yelled it into a canyon: "Are you ignoring clear signs from God that it's time for you to go?"

Did you hear that echo?

I'm pretty sure I can still hear that echo.

That night David and I talked through Retha's questions, and within twenty-four hours, we had decided: I would leave school in May. In three-and-a-half months. Our decision brought both of us total and complete peace that it was the next right thing, even though I knew that saying good-bye would be terrible. After all, it was a place filled with people who had been a huge part of my life, who had impacted my family and my faith in more ways than I would ever be able to count.

Surprisingly (at least to me), we never wavered in our decision. In fact, late that April I was sitting behind my desk at lunchtime, and there were probably ten junior girls who were eating lunch in my office. They were sprawled out on the sofa, propped up against one another on the floor, and perched on the edges of the bright yellow stools that lined the wall. It was one of those days when everything struck the girls as absolutely hysterical, and the sound of their laughter completely drowned out any possibility of conversation with my friends Heather and Steph, who were sitting in chairs across from my desk. That kind of environment was one of the very best parts of my job—watching girls laugh together and enjoy the silliest parts of each other's personalities.

And as I sat there and took in the sight before me, along with the realization that it was likely one of the last times I'd see those girls in that kind of context, I thought, *I love this so much. And I still know that it's time for me to go.*

Here's why I tell you all of that.

We can look at a historic, world-changing event like Moses finally leading the Israelites out of Egypt—the Israelites finally being free—and think, *Well, of course God was clear with them. There was a huge number of people involved, and they were his chosen people who had been enslaved. They were incredibly vulnerable. Plus, God spent eighty years preparing Moses for the task. It makes total sense that everyone's instructions were really specific, right down to their remembering. Big Old Testament vibes with all of that.*

But I want you to consider something.

As leaders and believers, it's easy to assume that God won't be as direct with us when it's time for us to move on from a longtime something-or-other in our lives—whether that's a job or a ministry role or a church or even a relationship, though I am not about to get all up in your personal business. And I'm not necessarily talking about having your head turned by a new challenge on the horizon like we discussed in the last chapter.

I'm talking about not necessarily knowing what's on the other side—but still closing up shop. Watching the end credits. Handing over your keys. Wondering what in the world life will look like on the other side.

So often we content ourselves with thinking, *Well, I don't need to do anything disruptive. I'll just stick it out right where I am. At least this place is familiar.*

It's almost like we forget that we can expect direction from God. Provision from him. In particularly tough situations, just like the Israelites, we forget that we can expect *deliverance* from him. But we can.

And I believe this with everything in me: when it's time to go, God will make that clear. If you still feel uncertain, hold on. Be patient. Because he'll continue to make it even more clear. He's not going to let you stay in a place where you've grown comfortable if it's really and truly time for you to leave.

It's not always easy, but sometimes the most courageous way to use your voice and your leadership is to say four very simple words: "It's time to go."

●●●●●

The Lord gave Moses three sets of instructions to commemorate the Israelites leaving Egypt: first for Passover, then for the Feast of Unleavened Bread, then for the Consecration of the Firstborn. These practices were signs of remembrance, a means of testifying that "by strength of hand the LORD brought us out . . ." (Exodus 13:16).

The Lord made it clear that remembering would be an active part of his people's lives as they moved away from all they had known and moved forward in their deliverance. And what God did next—well, it continues to provide so much assurance as we navigate change and transition all these thousands of years later.

Concerned that the Israelites might turn and go back to Egypt if they encountered war, God didn't want them to have to travel through the land of the Philistines. So instead of heading east out of Egypt, their initial movement was to the south. On paper it's a puzzling approach—sort of like traveling from Missouri to Maryland but going to Louisiana first (and maybe a little bit like American Airlines plans its domestic flights). Scripture even tells us that their route was a "roundabout way" (Exodus 13:18).

Life feels that way so often, doesn't it? But I'll tell you what: the Israelites' way was deliberate, and that way was purposed. The same is true even now.

Eventually the Israelites left Succoth for Etham, where they would camp, and "the LORD went in front of them in a pillar of cloud by day, to lead them along the way, and in a pillar of fire by night, to give them light" (Exodus 13:21). So while the Israelites were definitely on an unexpected journey and traveling a "roundabout way," the Lord made sure they could *see*. Day and night he went before them, and he never "left [his] place in front of the people" (13:22).

As the Israelites moved out of Egypt, the Lord seemed to have two main priorities: 1) teaching them to remember and 2) helping them to see.

It makes me teary-eyed when I think about this. Because it's not just that God did this for the Israelites—it's that we can still trust this very same God to do the very same for us. Right now. What was true in the Great Big Leaving for the Israelites is still true in all of our Little Leavings. We can remember what the Lord has done, and we can count on him to help us see.

It's been almost three years since I said good-bye to something that was a massive part of my life. The adjustment to life away from school has been a mixture of bitter and sweet, and I was not at all prepared for the amount of emotional and spiritual untangling I would need to do on the back side

of twenty-plus years of vocational ministry. But sometimes, if we want to be women and leaders who go the distance, we have to be willing to change our route. Maybe even to go a "roundabout way."

And in moments when I've been tempted to focus more on the bitter than I should—or when I've been tempted to wonder if the years I spent in that place did any lasting good at all—the Lord has been so kind to point out the sweet: to comfort my heart with the most wonderful memories, to remind me of all the works and wonders I saw him do in the lives of those kids and their families. It was an incredible gift to continually bear witness to his kindness and his care.

By God's grace, I'll never forget it.

I'm still figuring out exactly what it looks like to move forward. But the Lord's guidance—his light—has gone before me every step of the way and has helped me to see: in the deciding, in the leaving, in the grieving, in the missing, in the healing, and in the remembering.

Our God is trustworthy and true.

And by God's grace, I'll follow him as long as I live.

WHEN YOU HAVE TO
LOOK OVER YOUR SHOULDER

IT WAS EARLY IN THE MORNING—a little after six—when my phone alerted me to a text from a friend on the writing side of my life. Over the course of a decade or so, I had discovered that this friend was someone who sees the intersection of the Gospel and the issues of everyday life in many of the same ways that I do (that is to say, she is not someone who regards "the culture" as a Christian's great big enemy). I also knew this friend to be a fierce champion of women and their gifts, and because of that, I have always appreciated having the chance to talk with her about creativity and literature and maybe even sentence structure because NERDS ARE GONNA NERD, good people.

At the time, my friend and I were both paying close attention to a scandal involving a seminary leader, and when the story became public, there was quite a bit of coverage in the national press and on social media. I don't feel like the finer points of that scandal are mine to share since I wasn't a direct participant,

but on a broader scale, the heart of the allegations was that the person had mishandled allegations of sexual assault that were reported to him. He also had a history of speaking about women—and rape—in a way that raised red flags with me, so I was interested to see how the institutional situation played out.

And, as it turned out, he was the subject of my friend's early morning text.

The trustees of the board at this institution were considering consequences against their leader because of the scandal-related issues. I believe the hope among many people was that the trustees' actions would communicate deep care and compassion to women in general and to victims of rape, assault, and abuse in particular. I'll resist the urge to run all the way down this rabbit trail, but when it comes to how we handle matters within the church (and organizations connected to the church), I always think of Romans 12:10: "love one another with mutual affection; outdo one another in showing honor." When someone isn't loved and honored—when we refuse to see the depth of someone's pain, especially in their most vulnerable moments—we have missed the mark. We have neglected our call.

So.

My friend wanted me to know that in light of the trustees' upcoming meeting, a group of women within that denomination—of which I was a member at the time—had put together a letter petitioning the trustees to take action against their leader. My friend told me that she had reason to believe that the letter would receive attention from the board, and she expected that the signatures on the letter would become public. If I wanted to sign, she added, she just needed to know by eleven o'clock that same morning.

I thought about her text for the next four hours. In the interest of being as direct as possible, here's a list of what was running through my mind:

1. I very much appreciate that a group of women want to do what they can to make their voices heard. But.

2. If women are having to write a letter asking a board made up solely of men to do the right thing, then that raises a question: why are there no women at the table?

3. If the only recourse women have in this situation is to *write a dadgum letter*, I'm not so sure that the powers-that-be are very interested in hearing a woman's perspective.

4. How can an organization or institution care for women well—or even adequately—if women don't have representation at the highest levels of leadership?

5. If I want to sign a potentially public document that challenges the leadership of an institutional head within my own denomination, then I probably need to get clearance with the leadership of the school where I work and the church over it. Which means I need to ask the men in charge for permission to publicly stand with other women.

6. This is all maddening.

7. I give up.

I didn't actually give up, of course. I continued to consider the options. But it wasn't lost on me that four hours of trying to figure out how to navigate a system that excludes women from decision-making was exhausting, and I was just an observer in this instance. I wasn't someone who had been mistreated by a leader who I might assume would be quick to protect me.

In the end I didn't sign the letter, in part because I didn't have time to make that fifth thing on the list happen (we can get together later and ponder the irony of needing to ask the patriarchy if I could please make a public plea to the patriarchy), but mainly because I was so deeply troubled by the power

structure. If women didn't have a legitimate say in the institution's issues—and when it seemed to me that the institution's leadership had been initially dismissive and reluctant to act on behalf of the female victim—then it was hard to understand how a letter from a group of concerned women would make any difference. It has taken me a long time to come to this conclusion (and certainly you are welcome to disagree), but when women don't have representation in leadership, then that leadership structure seems likely to fail at least part of the population it's set up to serve.

In the interest of clarity—and issues with women's representation in leadership aside—I want to make sure to point out that the trustees did take action. About three weeks after my friend told me about the letter, they removed the man from his position—with pay—and offered him another role at their institution. Soon after that, news broke that another woman who had been sexually assaulted had come forward with details about how the same man responded to her at a different institution many years prior. At that point the trustees fired him.[1]

And if you're someone who thinks, *Well, justice can be slow, and ultimately, that was justice*, I guess I can sort of understand where you're coming from.

But mostly I just think—even now—that when an institution's primary objective is to protect itself over anything else, Jesus has likely left the building.

And I wonder, as Christian leaders work to address situations where people have been emotionally, spiritually, or physically abused, does the church look more and more like Jesus? Or more and more like Pharaoh?

●　●　●　●　●

The weird thing about oppression is that you can't always see it for what it is when it's happening. Maybe that's because

you're so deeply immersed in a culture or a system that the oppressive behaviors just feel normal. Maybe it's because you've conditioned yourself to look past it. Maybe it's because you've been gaslighted within an inch of your life and people have convinced you that certain rules, policies, or procedures are in your best interest.

But most of the time, after you've been set free of it, you know you don't want to go back to it. You know you don't want to be under its authority or influence if there's any way to avoid it.

In Exodus 14, the Israelites were likely feeling upbeat about their movement away from Pharaoh and Egypt when the Lord gave Moses what I assume would have been very unexpected instructions: "turn back" (14:2).

Um—excuse me, beg your pardon?

The Lord had his reasons for sending the Israelites in the direction of the Red Sea instead of Mount Horeb. He knew that Pharaoh would think that "Israel's divine help had run out and that they were hopelessly entangled on a dead-end trail. . . . God, however, had commanded Moses to take this impossible route to show the Egyptians once more that he was God."[2]

Meyers echoes this idea when she writes, "God's purpose [was] clear. The Egyptians [would] fail in a spectacular way."[3]

And listen. God is God. He can move as he sees fit. But this is one of those instances when, as much as I know that God was about to put his power on magnificent display, the logistics feel like a whole lot of trouble to me. Also, God, *this might have been slightly overwhelming for the Israelites.*

Naturally, though, Pharaoh took the bait, and his reaction was the essence of erratic leadership. He and his officials completely second-guessed their decision to let the Israelites go, and they rounded up their chariots and their army to chase after the people they released, like, six and a half minutes ago. Matthew Henry speculates on Pharaoh's change of mind: "he

either forgot, or would not own, that [the Israelites] departed with his consent, and therefore was willing that it should be represented to him as a revolt from their allegiance."[4]

Pharaoh's gonna Pharaoh, I reckon.

What happened next breaks my heart, because initially it seems like such a harsh 180 from all the promise and hope the Israelites experienced just a few verses before. Scripture tells us, "As Pharaoh drew near, the Israelites looked back, and there were the Egyptians advancing on them. In great fear the Israelites cried out to the LORD" (Exodus 14:10). Then they questioned Moses: "What have you done to us, bringing us out of Egypt? Is this not the very thing we told you in Egypt, 'Let us alone and let us serve the Egyptians'? For it would have been better for us to serve the Egyptians than to die in the wilderness" (14:11–12).

I understand that I am hopelessly human and all, but I cannot think of anything more terrifying than finally escaping my oppressor, only to find out that I'm being pursued by my oppressor again. Even worse: realizing that I might have to face my oppressor. Fight my oppressor. Die at the hands of my oppressor. Especially if I was still trying to wrap my head around the whole concept of being free. Meyers asserts that the Israelites' reaction "is inevitable. It is the normal response of people who are embarking on a journey away from the familiar, however abhorrent it may be, into the unknown."[5]

So it's interesting to me, in light of the fact that the Israelites were straight-up terrified, to consider Moses' response to them: "Do not be afraid, stand firm, and see the deliverance that the LORD will accomplish for you today; for the Egyptians whom you see today you shall never see again" (Exodus 14:13).

And then, Moses uttered one of the most famous verses in the Bible: "The LORD will fight for you, and you have only to keep still" (Exodus 14:14). Don't miss the fact that as he calmed the Israelites, Moses very specifically connected their

hope to their sight. *Look and see, everybody. Watch what the Lord is going to do.* Meyers expounds on this idea: "There is a military threat, for the Israelites face an incredibly powerful army; and they are about to see God's presence manifest in an act of astonishing redemptive power."[6] Moses essentially asked the Israelites to fight through the tension of what they could see in that moment and what he believed they would see from the Lord. The prospect of radical deliverance contrasted sharply with their immediate challenges, and Lord have mercy if that doesn't also ring true over thirty centuries later.

Right after Moses' assurances, God began giving instructions and "immediately [engaged] Moses in the task at hand."[7] There's really no substitute for reading the sequence of events as they're laid out in Exodus 14, but if you're willing to temporarily content yourself with an Alabama-flavored summary of verses 15 through 29, here you go.

God told Moses that the Israelites should get after it and go. He had every intention of showing Pharaoh and his army who he was and what he could do, and Moses' staff was going to play a big part in that process. So with the pillar of cloud between the Israelites and the Egyptians, everybody headed in the direction of the Red Sea. When they arrived at their destination, Moses, staff in hand, stretched his hand over the sea, and as my Papaw Davis would have said, God kicked up a real good wind. That wind blew all night, dividing the sea, and the Israelites were able to cross on dry land—a wall of water on either side.

As you might expect, the Egyptians followed the Israelites— crossing over was working out so well for their former slaves, after all—but in the morning light the Lord disrupted their travel plans. The Egyptians found themselves unexpectedly bogged down in the mud, and while they wanted to get the heck out of the bottom of the sea, their chariots wouldn't cooperate.

That's when the Lord gave Moses his final set of Red Sea–related instructions: *take your staff and stretch out your hand again.* The sea gradually returned to its normal depth, and in the end, not a single member of the Egyptian army survived.

In that moment, Moses would have been perfectly justified to pound his chest and address the Israelites with this four-word phrase: I TOLD YOU SO.

And no doubt about it—the sense of freedom represented in the final verses of the chapter will bring tears to your eyes:

> Thus the LORD saved Israel that day from the Egyptians; and Israel saw the Egyptians dead on the seashore. Israel saw the great work that the LORD did against the Egyptians. So the people feared the LORD and believed in the LORD and in his servant Moses.
>
> Exodus 14:30–31

Say it with me, everybody: *they saw.*
The Israelites saw the demise of their oppressors.
They saw the end of their oppression.
And they saw the power of their God.

• • • • •

It may sound strange, but do you know what my reaction is when I read Exodus 14? *There's leadership all over that passage of Scripture.*

Seriously. FOR DAYS.

Now clearly God is a strong candidate for MVP with that whole parting the waters business. But let's take a minute to consider what's going on with the Israelites and Moses, too.

The Israelites traveling with Moses hadn't known much life apart from oppression. They had only recently left Egypt. And while they were terrified by the prospect of having to deal with

Pharaoh again, don't miss this: they cried out to God in their fear, then went straight to Moses. They told him how they honestly felt—no small feat when trauma had dictated the terms of their lives—and when Moses heard their concerns with compassion and spoke to them with hope, get this: they believed him. They took him at his word. They were, somehow, still willing to trust.

This blows me away. Because if I had been an Israelite in this same situation, I can see my personality turning in one of three directions: 1) rebellion, 2) anger, or 3) surrender.

With option one, I'd basically try to burn it all down—maybe rally some fellow Israelites and charge the Egyptians and let the chips fall where they may. But having to deal with my oppressors coming after me again? Nope. Hand me a sword or a stick or whatever. *I'm sick and tired of all y'all.* And while it would be unwise—not to mention the end of me—I would be tempted to direct every bit of my fear and frustration and weariness in their direction.

With option two, I'd mostly be ticked. Furious with God, furious with Moses, furious with Pharaoh and his cronies. Furious with what could very fairly be considered an unreasonable amount of despair and heartache for any group of people to endure. Would I have followed Moses' instructions? Maybe. But no way would I have been a team player with anger running the show. Nobody would have handed me a certificate of recognition for Best Attitude.

And with option three, I imagine that I'd just take a seat. You could look for me sitting crisscross-applesauce on the shore of the Red Sea. End of my proverbial rope. The prospect of having to muster strength and courage one more time would have been more than I could handle. As my friend Melanie likes to say, that would have been a fantastic opportunity for me to rest my eyes and wait for death's sweet embrace. All done, thanks.

This is why I think the way the Israelites react to the reality of Pharaoh being the actual worst is remarkable. Scared but

not afraid to trust. Not afraid to listen. Not afraid to move. And ultimately, not afraid to *see*—to behold God's faithfulness on their behalf.

So all of that is a real lesson for me.

And as we continue in our Leadership Master Class, let's not forget about Moses.

First of all, he didn't question God when God told him that the Israelites needed to turn back. As someone who is a Certified Impatient Individual, I can only imagine that my (very prideful) reaction would have been something along the lines of *Dude!* (side note: I don't know that I have ever used the word *dude* in conversation, but let's run with it) *Are you kidding me right now? These people are at their limit!*

But Moses, to his credit, didn't try to escape responsibility or use his tried-and-true argument that he wasn't a very strong speaker. We know that he was obedient to the Lord's request because of one short sentence at the end of Exodus 14:4: "And they did so."

Then, when the Israelites looked back and saw the Egyptians gaining ground, they challenged Moses with questions. He could have shamed them, belittled them, gaslighted them, or ignored them. But his character matched the heart of his Heavenly Father, and in addition to the fact that Moses comforted the Israelites, he used his voice to give them *vision*. In the most sincere way, he reminded them of what—and who—they could believe and trust.

More of that in the here and now, everyone.

When they arrived at the Red Sea, Moses did exactly what God had asked him to do. His obedience resulted in life for God's people and some very significant consequences for their oppressors.

If you feel like I'm stepping across a bridge too far, just raise your hand and we can talk it out, but I can't help but think how fantastic it would be if we could expect a similar kind

of response from our modern-day leaders in situations where our brothers and sisters have been oppressed or victimized or abused. Doesn't it seem reasonable to expect that when people's lives have been marked by trauma, the church would rush to their aid and care for them as unto the Lord—and that we wouldn't relegate decisions regarding that care to a committee made up only of men?

I understand that within different denominations there are nuances to all of this, but I'm Officially Weary from too many instances of people suffering at the hands of oppressors inside the church. Obviously, it happens in all sorts of institutions, but the fact that it happens in the church SHOULD NOT BE A THING. It's equally horrific when someone who has been abused or assaulted or mistreated looks to the church for help, and they're told, for example, that they should have been more loving to someone who hurt them, or the church seems to prioritize the restoration of the abuser over care for the abused, or a woman has to share details of her sexual trauma in front of the elders—who are only men.

Those are not hypothetical situations. So while it feels like I shouldn't even have to say this, the church must do better here. Our response to these situations should look different from the rest of the world because of who our ultimate leader is. Claiming the name of Jesus as Savior means we care for people in his name and under his authority. That should mean something to us. Our leadership should follow his example.

And don't even get me started about churches that ask victims to sign nondisclosure agreements. Because I will curse, and I'm trying to behave.

Even still, I continue to believe this with everything in me: our God still wants to make a way for the oppressed. Maybe we won't get to bear witness to the full Old Testament experience, but he remains a way-maker and a sea-parter for his children.

Also.

If we're going to claim him as the Lord of our lives—if we're going to name him as the One we follow—we'd better be dang sure that we're on the right side of that pillar of cloud and fire. That we're about the work of deliverance and not complicit in oppression.

When an institution has done the wrong thing, we're not responsible for protecting it. We're responsible for protecting the *victims* of the institution's policies and practices. Given the way-too-many instances where that hasn't been the case—where believers and so-called leaders have sadly resembled Pharaoh and his army chasing after people who have endured enough already—Amos 5:24 strikes me as a fine place to close: "But let justice roll down like waters, and righteousness like an ever-flowing stream."

BEHOLD THE TEAMWORK
MAKING THE DREAM WORK

I DIDN'T EXPECT that dinnertime would hit quite so deep.

At the end of last year my husband, David, and I invited some family friends to come over for what I like to refer to as A Big Ole Country Supper. Usually this means that I'll cook some sort of meat—I think on that night I fried chicken—but typically the stars of the show are the vegetables. This was how my mama, Ouida, and her mama, Lucy, planned and prepared big meals, and as much as I can, I love to get in my kitchen and pay tribute to their menus, their methods, and their flavors. They were gifted at all of the above.

Before our friends arrived, I gathered my ingredients and did my best to channel my inner Ouida and Lucy. I cut corn off the cob, sautéed it in butter, and covered it with seasonings and a little heavy cream. I boiled squash with Vidalia onion, then combined butter, sour cream, and cream cheese to make

Mama's squash casserole recipe. I nursed a pot of collard greens for the better part of the afternoon, always making sure to add another dash of hot sauce, another teaspoon of red wine vinegar, or another sprinkling of red pepper flakes when I lifted the lid to check on their progress.

Now that I think about it, that's precisely why, when I served the collard greens, I had to give our guests a warning: *Enjoy, everybody, but know that these collard greens will LIGHT YOU UP.*

On top of all that, there was a pot of baby Lima beans, a couple pans of rolls, and Mamaw Davis's homemade chocolate pudding for dessert. We had ourselves a post-Christmas, almost-New Year's Day feast, and it was delicious. However, as is almost always the case, the food paled in comparison to the company. We laughed until we wheezed, which is always my personal gauge for knowing that a fine time was had by all.

After we cleared the table, we settled in for what Mama would have called "a good visit." I sat down on the den sofa with our friends' college-aged daughter—we'll call her Olivia—and as is my tendency, I started asking her questions. *What was the biggest surprise of the semester? What was the hardest part? How have friendships been? When you think back on high school, what prepared you for now? How do you wish you had prepared differently?*

Oh, listen. I'm a real Anderson Cooper in conversational settings. I can't stand small talk, so when I know somebody well, I don't have much patience for your standard-issue pleasantries. I love to hear what people are learning, who delights them to no end, how their perspective is growing or changing in a certain area, what epiphanies they've experienced since our last heart-to-heart—you get the idea.

We eventually started talking about different campus organizations and how Olivia was hoping to participate in them, and I said something along the lines of *WELL DONE—you*

know I love to see some leadership! She grinned and then was quiet for a few seconds before she responded. The gist of what Olivia said was this.

You know, I've been in Christian settings all my life. I grew up in church. I've been in Bible studies. I've taken Bible classes. But I don't remember—not even one time—talking about what leadership looks like for women. We always talk about leadership in connection with men, but what about women? Women are leaders. I'm a leader!

And she was right. She is absolutely a leader.

But if you don't think the church can get REAL WEIRD about women and leadership, look around. And you might want to begin your research on Twitter (I know I should call it X, but I am standing my Twitter ground).

I continued to think about Olivia's words when I was cleaning the kitchen later that night. At her age I didn't think much about leadership at all, but when I was quick to shoot for the tree limbs as opposed to the stars, my daddy was the first person to challenge me and offer a reminder that I could accomplish anything I put my mind to do. I don't know that I took his words to heart—I mean, when you're nineteen and on the receiving end of a parental pep talk, the vibes can get a little *Afterschool Special*-ish—but looking back, there's no question that Daddy's refusal to set a single limit on my potential was incredibly impactful. It wasn't until my late twenties that I experienced any sort of inner determination to do whatever good I could in whatever ways I could, but I am quick to give Bobby G. Sims his due credit for that development.

By the way, my daddy is ninety-two now, still sings in the choir at church, and plays golf at least three times a week, so clearly the *G* stands for GOAT.

I'll tell you something else I've thought about a whole lot lately, whether it's because we're about to celebrate our twenty-seventh wedding anniversary or because I'm writing

this book or because I'm increasingly tenderhearted in my old age: David Hudson is the most effortlessly supportive man I know. We had no idea when we got married that I would write books one day. We had no idea that there would be something called social media where I would be active and also vocal. But I'm telling you: every step of the way—every curve in the road—he has been my biggest cheerleader and fiercest advocate. He is not threatened by the fact that my work is more public-facing than his. I have never been his competition. And while for sure we have navigated bumps in our marriage—everybody does—one thing I have never doubted is that the two of us are a team. Whatever is ahead of us, we will lock arms and survey the landscape and talk it out and figure out how to move forward together. That's been true in his work life, in my work life, in parenting, in unexpectedly needing to replace most of the plumbing in our basement, which is a real thing that just happened—you name it. We're gonna handle it together.

And I guess it's because of the good, strong, not-one-bit-threatened men that I know—Daddy and David and Barry and Travis and Shawn and Joey and Joel and I could keep going—that I'm legitimately shocked when I encounter men (and honestly, sometimes women) who actively oppose women leading and using their voices at their full potential. I'm also puzzled by the anger and resentment that sometimes saturates their disapproval.

It's tricky. Because yes, denominational preferences, doctrinal differences, etc. I get it. But meanness and condescension should never enter the chat.

And I really don't know how to express how hard it's been to process the vitriol I've witnessed—especially online—from people who would consider themselves godly and faithful, so I'll throw out this question and see what y'all can come up with.

Hey, everybody—what's up with all the hate coming from people who profess Jesus?

And, if I may, one more question:

Why are they so afraid?

• • • • •

Miriam, if I may say so myself, was a bit of a rock star.

We know, of course, how she looked after her little brother Moses when he was floating down the Nile in a basket. But she was also with him as he led the Israelites out of Egypt.

In Exodus 15—with all the Israelites safely on the other side of the Red Sea—they began to sing. *Asbury Bible Commentary* offers perspective on the significance of their worship: "The first person pronoun occurs eight times. God, who [had] been abstract and impersonal, [had] acted personally for them. The Maker of the universe [was] indeed their personal God."[1]

This passage of Scripture also marks the return of Miriam to the Exodus narrative—and she returns as a leader. In fact, she "is also referred to as a prophet, a title which recognizes her role in speaking to and shepherding the Israelite people through the wilderness"[2]—a woman of "prominence, power, and prestige in early Israel."[3] Miriam led with song and tambourine, and I don't want to overstate it, but I think that might make her the first female worship leader in the Bible. In Exodus 15, Miriam, Moses, and the rest of the Israelites offer such a beautiful picture of what the posture of our hearts should be when we have seen God move on our behalf. We should sing about what we've seen him do. We should testify to his strength and power. We should *worship*.

So it seems fitting—and inspiring—that the Israelites' first corporate act after their deliverance across the Red Sea was to praise God. That's our big picture and big perspective from Exodus 15.

Some of the finer points of the narrative are interesting as well. There's lots of commentary about the structure of the verses in Exodus 15—Google can help you locate all manner of treasures—and if you are a word nerd like I am, you'll be intrigued by what you find. There's also a theory that I've seen pop up in a few different places, and it has grabbed my attention for sure. It's about the authorship of the song the Israelites sing, and if you had been in any of my Shakespeare classes in college, you would know that this kind of thing fascinates the fire out of me.

In some of our Bible translations, the heading above verses 1–19 of Exodus 15 says, "The Song of Moses." Then, above verse 20, a different heading: "The Song of Miriam." So most of those verses are attributed to Moses, and just the end is attributed to Miriam. I've read several sources that propose that Miriam was leading what's called an antiphonal response (true story: I didn't know how to pronounce *antiphonal* until I said it wrong earlier today and my choir teacher friend Kasey very kindly corrected me), but there are definitely scholars out in these hermeneutical streets who believe all signs point to Miriam as the author of the whole song in verses 1–21.

Phyllis Trible asserts, "Contrary to the impression that her one stanza sung at the sea is but an abridgment of the lengthy song attributed to Moses, historical and literary studies show that the latter version is itself the Song of Miriam,"[4] and Carol Meyers notes that "the poem was Miriam's before it was Moses'."[5] Not everyone agrees, of course, and we're not here to definitively settle this piece of biblical scholarship.

But. After everything I've read, I'm persuaded. It's totally fine if you look into this idea and you're not. Because the bottom line is that whether the song originated with Moses or with Miriam, both of them—man and woman, brother and sister—used their voices to lead the Israelites in singing words of liberation, words of hope, words of praise.

Both and. Not *either or.*

The Israelites had prevailed against Pharaoh, against his army, and against a great big sea. And when they gathered to worship the God who delivered them, a man's voice wasn't the only one they heard.

The church needs the voices of both men and women in leadership. Different gifts. Different strengths. Different capacities. Different strategies. And according to Tony Evans, Miriam—referred to as *prophet* in verse 20—shows us that "even in the early biblical witness, women were not marginalized but were critically involved in the kingdom program of God. Thus, the church must celebrate and encourage them."[6]

Amen, Tony Evans.

And thank you, Miriam, for blazing the trail.

● ● ● ● ●

Kasey had barely sat down at dinner when she practically yelled at me across the table.

"YOU HAVE TO SEE IT," she said, eyes as wide as the basket of cheese biscuits sitting between us.

Before she met me at a local barbecue place, Kasey had gone to see *Barbie* with her teenaged kids. It was the movie's release day, and while I had certainly heard lots about it, I didn't have any intention of seeing it. I love movies, but theaters can be challenging spaces for former teachers who like to control noise levels and phone usage and unsolicited commentary. Don't even get me started about the people who believe a quiet theater is an ideal spot to unwrap pieces of candy for the better part of forty minutes.

"I don't want to give away anything," Kasey continued, "but I think it ties into what you've been writing. I really do. I'll go see it again whenever you want to go."

A couple of days later, I met Kasey, her mom, Marsha, and our friend Retha at our neighborhood AMC for a Saturday matinee. We ended up sitting in front of our friend Angelia and her daughter Savannah, and let me tell you: the pre-show conversation got real deep real fast. Most of us have spent many years in vocational ministry, and all of us want to see women empowered and encouraged to fully exercise their gifts. I told them about this chapter—about how I had been deep in the weeds with Moses and Miriam and the song of the sea—and that launched us into a discussion about leadership structures and control and leadership and how one thing you can depend on with God is that he will always—*always*—come for our idols. It was a whole Bible study lesson right there in auditorium number eight, and I was a little sad when the previews started in full force because we had to stop talking.

What I did not anticipate, however, was that *Barbie* would have a word for all of us.

I guess my primary expectation for *Barbie* was that it would be some sort of girl power extravaganza—entertaining but likely fluffy. After the movie ended, though, I realized how wrong I had been. Yes, it was funny and silly and maybe more critical than it had to be of men who enjoy a certain level of power. Mostly, though, it was nuanced. Thoughtful. And, well, *true*. I don't want to ruin the movie for you if you haven't seen it, so just be aware that the next several paragraphs are chock-full of spoilers.

There's a scene about midway through the movie when Barbie walks confidently into a board meeting that's exclusively (and pointedly) made up of men. She's hoping they can help her with a problem, and they eagerly offer their advice for how she can fix it. They point to a giant rectangular structure—hot pink, with the familiar Barbie logo—in the corner of the boardroom, and they urge Barbie to move in that direction as they repeat versions of the same basic directive.

Just get back in the box.

Initially, Barbie complies—I mean, these guys are in charge, and they should know the best course forward, right? So she gets in the box—fake smile plastered on her face—and it's only when the plastic ties start to tighten around her wrists that she realizes *Nope, this isn't the answer. This isn't for me.* She runs out of that box like an Olympic sprinter, and though the men chase her, they can't catch her.

That actually brings us right back to the Bible and something that never made it onto the flannel board retellings of the book of Exodus when I was a kid: the women who refused to stay in the boxes the world built for them. Miriam leading worship. Shiphrah and Puah defying Pharaoh's orders to kill infant Hebrew boys. Jochebed hiding her infant son. Pharaoh's daughter rescuing Moses from the Nile. Zipporah circumcising her own son because Moses had dropped the ball on his paternal responsibility, and yes, I realize that unintended pun is terrible. Not a single one of those brave women stayed in their dictated boxes, and my goodness—aren't we beyond grateful for the leadership that resulted from that?

Barbie also makes a case for what balanced, healthy leadership looks like. When only Barbies run the show, the men are unfulfilled. When Ken finds out about patriarchy and men get to run the show, the women are reduced to supporting characters. The extremes may offer some control, but ultimately, they don't solve anything. And in the end, the Barbies and the Kens realize that, as is true in the real world, the answer is somewhere in the middle. Life is fuller and richer and better when men and women alike have the freedom and the support to figure out who they are and how they're equipped to use their voices and lead. As Kasey said last night when we were processing some of our *Barbie*-related thoughts: "Best case scenario is that everybody elevates everybody."

No doubt about it. But is it realistic?

I hope it is. And I really do believe that most of us hope the same.

I don't know why there are such persistent modern-day pockets of resistance when it comes to women's leadership, particularly in some church circles. I'll never understand how men who are quick to call themselves "protectors of women" can justify bullying women on social media—and sometimes even from the pulpit. I suspect, though, that it has something to do with women rejecting the boxes men have created for us. And after over a decade of feeling shocked by this bad behavior, hearing the boys' club "rebukes" directed at women, and trying to figure out what in the world has gone so horribly wrong, I'm a hard *no* with this dynamic.

I can't find a single reason to support it with my time, my energy, my money, my attendance, my participation, or my vote.

Because when people have confused leadership with control— well, working that out will have to be the Lord's doing. I'm not banging my fists against that ancient brick wall for one more second. There's too much good work to do. Too many people to love. Too many reasons to keep moving forward.

And thankfully there are way more good guys than mean ones. Good pastors, good leaders, good husbands, good fathers, and good friends.

So here's to the men and women who relentlessly esteem one another, who see one another as partners rather than competition, who enthusiastically steward their voices and their influence for the glory of God and the good of the great big group, who have no time for putting people in boxes because they're too busy building bridges.

And, lest we forget, here's to the younger men and women who are watching us. We're probably not going to get it all the way right, but man oh man, I pray we get it better.

It's not always easy for men and women to figure out the dynamics of leading together and supporting one another, but

that's no reason for us to grow bitter or diminish one another. Let's don't miss an opportunity to affirm our brothers who lead with humility, kindness, and courage. Let's take the encouragement to heart when they do the same.

Together, let's sing what we've seen the Lord do.

That harmony is a beautiful sound indeed.

The world needs to hear it. And see it, too.

HUMANS ARE GONNA HUMAN

Big Ideas & Modern Concerns

I AM A TRADER JOE'S FAN by pretty much anyone's definition. I love their produce, their cheeses, their assortment of almonds and cashews (WHO KNEW that almonds and cashews could be so versatile?), their endless varieties of potato chips, and their frozen foods. I could write odes to the dark chocolate peanut butter cups, and if there was only one container of Unexpected Cheddar cheese spread in the refrigerated section, I would be tempted to fight you for it.

To be clear, I *won't* fight you for it because #Jesus. So I would consider my Savior, and then I would offer you the last container of Unexpected Cheddar cheese spread—with clenched teeth. My sanctification is ongoing, you understand.

Thankfully, Trader Joe's is close to my house, and yesterday I decided it would be the first stop on my morning errands. I only needed a few nonperishable things, and there was something

about the possibility of being at TJ's right when the doors opened that filled me with hope and promise.

It was about 8:45 when I pulled into my parking spot, and to my surprise, there was already a line forming outside the store. A couple of women were holding empty flower buckets, so I assumed they were there for some of the morning's fresh flower offerings. After all, TJ's flower department is legendary in terms of quality, variety, and price. Instead of joining the line, though, I decided to sit in my car and answer a few emails. I did just that, and around 9:01, I grabbed my purse and my grocery bag from the front seat, hopped out of my car, and turned in the direction of the store.

I was unprepared for what I witnessed.

There must have been fifty people clamoring to get through the store's sliding double doors. Initially, I couldn't make sense of it. *Is there a shortage of Two Buck Chuck? Are Patio Chips back in stock? Do they finally have organic green grapes again? Is Beyoncé scheduled for a pop-up concert?*

I had no idea what was causing such a sense of urgency, but I stood on the edge of the parking lot until the masses made their way inside. When the coast was clearer, I grabbed a buggy (aka a shopping cart, for any of you not from the South), got my purse and grocery bag situated, and mentally prepared myself for whatever was happening on the other side of the entrance.

There's no way to do justice to what I saw, but I'll try.

My fellow early morning shoppers had flat-out descended on Trader Joe's flower section. I couldn't see faces as much as I saw hands grabbing for stems of tulips, belles of Ireland, roses, and hydrangeas. Friends were barking out instructions to each other—"Six of the eucalyptus!" "Fourteen sunflowers!" "Only the ranunculus!"—and the front line of flower seekers had stationed themselves around the main flower island like they were staking out their territory at baggage carousel #2. Those ladies meant business, they wanted first dibs, and if that meant they

needed to team up and play zone defense, they were fired up and ready for it. They had the eye of the tiger lily, and the slowpokes standing behind them could wait. As the old adage says, *you snooze, you lose the dianthus*. Or something like that.

I quickly determined that only about three of us were in the store to buy actual food, so I delicately maneuvered my shopping cart around the very aggressive rows of flower shoppers, and I am not ashamed to tell you that I shook my head and silently reprimanded the whole bizarre assembly. I snuggled up in some self-righteous judgment like it was a favorite blanket, and after I secured my salt and pepper pistachios, my quinoa and black bean tortilla chips, and my white cheddar popcorn, I made sure to side-eye the aggressive flower-focused patrons on my way to the checkout.

HUMANITY, I thought. And as soon as I put my groceries in my car and settled into the driver's seat, I texted my friend Erin: "What I just witnessed in the Trader Joe's floral department . . . I feel like I need to report a crime."

Last night I spent some time reflecting on my reaction to Friday morning's flower frenzy. I mean, yes, the sight of all those grown women acting absolutely desperate over some greenery was sort of annoying, but so was the way I lumped all of them into a category as The Worst Among Us. I certainly don't want to make a habit of dishonoring God's children because of their enthusiasm about some hydrangeas. And if you have ever seen me make a beeline for my seat at a football game—I DO NOT LIKE TO MISS WARM-UPS—then what you know for sure is that my reaction at Trader Joe's was a sure sign that I needed to look at the plank in my own eye, because that sucker was roughly the size of a drywall panel. That is to say: the hypocrisy on my part was *significant*.

This is one of the most challenging parts of leadership, honestly. We adore people, and people drive us nuts. We want the absolute best for people, and we pray that they'll leave us alone.

We thank God for the very good gift of relationship, and we lash out at the people closest to us. We vow to be loving and accepting, and we scoff when we see a bunch of women setting personal records for the forty-yard dash so they can lay claim to the spray roses.

And somehow, we need to reconcile all of that. We need to settle it.

This is a good time to think through it, I think, because we're headed into a section of Exodus where the Israelites are not exactly the easiest group of people to deal with. Certainly that's understandable because of the trauma they had endured—not to mention that they had suddenly become participants in what would amount to a forty-year cross country camping trip with a bajillion of their closest friends. This was not exactly a recipe for POSITIVE VIBES ONLY.

Also, the Israelites likely had been conditioned by their life experiences to distrust authority, and they had every reason to feel afraid about all the unknowns in front of them. So basically, what I'm saying is that even though the Israelites were prone to forget God's goodness, provision, and deliverance (we all are, by the way), we can look at what they lived through in Egypt and extend some grace for their occasional impatience and obstinance with Moses as they journeyed in the direction of the Promised Land.

We'll talk more about the Israelites in the chapters to come, but right now I'd love for us to take a minute and honestly examine the lens through which we view other people in our everyday lives. Is anything cracked or distorted? Are things blurry in any way? Are we still trying to work with a prescription from 1997 when everything in our field of vision was clouded by drama?

That's all figurative, you understand. But still—let's get into it. Because what we're going to see in the next phase of the Israelites' journey is that while yes, there were times when the Israelites absolutely drove Moses to the point of distraction,

he never shirked his responsibility to them. He never stopped loving them. He told them the truth, and he corrected them when necessary. But his commitment to them was unconditional and unwavering.

So what does that mean for us in the spaces where we love and lead and strive to reflect the character of Jesus?

Well, first of all, I want to share some verses that I went back to over and over again when I was working with teen-agers. I know that I already mentioned Romans 12:10 back in chapter 11—but I cannot leave it out here. I trust you'll forgive the repetition.

> Let love be genuine; hate what is evil, hold fast to what is good; love one another with mutual affection; outdo one another in showing honor.
>
> Romans 12:9–10

> Put away from you all bitterness and wrath and anger and wran-gling and slander, together with all malice, and be kind to one another, tender-hearted, forgiving one another, as God in Christ has forgiven you.
>
> Ephesians 4:31–32

> Those who say, "I love God," and hate their brothers or sisters, are liars; for those who do not love a brother or sister whom they have seen, cannot love God whom they have not seen. The commandment we have from him is this: those who love God must love their brothers and sisters also.
>
> 1 John 4:20–21

> As God's chosen ones, holy and beloved, clothe yourselves with compassion, kindness, humility, meekness, and patience. Bear with one another and, if anyone has a complaint against an-other, forgive each other; just as the Lord has forgiven you, so

you also must forgive. Above all, clothe yourselves with love, which binds everything together in perfect harmony.

<div align="right">Colossians 3:12–14</div>

Next, let's consider some common denominators between these verses, because I think they give us a pretty good set of nonnegotiables for our relationships with other people, maybe most especially when we're leading them.

1. Be kind.
2. Be humble.
3. Be tenderhearted.
4. Be loving.
5. Be forgiving.

There's other stuff in those verses, of course—and I trust it goes without saying that we need to be honest. But man—if every leader resolved to do those five things, I'm pretty sure it would change the world. Somewhere along the way we've lowered our collective leadership standard, and at times we've settled for looking at the most aggressive person in the room—or the loudest—and labeling him or her as the leader. It's not accurate, though. Good leadership is always others-focused; it always calls people to higher and better.

Also, I think it's important to be specific about this. Name callers aren't leaders. Scorekeepers aren't leaders. Bullies and belittlers aren't leaders. Sure, there may be times in our lives when those people are technically in charge. But just because someone holds a microphone doesn't mean we should listen, and just because they lead a charge doesn't mean we should follow.

So—and this is the third thing—let's commit to who we're going to be and what we're going to model in the places where

we have influence. Let's commit to how we're going to love people. Obviously, we're occasionally going to lose our tempers, and we're going to have to apologize, and we're occasionally going to make unfair judgments, and we're going to have to apologize, and we're occasionally going to believe the worst about a situation, and we're going to have to apologize. If we could do these things perfectly, we'd have no need for Jesus or each other. Plus, when it comes to leadership, the odds are strong that we will have plenty of opportunities to practice humility.

But do you know what we *can* do? Our best. By the power of and dependence on the Holy Spirit, we can be people who strive to lead in ways that point people to Jesus. So, my friend, let us—on this very day—be resolved:

- **To esteem all people.** God has designed every single person on this earth with innate worth and purpose. Whether we *agree* with people about their theology, their denomination, or their feelings about mayonnaise—well, it's completely irrelevant. Honoring someone isn't precipitated on agreement. You don't have to cosign a single thing to treat someone like the child of God that they are. Love big.

- **To build up and strengthen the body.** Point out the good you see in others. Celebrate successes. Find constructive lessons in defeat. Resist pettiness, cynicism, and shame. There's so much in life that can be difficult and discouraging, but the voice of a trusted leader can be a balm and a comfort in hard times. Don't miss an opportunity to encourage, to affirm, and to name the gifts you see in someone else.

- **To continually seek after Jesus.** Our Savior is a bottomless well of hope, truth, love, and life. We will never

waste a second that we spend in his presence. Let's be leaders who are persistent in worship, in learning, in prayer, and in praise. Let's keep him at the heart of everything we do—because at the end of the day, we want to make much of him in every way that we can.

All righty. It's time to jump back into the book of Exodus with the Israelites so we can watch God and Moses work to get them where they're supposed to go.

(Thank goodness there were no floral departments in the wilderness. That would have surely required an additional miracle.)

Exodus 15:22 is up next.

See you there.

LET'S GET READY TO GRUMBLE

I BELIEVE I'VE MENTIONED that I used to be an eleventh grade English teacher. I believe that I've also mentioned that I loved it, adored it, and continue to believe junior year to be the best of all the high school English classes. Keep in mind that I haven't actually *taught* an eleventh grade English class in about ten years. It doesn't matter. My enthusiasm remains unhindered.

Every single year of teaching high school juniors was fun for different reasons, but there's one group of students who are forever etched in my memory, Mount Rushmore-style. Before they ever stepped foot in the school building for their junior year, my friend Marcia and I knew that we had better be ready for them. Marcia was a veteran English teacher with almost thirty years of experience under her belt, and for the fourteen years we worked together on the English faculty at our school, she was an amazing mentor, a revered instructor, and an absolute queen of a human. So at the end of summer vacation, when we returned to school for teacher workdays, Marcia continually

stressed to me that as the two eleventh grade English teachers, we needed to be a unified front.

Why, you might wonder?

Well, the incoming junior class had what you might refer to as a *lively* reputation, and their group dynamic had stymied teachers for years. I never liked to make assumptions about a group of kids based on what previous teachers said, but it had been impossible to miss the persistent buzz about the kids who were about to fill the seats in our classrooms. Marcia and I resolved to be loving but tough, and we mapped out our first nine weeks of curriculum like we were planning for battle.

Maybe that *is* what we were doing now that I think about it.

By that point in my career, I was comfortable in the classroom. After almost twenty years of teaching, I had settled into two big, overarching philosophies about working with teenagers: 1) let them be who they are and 2) love them right where they are. To my surprise, when that specific school year started, those core beliefs looked like they were going to be a perfect match with the juniors who had given us some pause during our late summer planning. Everyone was respectful, everyone was on their best behavior, and (almost) everyone did what they were expected to do (one student was quick to tell me that he hadn't bothered with summer reading, but *hey, at least I'm not lying to you, Mrs. Hudson*). Marcia and I felt like we had cracked the code of that year's junior class; it seemed like everyone was bringing the very best versions of themselves into our classrooms.

The honeymoon lasted for approximately one week. And then, well, everything went sideways.

Part of the juniors' summer reading had been to read *Peace Like a River*, a beautiful book about family and miracles by Leif Enger. The assignment connected to the reading was to write an essay based on one of several possible prompts, and we collected those essays on the second or third day of school.

Not long after Marcia and I began grading the essays, we noticed some pointed similarities in some of the kids' papers. We checked the papers with the plagiarism-detecting program that our school used, and while I don't remember the exact number of papers that came back to us as *Alert! Alert! Content has been plagiarized!*, I think it was somewhere around twenty-five—which was the most we had ever encountered on one assignment. Dealing with all of that from a disciplinary standpoint was a real drain on the overall mood, and mostly I was just bummed because *we had been doing so well.*

We had been off to such a good start.

I was so disappointed. And I was also mad.

Looking back I don't love how I reacted to the kids, because I feel like I responded with 1) shame, 2) more shame, and 3) lo, ever-increasing quantities of shame. We worked through it, though, and after our administration settled on consequences, we enjoyed a junior English nirvana for approximately three to three-and-a-half days before the next crisis arrived. And then the next crisis. And then the next one.

By the time we made it to Christmas, I was bug-eyed and numb. My feelings had left the building.

Now—let me be quick to say this: I was wild about those kids. By October of that school year, we were like war buddies—bonded forever. I've never grown closer to a group as quickly as I did with that one. To this day I've never been more invested in a group's well-being on every level, and I get the biggest kick now when I run into them in and around Birmingham. Many are married now—parents, even—and some of the things that got in their way as high school juniors have become their superpowers as adults.

But listen. In the year of our Lord 2011, I wondered if that group of high school juniors was going to be the end of me. Teaching them and trying to keep a check on classroom discipline was a little bit like being on one of the carnival rides I

remember from the East Mississippi/West Alabama State Fair in the early '80s; you could go from *yayyyy* to *noooo* to *I wonder if this ride will become my grave* in the span of several seconds.

It's been over a decade since those people sat in my classroom, and I honestly can't help but smile when I think of all their hijinks—the sheer number of class periods when I had to pull one of them out in the hall and ask, essentially, *have you lost your fool mind?* In retrospect I can recognize that a lot of those kids were type-A, highly driven, highly intelligent—likely a world-class assembly of Enneagram 3s and 8s. That's precisely why the group dynamics could be so tricky. They didn't always play well with others. They wanted to call the shots. They thrived on uproar. They craved a steady diet of drama and discord. They even had a class motto they came up with for themselves: *We Will Be Remembered.*

And despite every bit of that, here's what I will tell you: those teenaged babies were *precious*. Individually each one of those kids was an utter delight. But put ten or more of them together, and you would likely require some Tums and maybe even a nerve pill.

I had the migraines of my life when I taught those kids, and thinking back on their junior year always reminds me that no matter how idyllic a journey may seem at first, well, it's eventually gonna get bumpy. It's gonna get tiresome. It's probably going to teach you more than you ever intended to learn.

And what a reminder that when we're leading people—as bosses, parents, teachers, volunteers, you name it—there's just no escaping that, at some point, the road is going to get rough.

So wherever you happen to be leading right now, don't forget to buckle up, everyone.

You'll be wise to gird your loins.

●　●　●　●　●

In Exodus 15:22 we rejoin our friends the Israelites after the world's first mega praise and worship service. The Lord had delivered them across the Red Sea, they had thanked him for all he had done, and they set out on the next phase of their uniquely designed route to the Promised Land.

The first challenge they encountered was bitter drinking water when they arrived in Marah. The Israelites complained, and God told Moses to throw a piece of wood in the water to make the water sweet. It worked, and God used that experience as a teachable moment for his children. I love how *The Message* phrases what God said: "If you listen, listen obediently to how GOD tells you to live in his presence, obeying his commandments and keeping all his laws, then I won't strike you with all the diseases that I inflicted on the Egyptians; I am GOD your healer" (Exodus 15:26). Afterward the Israelites moved on to Elim, where God's abundance was in full force: twelve springs of water and seventy palm trees surrounding the place where they camped. God was reminding them—yet again—that he loved them and would take care of them.

But when the Israelites left Elim, the overall mood took a turn; there were proverbial potholes aplenty for our friends. It had been a month and a half since they first moved out of Egypt, and "the whole congregation" (Exodus 16:2) seemed frustrated with Moses and Aaron.

What were the issues, you might wonder?

1. **The Israelites were hungry.** Hangry, even. They told Moses that they wished they had died in Egypt because at least they had bread there—and clearly, they had been brought to the wilderness so that he could kill them with hunger (Exodus 16:3). The Lord responded by saying, essentially, *Hey, y'all—no worries—I'm gonna make bread rain down from the heavens.* Moses told the assembly that when manna arrived every

morning, it would be a reminder of God's deliverance and a way for them to "see the glory of the LORD" (16:7).

Moses also gave everybody a heads up regarding the persistent complaining: "Your complaining is not against us but against the LORD" (16:8). The Lord went a step further than manna and also sent quail to the camp at twilight (carbs by day, protein by night)—so surely the Israelites were going to settle into a posture of resting in God's provision, right?

Welllllllll.

2. **The Israelites didn't listen to Moses' instructions about manna.** First, they didn't dispose of uneaten manna at the end of the day, and their leftovers "bred worms and became foul" (16:20)—sort of like my refrigerator's vegetable drawer about a week after I've gotten really enthusiastic about cooking healthy meals (though I am happy to report that I have never encountered a worm).

Then, when some people didn't gather enough manna on the sixth day—which is when they had been instructed to gather a double portion and then boil or bake their leftovers (so as to avoid the unfortunate spoilage)—they went out on the Sabbath to look for food and realized there was no manna to be found. In verse 29, God repeated the lesson Moses had taught earlier: "See! The LORD has given you the sabbath, therefore on the sixth day he gives you food for two days."

I can't help but hear some serious tonal echoes of *Do not touch the hot stove* from the days when I was parenting a toddler, but God didn't stop providing just because he had to repeat the instructions.

So everybody was good, right?

Welllllllll.

3. **The Israelites were thirsty.** When they arrived in Rephi-
dim, they saw the lack of water and once again became
frustrated with Moses. Moses repeated his usual refrain
of *WHY ARE YOU YELLING AT ME?* (to be clear,
that is a loose paraphrase of Exodus 17:2), and the Is-
raelites countered with their favorite argument, which
was something along the lines of *Why did you bring us
out of Egypt if you were just going to kill everybody by
letting us thirst to death?*

Listen. The group dynamics weren't great at this
point. Moses was at the end of his leadership rope, so
he cried out to God and said, essentially, *WHAT AM
I SUPPOSED TO DO WITH THESE PEOPLE?* It was
like they were on hour eighteen of a road trip in an un-
air-conditioned 1988 Ford Econoline van, and by the
way, the radiator was overheating, and the right front
tire was running a little low. Everybody was done. Ev-
erybody was aggravated.

And God gave Moses a critical piece of instruction:
"Take in your hand the staff. . . . I will be standing there
in front of you on the rock at Horeb. Strike the rock,
and water will come out of it, so that the people may
drink" (Exodus 17:5–6).

Surely things were about to get better, right?
Wellllllllll.

It's all so relatable, don't you think? And while these three
incidents happened at three different stops along the journey,
they definitely share some common denominators:

1. **Every single time, the Israelites panicked.**
2. **Every single time, Moses, in his frustration, looked to
the Lord for answers.**
3. **Every single time, God provided.**

That last thing is pretty significant for all of us in the here and now.

Unfortunately, it doesn't change the reality of bumpy roads, tricky dynamics, testy people, and daily challenges. I'd be willing to bet, though, that most of us would say that despite all those things, we want to stay in it and make a difference. As long as we can, we want to keep seeing, keep working, keep leading, and keep loving.

Even still, it's totally normal—and understandable—to look around every once in a while and wonder, *Are we doomed to just keep repeating the same mistakes?*

Are we ever going to learn the lessons?

●●●●●

Here's the reality: when we're in a leadership role, getting people from point A to point B is a grind.

Getting *ourselves* from point A to point B is a grind, for that matter.

And when it's our responsibility to lead other people—in whatever context we're doing that—it's so easy to grow frustrated and weary, to feel like we're trapped in some real-life version of *Groundhog Day* where we experience the same series of events day after day after day. Same miscommunications. Same misunderstandings. Same mistakes.

Sure, there are joys. There are victories. There are celebrations. But there are also, almost always, problems—because, well, you're dealing with people.

The year I taught the We Will Be Remembered kids, there were absolutely days when I felt like Moses and wanted to scream WHAT AM I GOING TO DO WITH YOU AND MY GOSH WHY CAN'T YOU JUST BE NICE TO EACH OTHER? There were absolutely days when I acted like the Israelites and wondered if God was setting me up to fail and also

160

THIS FEELS LIKE A TRAP MAYBE I'M BEING PRANKED RIGHT HERE IN ROOM 218.

But I'll tell you what was available to me every single day—there was literally not one single exception—manna and water.

Now just to be overly clear, those weren't snacks courtesy of the PTO that were available in the teachers' lounge. I'm talking about daily provisions—in the spiritual sense, of course—that arrived in a myriad of ways. Infusions of patience. Forgiveness. Listening. Laughter. Humility. Repentance. Relationships. Second and third and fourth chances. An appropriately timed sarcastic remark that instantly defused a tense situation (listen—talk about something that needs to be listed on the SPIRITUAL GIFTS INVENTORY, because that is an undervalued skill, and the Lord has blessed our millennial friends with a double portion).

Yes, we were dealing with nasty lunch boxes instead of worms infiltrating manna. We were never inundated with quail, though for sure that would have been the best day ever for some of the hunters in the group. I never had to hit a rock with a staff, and thank goodness none of us had to figure out how to measure an omer because that feels like math. But somehow, someway, God made sure that we had everything we needed.

I don't know what your particular leadership challenges are right now: if you're caught in the middle of a recurring issue, if you're not sure where funding for a special project is going to come from, if you're dealing with a troublesome HR problem, or if you're feeling adrift in a sea full of complaints and arguing and no small amount of drama. What I do know, though, is that sometimes when you're just all the way in the middle of it—whatever your *it* happens to be—sometimes encouragement comes across more like platitudes (and maybe even clichés). Given that, I wouldn't say what I'm about to say unless I really felt like it was meaningful, true, and well worth remembering.

Here we go.

During their stays at Marah, Sin, and Rephidim, the dynamics between the Israelites, Moses, and God provide us with some practical guidance for our present-day challenges.

1. **When we're in difficult leadership spots, God faithfully provides what we need.** Manna for the day. Granted, it may not be what we think we want. We may not even initially see how it's helpful. But he will absolutely give us what we need. We'll be wise not just to see what has been apportioned to us for the day but to use it and give thanks for it.

2. **When we cry out to God and ask him for help—for wisdom—he not only hears us, he *listens* to us.** He is not put off by our frustrations or our questions. He loves us and continually goes before us. None of what surprises us has caught him even the tiniest bit off guard. And by the power of the Holy Spirit, he's going to help us know the next right step.

3. **When we get to the other side of whatever we're working through, we need to make sure we take time to see how God has led us. Provided for us. Sustained us.** Part of that is because we want to give credit where credit is due, but maybe a bigger part of it is that seeing what he did—remembering his mercy and his help and his presence—better prepares us for the next set of challenges we face. Seeing leads to remembering, and remembering leads to trusting. We want to rehearse that process as much as we can.

And just in case we need one more nudge, Matthew Henry offers a Great Big Takeaway from this part of the Israelites' journey: "Let this direct us to live in a dependence . . . [u]pon God's providence, even in the greatest straits and difficulties. God can open fountains for our supply where we least expect them."[1]

No doubt we've all experienced a similar awareness as we've worked to guide and teach and build trust in our interactions with others. We've seen the truth of Henry's words in our homes, in our workplaces, in our friendships, and in our communities.

Those juniors who sometimes gave me fits have been remembered, all right—just not for the reasons they may have anticipated. I remember them because of what they taught me during our year together. I remember them because they always wanted me to shoot straight with them; sugarcoating was their sworn enemy. I remember them because, while they could certainly be tough as a group, they were delightful—charming, even—one-on-one. Yes, it was a perilous journey at times, but we made it all the way from August to May, and we were better at the end of the year than we were at the beginning. As best we could, we loved each other—even if we occasionally drove one another bananas—and while I don't presume to speak for the group, my impression was that we always had exactly what we needed to move forward. God was good and faithful to us.

God's going to be good and faithful to you and the people in your charge, too. He sees you. He sees what you need.

Yes, leadership can be stressful. Yes, leading well can feel impossible when you're overwhelmed by people's needs and wants and requests and suggestions. Throw in difficulties with creating a sense of unity and purpose and you have yourself a real party that no one wants to be invited to, much less attend. It's tempting to echo the Israelites' words in Exodus 17:7 "Is the LORD among us or not?"

But here's the answer: he is. So let's be quick to remember the One who meets us in the middle of our obstacles, the God who is "standing there in front of you on the rock" (Exodus 17:6). He changes absolutely everything.

Let's seek him—and take a good, long look at his mercy, his steadfastness, his provision, and his care—at every bump in the road.

WHAT YOU NEVER SAW COMING

AFTER FOURTEEN YEARS at my school here in Birmingham, I moved from a classroom to an office. I took over a position my friend Anne had started many years before—I think the official title at the time was "women's adviser"—and while I was sad to say good-bye to teaching English, I was excited about getting to focus more on the relational side of things. For as long as I can remember, I have loved not just getting to know people but digging into how they see the world and learning what means the most to them. Working with the girls at school was going to be such a great opportunity to do that.

Also, I wasn't going to have to grade essays anymore, and while that wasn't a deciding factor when David and I were talking through my potential job change, I can honestly say that it didn't hurt (do you know how many times eleventh graders will incorrectly use the verb *portrays* in an essay? INFINITY TIMES).

Since the new job—which eventually morphed into Dean of Women/Student Life Director—was mainly a discipleship

role, there were none of the typical tasks that had always given structure to my school days. I didn't have to check attendance, I didn't have to plan lessons, I didn't have to lecture or create assessments. On top of all that weirdness, I also had an office phone, which was one of the more bizarre developments in my professional life. I nearly jumped out of my chair the first time it rang. That was actually when I realized, *Oh, I have voicemail now,* and then I had to text Anne to figure out how to check it.

Anne had assured me that the days would take shape, that I would figure out where and how to direct my attention, and she was right. I tried to reserve early mornings for emailing and returning phone calls, because by nine or so, girls started to filter into my office. Sometimes they wanted to visit, sometimes they needed a safety pin or a ponytail holder or a tampon, and sometimes they were killing time between classes. There were always seniors hanging out during study halls and lunch, and in the afternoons I would call in girls who had either expressed interest in talking through something with me or had been referred to me by a teacher. Even with that loose structure, though, it only took me a few days to figure out that there was never a way to predict what a given day would hold. Because listen.

LIS-TEN.

I thought that, after fourteen years at school, I had a pretty good handle on what our girls were dealing with. I could not have been more wrong. I was wholly unprepared for the amount of drama that went on behind the scenes, on social media, in the lunchroom, in fourth period history class, you name it. I had never fully realized just how much pressure girls were putting on themselves to be the best at pretty much everything. I had no idea about some of the struggles girls' families were dealing with or the traumas they had endured.

I remember telling David that every day felt like a brand-new case of whiplash. I would think, for example, that my Tuesday

was going in one direction, and then someone would show up in the doorway of my office, sobbing, not wanting to talk as much as she just wanted to vent her pent-up emotions. On top of that there was constant, smoldering conflict between some of our girls, and every few days a fire would kick up between two or three of them and we'd have to work together to put it out.

And don't get me wrong. There were absolutely joys and victories and celebrations—so much that was memorable and good. We had a great administrative team, and I was grateful for their wisdom and support. Even still, that school year threw me for seven to nine loops; I was in over my head from day one, and when we finally crossed the finish line in May, I didn't so much want to come up for air as I wanted to get in bed. And I did.

It's interesting to look back on that first year in my office, because logically I know that there were three or four major events in the life of our school that should dominate my memories. But what I remember, more than anything, is the heaviness—the unshakable feeling that we were fighting for something much bigger than dress code compliance (I promise I'm rolling my eyes) or peace between friends or healing inside families. It was maybe the first time in my life when I felt overwhelmed by a persistent sense of darkness—and had a crystal-clear realization that we were fighting to shine some light. Or, I should say: Light. I know that sounds high stakes, so please know that I am not generally prone to see things in terms of spiritual warfare. It even makes me a little self-conscious to type those words. But at every turn, I felt it. I heard it. And I don't know that I've personally ever seen anything quite like it.

Obviously, there are lots of specifics, and I can't and won't share because those stories aren't mine to tell. But much to my surprise, my new job threw me on the front lines of what our kids at school were fighting, and believe me when I tell you I

had no idea how expansive the battlefield was. That sucker stretched out for some miles.

And when you're dealing with that kind of ongoing struggle? You'd better know not just where you stand but why you stand there.

You'd better know Who you stand for.

●　●　●　●　●

The battle that emerges in Exodus 17:8 seems to come out of nowhere. There was Moses hitting the rock for water in verse 6, the Israelites wondering if God was really with them in verse 7, and boom—verse 8: "Then Amalek came and fought with Israel at Rephidim."

So, you know, that was a significant development.

As I mentioned way back in chapter 1, I wrote five hundred-ish words about this very battle in my book *Stand All the Way Up*, and I don't want to repeat myself more than necessary here. That is why I currently have a copy of *SATWU* sitting next to me, and I'm going to reference it to make sure that you're getting some fresh, hot takes on the fight between the Amalekites and the Israelites. This trying-not-to-repeat-myself feature is just a little something that I like to offer at no cost to you, the reader. But first, a quick summary.

Since the Israelites were suddenly at war, everybody had a role to fill. Joshua stayed on the ground with the troops. Moses went to the top of the nearby hill with Aaron and Hur so that he had a big-picture perspective for the battle and could help with the Israelites' strategy. Over time it became clear that when Moses raised his staff, the Israelites did really well, and when Moses lowered his staff, the Amalekites did really well. Since Moses was eighty-plus years old at this point in the journey, we can imagine that his arms grew a little tired. So Aaron and Hur found a rock where Moses could sit, and

they held up his arms when he lifted the staff. It was just the support he needed. And in the end, the Israelites defeated the Amalekites thanks to the leadership of Joshua on the battle-field and the leadership of Moses, Aaron, and Hur on the hill. Not to mention the leadership of all the soldiers who bravely fought their enemy.

There are, naturally, some takeaways—and the first six here have occurred to me since I wrote about this passage in *SATWU*. If you'll indulge me, a list.

1. Moses, Aaron, and Hur remind us that when we find ourselves in a crisis or a battle, it's important that we support our friends, family members, colleagues, and employees in ways that are visible and clear. Anybody who looked at the top of that hill would have understood that the men's allegiance belonged to the Israelites, and the fact that they stayed on that hill until the end of the battle was a demonstration of their loyalty to the cause and their investment in the outcome. Tony Evans asserts that Moses' raised arms, along with the fact that Aaron and Hur joined him atop the hill, serve as "reminder[s] that we must avoid the extremes of thinking that either we'll simply pray and let God take care of the life battles we face or that we must assume all responsibility and solve each problem alone."[1]

 Now obviously, leaders also deal with conflicts that require a certain measure of diplomacy—situations where both sides need to be seen and supported, where we ultimately want our response to be helpful to everyone involved. But in any struggle or strife, we're going to need large measures of compassion, commitment, and awareness. We can't play both sides to the middle. There's no room for wishy-washy. And yes, you are correct if you're thinking that every bit of this will

be a real challenge for people pleasers. ASK ME HOW I KNOW.

2. When it comes to fighting for the stuff that matters, there are no supporting characters. Everybody who factors into the equation is important. Moses and Joshua might have been front and center, but everyone's role was critical. You already know this, I'm sure, but leadership is not about being the center of attention, it's not about standing in a spotlight, and it's certainly not about trying to make people afraid. Leadership is about identifying a problem and serving with humility until it's better. Leadership is helping.

3. So while it initially might be tempting to diminish what Aaron and Hur did, there's no question that they were essential personnel—every bit the leaders that Moses was. They climbed that hill, they paid attention, and they supported Moses. It wasn't glamorous help, it wasn't flashy. (I mean, can you imagine if someone had interviewed them about what they did? *Yeah—I moved a rock. Yeah—I held on to his wrist—and then I lifted it. Like this. TAH DAH.*) However, it was exactly what Moses—and by virtue of that, the Israelites—needed at the time.

4. I don't mean to beat this dead horse with a stick or even a staff, but really, we have to acknowledge it: Moses, Aaron, and Hur positioned themselves in a place where they could see. Their view of the battle was free from obstruction. It's the theme of Exodus that won't stop theming, don't you think? And when we're dealing with conflict that has surprised us, arrived seemingly out of nowhere, or figuratively knocked the wind out of us, we need to do the same. We need to see the landscape of that thing really clearly, and that may mean we have

to temporarily excuse ourselves from standing in the middle of the fray and move to higher ground.

5. I mentioned in *SATWU* that we all have a staff—something that uniquely equips us to lead. I still believe that. But here's something new I want to add to that idea, and it's something I just noticed. We've been reading about Moses' staff since Exodus 4, but when the Amalekites came on the scene, Moses referred to his staff as "the staff *of God*" (Exodus 17:9, emphasis mine). Meyers notes that this is "a designation that has not been used since its first appearance."[2] Why is this the case? I have no idea.

6. However, it does make me wonder if that might be a healthy perspective as we exercise our God-given gifts in the interest of making difficult situations better. I'm not saying that this viewpoint imparts any additional authority or power, but I am saying that it keeps the Source of our gift(s) at the forefront. It attaches some additional responsibility to how we use that gift as well. It's not just a matter of ability; it's a matter of stewardship.

7. I *will* repeat a tiny bit of *SATWU* here because I will scream this from the rafters for the rest of my days: we cannot miss the lesson that the Israelites weren't fighting for power; they were fighting for *deliverance*. That road was—and is—a long one. The battle against the Amalekites was just a tiny piece of the Israelites' journey, and as you know, there were many more battles and challenges ahead. All of them required leadership and service and a certain amount of selflessness. But deliverance is always worth the fight.

It's also important to consider this: we are deeply human, and sometimes we want to win more than we

want to serve and lead. We get obsessed with success and bottom lines and bolstering our own reputations and making our names known. That's why it's so important to remember that Moses wasn't trying to make Israel known. He wasn't trying to make Israel great.

Moses was trying to make Israel free.

That's a mighty fine goal if you ask me.

●　●　●　●　●

For me one of the most challenging aspects of a battle that shows up unannounced—and I really learned this about myself when I was working with the girls at school—is that the sheer volume of emotions leaves me overwhelmed. Numb, even. There are just so many *feelings*—from the people involved, the people affected, even the people watching from a distance who are worried that they'll somehow get pulled into the conflict. It can be difficult to process your own emotions when you're trying to be sensitive to everyone else's, and it can also leave us tempted to check out of being meaningfully involved. We may even decide that since it isn't technically *our* issue, it's totally fine to let the chips fall where they fall and relieve ourselves of any responsibility in that process. For me that was never more true than when there were too many fires to deal with at once—or when I felt like someone was habitually reckless with their choices. A repeat relational offender, if you will.

Obviously, it's different handling these sorts of things with teenagers than it is with adults, but I think the frustrations can lead to the same place: *I'm done, thanks. Please continue along your path of doom and destruction. I will not be joining you. I can no longer bear witness to this panorama of collateral damage.*

I don't think that makes us callous, necessarily—but we *do* have to guard against a pervasive attitude of *I shouldn't have*

to deal with that. We also have to guard against sliding into codependency and taking on everyone else's burdens and feelings. That's where Moses' example is so instructive. He didn't stand off to the side of the battlefield with his arms crossed, and he also didn't run from soldier to soldier to check and see if they were okay. He picked a spot where his help would be the most helpful—his staff was his voice in battle, after all, the way that he offered help and encouragement—and his involvement was appropriate for the task at hand.

A few weeks ago my friend Heather and I were talking about some of our favorite moments with our former boss Shawn, and Heather mentioned how Shawn's desire to bring restoration to every conflict he mediated had really impacted her as a leader. Shawn pursued the redemptive path even when it required forty-nine additional steps, and I could tell you story after story about how that changed people's lives. As much as he could, he was absolutely determined to move kids in the direction of freedom, and he understood that solely focusing on consequences wouldn't do that.

Heather went on to tell me that she tries to follow Shawn's lead at the school where she works now. "When I have to settle conflicts or mistakes," she said, "I always say two things. The first is *Tell me the whole truth.* And the second is *We're going to fix this together.* And then, to help them understand that they're safe with me, I always say, *I need you to understand that I'm not angry with you. I'm just here to help us fix what needs to be fixed.*"

Maybe I'm a little biased because Shawn and Heather are my friends and I think the world of them both, but I think that's about the best we can do. Apart from any *actual* battlefields, of course, which might require a different strategy.

My forever favorite devotional book is Paul David Tripp's *New Morning Mercies,* and there's a paragraph that I often reread, especially when I wonder if I've accidentally signed up

for some kind of Battles Galore membership (trust me—you don't want to join). Tripp's words are such a strong exhortation to stand and speak and love and lead like Jesus:

> Here's the plan: a God of grace makes his invisible grace visible by sending his people of grace to reflect his grace to the people who need grace. You have been called to be the look on his face, the tone of his voice, and the touch of his hand. You are to represent his presence and his love. You are placed where you are to make his mercy and faithfulness visible and concrete.[3]

It's a response that can seem particularly challenging when you're blindsided by the fight that's suddenly before you. When you feel whiplashed. When you thought you could put away your staff for a little while, only to realize that you need to drag it out again.

I'll tell you what, though. I still believe—just like I did when I wrote *SATWU*—that there are all sorts of good reasons to get up that hill. To take an unflinching look at the lay of the land. To lift one another's arms. To come alongside people who need our support and help.

We have no idea what's ahead, of course, or what's coming around the corner. But I do know this: whatever it might be, you are more than equipped to respond with the grace and mercy of Jesus, to use your voice (and your staff!) to point people in the direction of deliverance.

You were made to lead with love.

WHEN YOU CAN'T SEE STRAIGHT

WHEN I LEFT MY JOB a couple of years ago, I wanted to process my emotions in ways that were healthy. So that summer, I continued my daily walks at a park near our house—they had become a critical part of my morning routine during quarantine—and I tried to talk about my feelings as much as I am comfortable talking about my feelings, which is really about three to five times a year for a maximum of six minutes.

You would be right to assume that this was an ineffective strategy, but we'll get to all of that in a minute.

Eventually, my first jobless summer ended, Alex began his senior year of high school, and I wasn't entirely sure what to do with myself. At first I busied myself with all the stuff surrounding a book release—I wrote a devotional book that came out that September—and my friend Melanie and I did a couple of live podcast shows in Texas and Tennessee. That was all delightful and fun. I also very much enjoyed having a flexible schedule; I could have written love songs about not having to wake up at the crack of dawn to get showered and dressed in clothes with buttons and zippers.

There was a persistent issue, though, that I was doing my very best to ignore. For the better part of ten months, anxiety had been bossing me around pretty consistently. It had gotten a little better back in February, after I told Shawn that I was leaving work at the end of the school year, but it didn't go away. I kept thinking I could manage it by walking more or going to sleep earlier or cutting back on caffeine, and while those things may have helped, they weren't a cure.

In late September I had a speaking event at Daddy's church in Mississippi, and being in the company of so many people who had known and loved my mama (she passed away in 2016) made me miss her more than ever. For the next few weeks I felt like I couldn't get out from under that sadness, and my anxiety ramped up in ways I hadn't previously experienced. All that to say, by the end of October I didn't feel like myself at all. I was tired, I was frazzled, and I was worried.

One night in late October I had plans to see the band NEED-TOBREATHE with Heather—we have loved their music for a long time—but the morning of the concert was a rough one. I remember sitting on the couch in our den and telling David that I couldn't get a deep breath, but I had no idea why. We weren't under any kind of financial or relational stress, Alex was having an incredible senior year, and Melanie and I were having a blast with everything surrounding our podcast. There was no logical reason why I should be feeling short of breath and constantly monitoring my pulse rate, which, by the way, felt like it was racing at warp speed. But there we were.

That afternoon I tried to take a nap—thinking maybe that would be a good reset for my nervous system—but I couldn't fall asleep. By the time I climbed out of bed I was in tears, and I decided enough was enough. I called my doctor.

To my surprise my internist had an opening the next day, and after I filled David in on the details of my appointment, I was happy to redirect my focus to spending time with Heather

and hearing some of my favorite music. I walked in my closet to figure out what I wanted to wear that night, and after I decided on my cropped jeans, I knew exactly which booties would be extra cute with them. So I bent over, and as soon as I reached for one of the booties, I thought, *Dang, I am realllllly dizzy.*

The next thing I remember is that my head hit something—hard—and I heard David yell "WHAT WAS THAT?" as he ran to the closet. I wanted to ask the same question, but I was completely disoriented ("drunk as a doodle," Mama would have said). Somehow I was on David's side of the closet, my head was throbbing, and I felt like I couldn't wake up enough to make sense of what happened. I managed to roll over about the time that David threw open the closet door, and we stared at each other in utter confusion about what in sam hill was going on. I spoke up first.

"I think I blacked out."

And then: "I think my head is bleeding."

(The word you're looking for is *thriving*, everyone.)

When I finally regained my bearings, I quickly told David that I could *for sure* still go to the concert, that I just needed a minute to recover from the shock of it all. He was kind enough not to tell me that I was delusional. But then, when I actually started to recover from the shock and realized that my whole body was basically shaking like OutKast's proverbial Polaroid picture, I rethought my concert plans and called Heather.

"So, funny story," I said. "I just fainted."

That was really all Heather needed to know before she promised that we could catch NEEDTOBREATHE the next time they were in town. I believe she also offered to bring me some soup.

David wanted to take me to the emergency room because, you know, *head injury*, but since I am stubborn and had determined that the wound wasn't very deep (I hit my head on one of David's dresser drawer pulls, and I knew this because the edge

of the drawer pull looked like a crime scene), I convinced him that I could just apply pressure with a towel and let the doctor take a look at the next day's appointment. Maybe it wasn't the wisest course of action, but I didn't have a headache, my eyes weren't dilated, and the thought of a team of medical people fussing over me in the ER sounded like the worst possible post-fainting option.

I didn't want Alex to see me in such a shaky state, so for the next two hours, I hid out on the floor of our closet—David made me an ice pack for my head—and thought about everything that had led me to that exact place in that exact condition. For the better part of fifteen years, I had worked pretty diligently at my juggling skills: taking care of my family and running carpool and writing books and podcasting with Melanie and traveling to speaking engagements and, until just a few months prior, working full-time. There was also a whole lot of unprocessed grief and sadness connected to my mama's death as well as leaving school, and there wasn't a doubt in my mind that I probably needed to process those feelings in healthier ways. I had been exercising regularly for several years—that was a thumbs up—but I had lapsed back into some unhealthy patterns with food—that was a thumbs down. And as I adjusted my ice pack on the back of my head, I knew that my body was calling my bluff. I couldn't ignore the anxiety, the racing heartbeat, and, you know, the fainting.

My body was trying to tell me something. And in a little over twelve hours, I had an appointment with a doctor who was going to make sure that I listened.

● ● ● ● ●

Exodus 18 kicks off with a family visit from Jethro, Moses' father-in-law, who I referred to as Reuel earlier in the book. That's because he's introduced to us with two names. Nonetheless,

Jethro heard the news about all God had done for the Israelites, so he—along with Moses' wife, Zipporah, and Moses' two sons—paid Moses a visit. I don't know exactly how long it had been since the family had been together, but it was no doubt a joy to see one another face-to-face. We know from Scripture that Jethro and Moses greeted one another, they went into the tent, and to my limited way of thinking, maybe they caught up with an old-fashioned session of "highs and lows" (high = Red Sea!) (low = everything Pharaoh!). Regardless of the format of their conversation, though, Scripture is clear about its result: "Jethro rejoiced for all the good that the LORD had done to Israel, in delivering them from the Egyptians" (18:9).

All signs point to Moses and Jethro's reunion being the best kind of catch-up: encouraging, edifying, and, considering the dramatic exit the Israelites had made from Egypt, it was likely also energizing to share those stories. Jethro made sacrifices to God, and then Aaron stopped by so they could all break bread together. Happy family reunion all the way around.

The next day Jethro got to see Moses in action with the Israelites. It happened to be a day when Moses was sitting as judge, and after seeing the realities of that responsibility, Jethro asked Moses a question: "What is this that you are doing for the people? Why do you sit alone, while all the people stand around you from morning until evening?" (18:14). No doubt the pace of those days was normal for Moses, and he logically explained to his father-in-law that he was doing good work by settling disputes between people. Jethro, however, was able to see what Moses could not, and he expressed his reservations plainly: "What you are doing is not good. You will surely wear yourself out, both you and these people with you. For the task is too heavy for you; you cannot do it alone" (18:17–18).

Moses may have thought his father-in-law was just there for a visit, but it seems to me that Jethro was also there to help Moses set some boundaries.

I've learned this lesson the hard way, but I believe that setting—and keeping—healthy boundaries is one of the most critical components of strong leadership. We'll talk more about that in the next chapter, but in the meantime, here are a few thoughts that occur to me in light of Jethro's admonition to Moses in verses 17 and 18.

1. People on the outside of organizations or institutions where we lead and serve can sometimes see dynamics, disciplines, and practices more clearly than we can— even though we're living and working right smack-dab in the middle of it all. Standing on the outside and looking in might not offer a 360 view, of course, but it can provide helpful perspective and insight. When you're leading, give trusted people access to what you're doing. Let them see you in action in your natural leadership habitat. Ask them to speak into that part of your life. Listen to what they say.

2. Jethro wasn't just a random someone who was popping into Moses' workplace and offering hot takes on how Moses conducted the Israelites' affairs. In addition to the fact that he was Moses' father-in-law, he also had been the priest of Midian for many years and the owner of the flock Moses tended. Moses would have been well aware of the span of Jethro's leadership, and because of their personal history, there was some space and trust there to receive the older man's input and suggestions. Relational capital is priceless.

3. Odds are good that Moses had witnessed Jethro practicing what he was preaching. The mandate "Do as I say, not as I do" is zero percent helpful when we're mentoring someone. As a Gen X'er who has spent a lot of time working with Millennials and Gen Z'ers, I can

vouch that they will call out hypocrisy in older genera-
tions when they see it. They won't let us get away with
it—and they shouldn't. Integrity still matters, just as
it likely mattered to Moses when he received feedback
from his father-in-law. So if we're going to be a Jethro
with a younger leader, we'd better come correct. And if
someone is acting as a Jethro with us, we don't have to
take their words to heart just because they're older and
more experienced. We take their words to heart when
we know that their words match up with how they lead
and use their voices for good.

That's not all we can learn from Jethro. He led with ques-
tions, and after Moses answered, Jethro offered initial feedback.
Then he offered Moses a plan. He had a more efficient, more
effective system in mind—one where Moses still handled the
cases that were difficult but also selected qualified people to
help him with the overwhelming number of minor cases. Jethro
didn't suggest this system because he wanted credit or because
he wanted to impress Moses with his insight. He suggested a
new way of doing things so that Moses "[would] be able to
endure, and all these people will go to their home in peace"
(Exodus 18:23).

Isn't that a beautiful greater good? Not only would Moses'
load be lighter, but cases would be resolved more efficiently—
and as a result, the Israelites would live with increased peace.
Jethro gave everybody in the camp some margin.

I haven't done any scientific polling, but I think margin—
operating with clear and healthy boundaries—might be the
aspect of leadership that people crave the most. And ironi-
cally, it's also probably the aspect of leadership that's most
elusive.

It's possible, though. It really is. I would even say that if we
want to endure, well, it's critical.

And based on what we see in Exodus 18, I think there's one very wise first step.

When people with wisdom, integrity, and experience take the time to talk, we need to listen.

● ● ● ● ●

I was a humbled woman when I met with my doctor the day after, you know, I fainted in the closet. I was also emotional. Concerned. Not to mention a tiny bit sore from my head slamming into the dresser handle. Funny how that works.

Early that morning I had promised myself that I was going to shoot completely straight with my doctor. No making light of anything. No diminishing the stuff that had been bothering me emotionally, physically, or spiritually. No faking bravado. I was going to tell the truth, the whole truth, and nothing but the truth. I needed her help, and there would be no pretending otherwise.

It might be surprising, but that Friday morning was the first time in my adult life that I had sat in front of a doctor and laid out every single concern. I felt completely overwhelmed by the fact that I couldn't make my body cooperate with me—I especially couldn't seem to convince it to stop feeling anxious—and I was so desperate for help that when I was face-to-face with my internist, I overshared like a champion. My doctor listened, she nodded, she evaluated, and she affirmed that I did in fact need some help. After a long conversation, a trip to the lab for blood work, some instructions about how to manage the gash on the back of my head, and a couple of new prescriptions, my doctor looked me in the eyes, patted my knee, and said, "We're gonna get this figured out. I promise. And I want you to come back in three months to let me know how things are going."

I will not bore you with the details of my personal medical history, but my doctor definitely figured things out—and

following her plan to shore up the weak links in my system has been life-changing. She looked at the big picture of my health in ways I didn't necessarily know how to see, and she continues to hold me accountable to follow her treatment plan. It's been over two years since I walked into her office a weepy, anxious mess. And at every turn, she has met me with compassion and understanding. She has suggested better strategies for taking care of myself—this is the only body I get, after all—and while she may not know it, she has been a Jethro to me. She has shored up the boundaries around my health, and she is helping me endure. She has increased my peace. Apart from my faith and my family, I'm not sure that there's anything at this stage of my life that means more to me.

There are all sorts of ways our leadership, our boundaries, and our capacities can get off-track. It could be a lack of organization, a lapse in judgment, a challenge with our health, or a refusal to set aside an idol. There are a million possibilities. We are vulnerable, fallible beings, and we're going to run up against our limitations time and time again. Anyone who says that's not the case is probably not well-acquainted with the truth. Or they're very well-acquainted with denial.

This is precisely why leaders will always find themselves in need of Jethros. Leaders need the input and insight of experienced men and women who have wisdom to share and who care enough to use their voices to share it. Jethro might be your mother-in-law, your neighbor, your first boss, or the empty nester who leads small group with you. There might be a Jethro who appears in your life seemingly out of nowhere. Even if you're Jethro-less right now, you can likely look back over the course of your life and see Jethros aplenty.

(This has nothing to do with our current discussion, but I just want to say that if I ever start a band in my old age, I would like the name of the hypothetical band to be Jethros Aplenty. Thank you for dreaming with me, friends.)

I want to be sure to say one more thing. Maybe you're in a phase of life where you're winding down your career, and as a result, your pace isn't quite so frenzied, your boundaries are easier to maintain, and you feel (mostly) rested and recharged on a daily basis. If that describes you, then first of all, WELL DONE. And second of all, maybe—just maybe—this is prime time for you to be a Jethro. Because if you have a lifetime of leadership experience under your belt—a solid history of loving people well and leading in ways that make the best kinds of difference—well, there are likely people in your church or your community who would be oh-so-grateful for you to take a look at what they're trying to build or grow or run or manage. They may have vision, but the breadth of your life and work has given you hindsight, foresight, and insight—a unique combination that helps you see what other people might miss.

So, no pressure, but let's go, Jethro.

There's a Moses or ten out there who really need your wisdom, and I have a feeling that they'll be absolutely delighted by your visit.

EXAMINING YE OLDE BOUNDARIES

Big Ideas & Modern Concerns

I KNOW THAT I HAVE A TENDENCY to be long-winded and overexplain. I've probably known this about myself for most of my adult life, but writing books has really shone a spotlight on this part of my personality. I have gone over my suggested word count in every single book I've written, and while I don't want to be dramatic about my reaction to having to cut 5,000 or 8,000 or embarrassing-thousand words from the final manuscript, I will tell you that every single time, I have felt like I needed stitches or perhaps a light cast in order to properly recover. It just kills me. It also hurts my feelings.

Given that, I am very mindful that as we get closer to the end of this book, word economy is of the essence. Technically this should be my chapter about Exodus 19, but I HAVE TO TELL YOU THIS.

Don't worry, though—I'm going to keep this as brief as I can. Straightforward. I'm not even going to include a story, and as you know all too well at this point, that pretty much goes against everything I stand for.

In the last chapter I mentioned that 1) Jethro helped Moses set some boundaries, and 2) I believe that boundary setting is one of the most critical components of strong, effective leadership. I want to take a little time to explain myself in what I'm going to call a chapterette. Because while setting boundaries isn't Israelite-specific, it is most certainly leadership-adjacent.

I'll kick us off with a big, overarching statement that I believe with my whole heart:

Bad boundaries annihilate good leaders.

Yep. I said it. And I mean it.

You may think that's hogwash, by the way, but I'm standing my ground. For over thirty years I've enjoyed the privilege of watching a lot of talented people use their voices and their leadership gifts in beautiful ways, but I have also witnessed some occupational and relational trainwrecks. Let me tell you what: those trainwrecks will teach you. And the lesson is that bad boundaries are almost always the culprit.

So first, let's make sure we have a shared terminology. What do I mean when I say *boundaries*?

I think author and professor Brené Brown can get us on the same page. She says that "setting boundaries is making clear what's okay and what's not okay, and why."[1] Boundaries, to my way of thinking, at least, might be emotional, relational, procedural, or physical. You can also have boundaries around your time, your health, your communication—wherever you feel it's important to establish guardrails in the interest of your overall effectiveness and well-being.

Sometimes it's difficult to identify our boundaries, but we almost always know when someone is pushing on them. We'll likely feel pressured, stressed, uncomfortable, overwhelmed,

anxious, tired, or maybe even depressed. In my experience, when boundaries get out of whack, I almost always start to feel like the emotional stakes are disproportionately high in the area where I'm struggling. My reactions tend to be disproportionate to the situation—because either I've created an unnecessary problem for myself or someone else is trying to pull me into their drama or problem that shouldn't be mine to solve.

Since I want to be brief and I want to be clear, here's a quick rundown of the most common ways I've seen bad boundaries derail the leadership of really good people—sometimes at work, sometimes at home, and sometimes at both.

1. **Burnout**—You cannot be all things to all people. You cannot be effective when you are perpetually exhausted. We all need the balance that comes from rest and fun. Plus, no one has been called to tend to one thing at the exclusion of everything else. We have to create room for and devote energy to all the parts of our lives.

2. **Unhealthy relationships**—Maybe you've trusted someone in your office despite the red flags that were all over that relationship. Maybe you've developed a pattern of talking down to the people you supervise. Maybe you're so desperate to please your extended family that you're no longer truthful. Healthy leaders prioritize healthy relationships.

3. **Idolatry**—Trust me when I tell you that I feel this one deeply. When we elevate a good thing—could be a job, our kids, a role at church—to a level of importance it was never meant to have in our lives, that idol is always going to fall hard. We should absolutely enjoy that thing and work to be excellent at it, but we need boundaries to help us keep it in the appropriate place in our hearts and minds.

4. **Compromised integrity**—Y'all don't need me to explain this. We all know that when we let our boundaries slide around our integrity, we run the risk of destroying what we have worked to build. And my gosh, it's so easy to let our guards down, to think that little lapses are no big deal, but we need to be vigilant. We need to be wise.

5. **Identity**—That job, commitment, or leadership role is not who you are. Getting our identity tangled up in the work we do usually leads to a distorted perspective of the work's importance. We start asking it to define us, to affirm us, to sustain us, even—and it just can't do that. It *shouldn't* do that. You don't want your whole identity to be *mechanical engineer*, after all. The sum of you is so much greater than that individual part.

Effective leaders establish and keep healthy boundaries. And I figure that if boundaries were good enough for Jethro and Moses, they're good enough for us.

Good chat, everybody.

Boundary up.

ARE WE THERE YET?

OUR FRIENDS KASEY AND JOEL are what I like to call high-capacity individuals. They've been married for twenty-six years, and they're both organized, disciplined, and driven. Basically, this means that they interact with the world in a completely different way than I do. Take Joel, for instance. He's a physician, and it is not unusual for him to finish a shift at the hospital, drive to the lake so he can take care of a boat-related chore, spend the night there, then wake up the next morning and drive to Pensacola to visit with his parents before he and his dad head to Baton Rouge for an LSU football game. He'll drop off his dad in Pensacola the next day, drive home to Birmingham, and be back at the hospital by 6:30 Monday morning.

Just typing that made me tired. But that kind of schedule totally energizes Joel. Same for Kasey.

HIGH CAPACITY.

I, on the other hand, am a low-capacity individual. I try to organize my days so I only leave my house one time—if at all.

I don't like it when my calendar gets crowded. I would prefer not to talk for the first two hours I'm awake in the mornings. I like a TikTok break in the afternoons (to be clear, I'm not creating TikToks; I'm just watching them). I love doing Pilates because the first thing I do after I take off my shoes at the studio is to lie down on a Reformer. I'm rarely happier than when it's close enough to bedtime to put on my pajamas and read. I need lots of time alone to process, to think, to ponder, and to figure out how I'm feeling. It's not that I necessarily subscribe to the adage that slow and steady wins the race; it's just that I like being slow.

LOW CAPACITY.

Interestingly, what Joel, Kasey, and I have in common is that all three of us love people. We love leadership. We love a team. We love being invested in an outcome and committed to a process. We love to win. We love a teachable moment, a sacrifice for the greater good, and a payoff for hard work. By and large we want the same kind of results in everything we do.

But our methods and our approaches? They are very different indeed.

I've been thinking lately about my low-capacity history, and recently I remembered something that happened over thirty years ago (when I tell you that makes me feel like I'm at a point in my life when I need to switch to soft foods, I am not kidding). I was a senior in college, living in an apartment with my friends Emma Kate and Catherine, and I pulled into our parking lot one afternoon just as Emma Kate was getting ready to leave. Now, something I should probably make clear is that Emma Kate and Catherine are both high-capacity individuals, and they have been as long as I've known them. They run things. Organize things. Execute plans. Stick to schedules. They're the people you want in charge of details.

Reader, believe me when I tell you that you do not ever want me in charge of details.

So I got out of my car, and as Emma Kate was walking in the direction of her car, she yelled across the parking spaces between us: "Hey! What's going on? I'm headed to a meeting!" With her keys in one hand and her beloved planner in the other, she was ready to roll. I'm pretty sure I was sporting unwashed hair and wearing sweats. I'm also pretty sure my afternoon plans included a nap.

"Just got out of class, and nothing on the agenda for the rest of the day!" I grinned. This thrilled my soul, you understand.

"I have meetings back-to-back-to-back this afternoon," EK replied. "And you know I love it! I love a productive day!" I laughed as soon as she said it, because a productive day really was one of her favorites. It still is.

Now, if you had asked me that day outside our apartment, I probably would have told you that I didn't care very much about having a productive day. I would have told you that the pressure to be productive in the traditional sense stressed me out a little bit, that I didn't feel like my brain worked fast enough to take on a lot of ideas or tasks or responsibilities at the same time.

And if you had asked me if I ever felt ashamed or embarrassed about how I frequently struggled with finishing what I started, about how often I felt mentally and emotionally overloaded, I probably would have said, "Oh, not at all! It's just how I am!"

But that would have been a lie. Because while I've only been able to put words to it in my middle-aged era, the reality was that I felt deeply ashamed about those things. I wondered if something was wrong with me. I wondered if I was just straight-up lazy. I wondered if I was destined to live an undisciplined, unproductive life.

It seemed like so many of my friends woke up on task and ready to seize the day, but I woke up groggy and ready to fire up the VCR to watch *Broadcast News* for the 644th time. More than anything, I felt like I was surrounded on all sides

by leaders, and I was just a slug who occasionally borrowed a leader's clothes and then wore them like a costume. Maybe I knew how to act the part, but the steady stream of activities that accompanied leadership roles made me feel like the walls were closing in.

And you know what they say about the walls closing in, right? *That probably means it's time to get under a blanket.*

(No one has ever said that.)

(But they should have.)

I wish I had known myself better then. I wish I had understood that I wasn't nearly as extroverted as I imagined. In fact, I wish I had known how to respect my introversion, how to manage sensory overload, and how to protect margin in the interest of some consistency. I wish I had known that productivity can take several different forms.

The good news is that over the last twenty or so years, I think I've figured it out. But man—that took a minute.

High-capacity leaders are invaluable. No doubt about it. I just happen to fall into the lesser understood low-capacity leader category. There's no shame in either game, of course. We're all interested in leader-ish pursuits. But some of us may need a little longer to get to where we're supposed to go.

And require a few more TikTok breaks. Naturally.

●●●●●

Now that we're in Exodus 19, let's kick things off with a broad, sweeping understatement: the Israelites' arrival at Sinai was a significant, historical milestone. You're so welcome for that insight.

Exodus 19 also chronicles God making a covenant with the Israelites and "giving of the law upon mount Sinai, which was one of the most striking appearances of the divine glory that ever was in the lower world."[1] Sinai wasn't a short-term stop,

either; in fact, the Israelites' time at Sinai would last "just under a year" and eventually fill fifty-eight chapters of Scripture.[2]

Maybe Sinai's official slogan should be *Sinai: A Pretty Big Deal.*

Oh, listen. I joke because I'm overwhelmed.

And I'm not even kidding about that last thing. There's just so much—SO MUCH—to take in when we start to examine the back half of the book of Exodus. We're obviously not going to get into many specifics with that—we're going to stay focused on the big picture—but the scope of Exodus 19–40 is something else. I'll tell you another thing, too: it's a lot of instructions. So many instructions. Instructions *for days.*

However, I want to be sure to address a few things that leap to the front of the narrative in Exodus 19, because this passage gives us some large pieces of the big picture puzzle when it comes to Moses' role in the next phase of the relationship between God and the Israelites. So we're going to take a good look at Exodus 19, and then we'll jump over ALL THE LAWS and land at Exodus 40. Even as we jump, though, we don't want to miss that this stop at Sinai centers on how God "wants to engage humans in the fullness of their dignity and responsibility and work through them."[3]

Think about that for a minute. As we've talked our way through the first eighteen chapters of Exodus, we've watched God move in amazing ways to deliver the Israelites, to try to help them see that they could trust him. But in Exodus 19, there's a significant shift—because God told Moses to invite the Israelites to join him in his redemptive work:

> You have seen what I did to the Egyptians, and how I bore you on eagles' wings and brought you to myself. Now therefore, if you obey my voice and keep my covenant, you shall be my treasured possession out of all the peoples. . . . a priestly kingdom and a holy nation.
>
> Exodus 19:4–6

The Israelites unanimously agreed. "Everything that the LORD has spoken we will do" (19:8).

This was a major development. A covenant relationship. A new kind of commitment between God and his people. A fore-shadowing of what the Lord would initiate with all his children through the life, death, and resurrection of Jesus.

And while I don't want to transfer my own personal issues to Moses, I can't help but notice how Moses' responsibilities escalated at Sinai. Now, it could well be that we get more detail because of the magnitude of what happened there between God and the Israelites, but based on the way the back half of Exodus plays out, I tend to think that the covenant didn't just mark a new level in the relationship between God and Israel; it also marked a new level in terms of what was required of Moses. He had long been a prophet and a guide, but in Exodus 19 we see him step more fully into the role of mediator. We see him step more fully into the role of priest.

Meyers reinforces this idea about Moses' leadership. She asserts that his "role in chapter 19 is truly remarkable, perhaps more so than in the narrative up to this point . . . [because] the content of the covenant [is] mediated through Moses. Moses looms large, his presence enveloping and lending authority to the diverse traditions gathered into the narrative of the Sinai theophany."[4]

Certainly, I understand that my perspective is limited, but every time I read this chapter of Scripture, I find myself won-dering how—if I were Moses, which, of course, no—I would keep up with everything required of me. Would I make a new page in my Notes app? Add everything to a Google doc? Start a new list on my trusty neon-colored Post-it notes? Find a piece of stone and get to chiseling?

Since it's the only way my brain can deal, I'm going to put his responsibilities in a list. Here's what our friend Moses did in Exodus 19 alone:

1. Went up the mountain to God.
2. Listened to God's message about initiating the covenant.
3. Went down the mountain.
4. Summoned elders.
5. Relayed God's message re: the covenant.
6. Listened to Israelites give their answer that they would do everything the Lord said.
7. Went back up the mountain to give God the Israelites' answer.
8. Listened to God tell him that he would appear in a dense cloud so people could hear God talk to Moses and trust Moses "ever after" (19:9).
9. Listened to God's instructions for consecrating the Israelites, which included:
 - Telling the Israelites to wash their clothes.
 - Telling the Israelites not to go up the mountain or to touch it. Lest they die.
 Seriously. Die as in *dead*.
 Like, being shot with arrows or stoned.
 - And then telling the Israelites that when the trumpet blew, they *could* go up to the mountain.
10. Went down the mountain again.
11. Relayed God's message re: clothes, death, and trumpet.
12. When the trumpet sounded on the third day, led people out of the camp to meet God at the mountain.
13. Informal but high priority Q&A with God in the dense cloud.
14. Back up the mountain.
15. Listened to God tell him to make sure that the people don't break through to try to take a peek at God.

16. Assured God HEY, I'VE GOT IT—because you already told me to set limits around the mountain.
17. Listened to God tell him to go back down the mountain, get Aaron, but don't let anyone else come back up.
18. Back down the mountain.

And we haven't even gotten to the Ten Commandments yet.

Exodus 19 is no joke in terms of what God required of Moses. It was like the most high-stakes game of Telephone ever. And also one where you ascend and descend a mountain multiple times when you're eighty-something years young and clearly in remarkable physical condition.

What we see Moses do is admirable. Aspirational, even.

But also: the pace of all that?

HOW?

● ● ● ● ●

Many of us grew up with parents who had a lot to say about our work ethic. I couldn't begin to count the ways that I internalized the message, but I knew from a young age that there were certain expectations in our family about working hard and giving it all you had and not stopping until the job was finished.

And no joke: if you want to see someone from my parents' generation—the Silent Generation—completely befuddled in a conversational setting? Bring up the topic of *self-care*. This is a language that children of the 1930s and early 1940s do not speak. Who even had time for such a thing?

Granted, Moses wasn't a member of the Silent Generation, but he also didn't seem to have a slot for *self-care hour* on his daily schedule. In fact, what follows after Exodus 19 is a truly overwhelming amount of information, mediation, and delegation. Establishing the covenant between God and his

people was obviously a huge task, but setting up the framework to live out that covenant? I COULD NEVER. However, Moses sure did.

There were laws concerning the altar, slaves, violence, property, restitution, and justice. There were practices established regarding the Sabbath, festivals, and offerings—not to mention detailed plans for the ark of the covenant, the table for the bread of the presence, the lampstand, and the tabernacle, from the framework to the curtain to the altar of burnt offering to the court to the oil for the lamp.

There were directions for vestments for the priesthood—what to make, how to make it, who would wear it. And that was still just in Exodus 28. Twelve more chapters to go.

The person who was responsible for passing along God's very detailed explanations of what was expected? Moses. The person who was ultimately responsible for every one of these projects being completed according to God's instructions? Moses. There were multiple workers, of course, but Moses was the supervisor. The project manager. The head of human resources. The Chief Operating Officer. Sure, God was ultimately in charge, but in the realm of daily get 'er done, the buck stopped with Moses.

And while I understand that it's hard for me to look at everything Moses had to do through my personal low-capacity lens, I think all of us can agree that he was likely exhausted. The Lord initiated each one of those projects during the year the Israelites spent at Sinai, and my goodness that was an ambitious roll-out plan. Yes, there were plenty of people to do the work, but organizing those people? Following up with those people? Encouraging those people?

All I know is that I hope somebody got Moses registered on TakeThemAMeal.com.

Moses wasn't high capacity. He wasn't low capacity.

Moses was supernatural capacity.

And somehow our friend with supernatural capacity made sure everything was completed. In fact, Exodus 40:33 tells us that "Moses finished the work." When I tell you that I cannot imagine what kind of grit and determination and sacrifice that took, well, just keep in mind that I am a person who, in graduate school, was so completely unprepared for my master's exam that I spent several hours trying to figure out if there was a pain-free way to break my arm and therefore receive an extension.

(I ended up cramming like my life depended on it.)

(And I passed the test. Won't he do it?)

No doubt God picked Moses because he trusted Moses with all the challenges ahead of him. And no doubt the challenges at Sinai were a little bit like eating an elephant, so maybe Moses' strategy was to take it a bite at a time. Maybe he would retreat to his tent and power nap. Maybe he wasn't fazed by the workload at all because, in the words of our more youthful friends, he was just built different. Not to mention that when Jethro gave him some time management pointers a few chapters back, Moses listened. He learned the lesson.

And the end result of all his hard work? God's glory filled the tabernacle. God's glory entered his earthly dwelling place. According to Exodus 40:38, "For the cloud of the LORD was on the tabernacle by day, and fire was in the cloud by night, before the eyes of all the house of Israel at each stage of their journey." All of Moses' responsibilities and tasks and to-dos ultimately provided a sanctuary for the Lord to shine his light and show his covenant children the way.

So, a takeaway: it's critically important for leaders to understand what kind of capacity they're working with. It may even be essential, because we don't want to burn out or give up while the Lord still has work for us to do. And it's good to remember that we're not racing against anyone, we're not trying to beat anyone, and we certainly don't have to run at a pace that's not sustainable for us. We want to follow Moses' lead and finish

whatever the Lord has given us to do, not so that someone will hang a plaque that says YOUR-NAME-HERE KILLED IT, but so that the glory of the Lord fills whatever he graciously enables and empowers us to complete. So that our work will be a light for him and a beacon for his people.

It just occurred to me that our voices won't carry very effectively if we're hoarse and worn out from running ourselves ragged. Leaders don't have to push themselves to the edge of their limits, and they don't have to squeeze themselves into someone else's mold. That's true whether we work most effectively when we take our low-capacity time to pace ourselves, make room for rest, and thoughtfully create margin around each next step—or whether we move at more of a high-capacity clip and synthesize information quickly, delegate complex tasks with ease, and burn the midnight oil whenever necessary. There's nothing prescriptive about Moses' methods.

But he was faithful. He finished.

And that's a big-picture perspective we need to be sure to see.

TAKE A LOOK DOWN THE ROAD

MY DADDY RETIRED when he was fifty-five years old. He worked for the state of Mississippi his entire career, and as soon as the calendar flipped to the thirty-year mark, he boxed up his belongings, took the nameplate off his desk, and turned in his keys. If Daddy was at all puzzled by the question of what might be ahead for him, nobody would have known it. As much as he had loved and excelled at his work, he was thrilled to close that chapter of his life and keep on keepin' on to whatever might be next. I was a recent high school graduate—about to leave home for my first year of college—and as proud as I was of my daddy, I distinctly remember considering Daddy's retirement and thinking, *Gosh—fifty-five is, like, OLD.*

I am fifty-four as I write this book, and for the record, fifty-five is most definitely NOT OLD. Daddy was a spring chicken when he retired. AS I AM NOW.

And of course I'm kidding about that last thing. Because while I may still feel twenty-seven *in my heart*, at fifty-four I am

not far from being eligible to live in a retirement community. In fact, on a flight last week I overheard a young man tell his seatmate about his work with the elderly—"you know, fifty-five and up," he said.

In case you are wondering, that is when I considered swatting him over the head with my in-flight magazine.

It's bizarre, the aging, because on one hand you feel like you're exactly who you have always been (HAVE YOU HEARD THE NEW PRINCE CD MY GOSH IT'S SO GOOD), and on the other hand you are constantly reminded that time is really starting to get away from you because you're almost the same age that your father was when he retired. There's also the ever-increasing awareness that trying to slow down time in any way is basically like trying to catch sand. You can't do it. What that means is that in a little over six years, Lord willing, I will be sixty years old. And also, Lord willing, it means that I might have twenty-five good years of writing and speaking ahead of me. Maybe more? I don't know. I'm trying to be optimistic but not presumptuous.

Also, will Melanie and I still want to podcast when we're eighty? Why is it so weird to think about that? Why am I asking so many questions right now?

Here's the deal: at fifty-four I'm very hopeful for the life (and the living!) that's ahead of me, but I feel a little bit like a reliable old car that requires more maintenance than it used to. Yesterday I had a doctor's appointment where we talked about what hormone supplements I might need to incorporate into my wellness plan. I regularly go to Pilates classes because I want to be able to get on the floor with my hypothetical grandbabies and not require anyone's assistance to return to a standing position. Every two months I go to my favorite day spa and get resurfacing facials—sort of like I'm a well-traveled road in need of repair. And while sure, part of the reasoning behind doing these things is that I want to take care of myself, there's

another reality that lingers in the background: eventually the stuff I take for granted is going to become increasingly difficult, so I need to be proactive now.

Also: time will win. Not a single one of us has been granted immunity against it. And try though we may, we cannot stop it. We may think that we can prolong our surrender, but make no mistake: surrender is inevitable.

Plus, there's this: apart from the physical concerns, I feel like my friends and I are at an age where there's an urgency, almost, about examining our lives with honesty and candor. We're asking ourselves similar questions: *How has it all gone so fast? How do I maximize every part of this current season? How do I finish well? How do I stay strong in mind and spirit?*

Yes, most of our kids have left home, but there are still responsibilities aplenty. Parenting looks different these days, and in some ways the stakes are higher. Frustrations haven't disappeared just because I'm forever free of driving to lacrosse practices (MAY THE LORD BE PRAISED). Challenges may have shifted and changed, but they haven't gone away. And they won't.

So there are moments when I literally sit and wonder, *When over half of your life is in the rearview mirror, what does it look like to continue to use your voice and lead and fight the good fight?*

And what does it look like to live that way all the way to the end?

* * * * *

After Moses completed the tabernacle at the end of the book of Exodus, his work continued. In fact, his work continued for about thirty-eight more years. But lest we're tempted to minimize the events in the early days of the Israelites' wandering and Moses' leadership—all chronicled in Exodus—Bob

Deffinbaugh reminds us of the magnitude of those first two years in the wilderness:

> [The Israelites] looked on as Moses confronted Pharaoh and witnessed the plagues that God brought upon the gods of Egypt, eventually bringing Pharaoh to his knees. . . . They saw God part the Red Sea before them, and then send it crashing down upon Pharaoh's army. They saw and heard the evidences of God's majestic presence at Mount Sinai. . . . They experienced God's guidance and protection. . . . God literally performed miracles daily to care for His chosen people.[1]

That's precisely why it's so frustrating to read what happened after the Israelites left Sinai. The Israelites reached Kadesh Barnea—where they could enter the Promised Land—but after they sent twelve people inside to spy on the Canaanites, they decided they were too frightened to stay. Only Joshua and Caleb believed they could make it, and everyone else told Moses and Aaron that "the people who live in the land are strong, and the towns are fortified and very large" (Numbers 13:28). Their fears kept them from taking residence in the land that God wanted to give them.

The Israelites' refusal to enter the Promised Land really set the tone for the next thirty-eight years. There were strong behavioral patterns in place—group dynamics, if you will—and while there were certainly enemies from outside the camp, the books of Numbers and Deuteronomy make a case that the greatest enemy the Israelites battled was, ultimately, themselves.

It would seem totally fair if Moses had just thrown up his hands at Kadesh Barnea and walked away. After all, he was old, and he was no doubt drained, and he was doing his best to lead a group of people whose repeated efforts to believe were in constant conflict with their fear. In Deuteronomy, in fact,

Moses clearly expressed his dismay at the Israelites' continued insistence on disbelief: "You saw how the LORD your God carried you . . . all the way that you traveled until you reached this place. But in spite of this, you have no trust in the LORD your God, who goes before you on the way . . ." (Deuteronomy 1:31–33).

This would have been the perfect spot in their journey for Moses to politely gather his belongings and pursue a life of leisurely retirement.

But that's not what he did. Moses stuck with the assignment God had given him. At the risk of oversimplifying: for the thirty-eight years after the Israelites shook their heads in defiance at the prospect of entering the land God had given them, Moses kept going. Kept leading. Kept using his voice to testify to God's faithfulness. Kept trying to move the Israelites in the right direction.

Here are a few post-Exodus examples.

1. Moses interceded for the Israelites after they refused to enter the Promised Land (Numbers 14:11–19).

When the Israelites said "no thanks" to the Promised Land, God was ticked. He said to Moses, "How long will they refuse to believe in me, in spite of all the signs that I have done among them? I will strike them with pestilence and disinherit them" (Numbers 14:11–12). Moses, however, pleaded for mercy and beseeched God to stick with the Israelites; he said, "Forgive the iniquity of this people according to the greatness of your steadfast love, just as you have pardoned this people, from Egypt even until now" (Numbers 14:19). This situation makes me think of times when David and I have both been incredibly frustrated as parents but, for whatever reason, one of us wasn't quite as prone to exercise the nuclear option as the other. In this case Moses'

intercession literally saved the Israelites' lives. He fought for the people he had been charged to lead—as he had done before and would do again.

2. **Moses continued to serve even after he messed up (Numbers 20:8–13).**

It was much later in the Israelites' journey—closer to the forty-year mark—when God told Moses and Aaron to "assemble the congregation . . . and command the rock before their eyes to yield its water" (Numbers 20:8). This moment echoed Exodus 17; when the Israelites were thirsty, Moses struck the rock, and water poured out. In Numbers, however, God specifically told Moses and Aaron to command the rock—not strike it—but Moses, whether out of frustration or rebellion or some combination of the two, struck the rock twice (Numbers 20:11). He also referred to the Israelites as "rebels" (Numbers 20:10), so, you know, it wasn't Moses' finest or most patient hour. Water still poured out of the rock, but God informed Moses that there would be a consequence: "Because you did not trust in me, to show my holiness before the eyes of the Israelites, therefore you shall not bring this assembly into the land that I have given them" (Numbers 20:12). After almost forty years in the wilderness, Moses wouldn't be able to enter the Promised Land because of his disobedience. However, Moses didn't storm away. He accepted his consequence and didn't abandon God or the Israelites. He continued to lead and serve.

3. **Moses invested in the generation behind him (Numbers 27:12–23).**

Logically we all know that we can't live forever, and logically we all know that we'll eventually reach

a point where we pass the torch of leadership to the next generation. It's not always the easiest reality for our pride, but it's a transition we'll hopefully approach with humility and wisdom. When God reminded Moses that he would only *see* the Promised Land—not enter it—because "you did not show my holiness before [the Israelites'] eyes" (Numbers 27:14), Moses asked God to appoint a successor. God appointed Joshua and gave Moses instructions for how to commission him. Numbers 27:22 tells us that "Moses did as the LORD commanded him." Moses also entrusted some of his responsibilities to Joshua, and when God told Moses to "encourage and strengthen" Joshua (Deuteronomy 3:28), Moses did just that.

One more thing to think about.

Throughout Moses' journey with the Israelites we're reminded of how important it is to *see*—to see who God is, to see what God has done, to see God's faithful care, to see God's holiness, to see God's people, to see God's provision. As image bearers, we are people who are made and meant to notice, to watch, to recognize, and to behold.

I'm convinced that's because really and truly *seeing* often precedes leading, encouraging, trusting, and believing. That doesn't mean it's a surefire leadership formula; as we know all too well, there were plenty of times when the Israelites proclaimed what they had seen and then promptly forgot about it. But God and Moses never stopped reminding the Israelites to trust what they had seen, and to look up when they were tempted to focus on their circumstances or themselves.

So all that to say: it stands to reason that one of the main ways that Moses was able to keep going and continue leading in the direction of deliverance is because he kept seeing. He never lost sight of how precious the Israelites were to God. He

never lost sight of his assignment. He never lost sight of the possibility of total freedom for God's chosen people. He never lost sight of God's goodness and kindness and care.

Moses stayed the course.

He kept seeing.

And he kept going.

●●●●●

Last summer my sister, Suzanne, retired from her career in the music industry. She worked for the same company for over forty years, and just days after her retirement, she and her husband, Barry, moved to Birmingham. They bought a house right up the hill from us—about a quarter of a mile as the crow flies.

If you're wondering if this is as dreamy an arrangement as it sounds, I can assure you that yes, yes, it is.

One of my favorite parts of Sister and Barry being so close to us is getting to live regular, everyday life together. From the time that I was eleven they lived in Nashville, so this is the first opportunity David and I have had to really bear witness to their everyday lives. It's the first time I've been able to pop into my sister's house mid-morning for a cup of coffee. It's the first time she's been able to call and see if I want to go with her to get a manicure. It's the first time we've been able to have standing Friday night supper plans. The fact that we get to watch Sister and Barry navigate this new season of their lives (retired! footloose! free!) is the icing on top of the my-sister-is-now-my-neighbor cake.

And do you know what just fascinates the fire out of me? Sister does so much of what I watched Daddy do in his early days of retirement. She makes sure every day has purpose. She listens to thirty-eight different podcasts and somehow keeps the plotlines organized in her head (with Daddy that

would have been mystery novels instead of podcasts, but same general idea). She checks on her former coworkers and friends who have become more like family. She continues to serve organizations that have meant the world to her. She loves to meet people, to laugh at a good story, and to welcome guests. She creates the loveliest spaces in her home and her yard (at least once a week she'll say, "This is a house of joy and hospitality!").

And almost every single day, I'm mindful that it is a gift and a privilege to stand back and watch Sister go first in this particular way. I know that technically she has always gone first—that's the deal when you're the lead-off hitter in the birth order lineup—but there's something about my current phase of life that makes me especially dialed in to her example. Do we agree on everything? We do not. Do we have the exact same interests? Nope. And that's okay. She's the matriarch of our family now, and she's leading us. I'm one-hundred-percent taking mental notes—just like I have with Daddy. It's important to do this with people who lead us in our very regular, very real lives.

It's also important to do this with people we know through Scripture. Obviously, I never got to watch Moses do his thing in Egypt or Sin or Rephidim. I never got to witness him making the 472 trips up and down Mount Sinai. Even still, his legacy, as documented in Scripture, is an instruction manual for what it looks like to lead sacrificially, humbly, and consistently. He wasn't perfect, but he was specifically gifted to lead the Israelites. Yes, he was broken. He was flawed. For a while there he was really looking for a loophole that would get him out of what God had asked him to do. He didn't have an official title or, you know, a salary, but to say that his leadership was historically and spiritually significant is a world-class understatement. It remains the very foundation of the faith we cling to and claim.

Here's the truth: no matter how old we are, if we want to lead well—if we want to be women who keep going through every age and stage—we need to be ever mindful not just to keep seeing, but to have discernment about what we see. I'm about the farthest thing from an alarmist, but for the rest of my days I will remind people I love that we have to be both careful and wise about whose example we're watching and following. As believers, how we lead matters so much; what we pass on matters even more.

A few years ago Daddy and I were sitting in my den on Christmas morning, watching *A Christmas Story* while I was figuring out my cooking timetable for the day. Every so often Daddy would share a current events tidbit as he read the news, and as I finished my to-do list, Daddy—who was eighty-eight at the time—looked up from his iPad and made an announcement that caught me completely off guard: "I just want you and your brother and sister to understand something. I intend to make some plans over the next few years. I don't know how much time I have left, but there are still a lot of places I want to go. There's still a lot I want to see."

I have thought about Daddy's declaration countless times since then. And every single time, I think, *Well, I relate to that.*

Because yes. I'm fifty-four. I'm officially in the second half of my life. I have so many age spots on my left arm that I think of my Papaw Davis every time I wear a short-sleeve shirt. I have at least four gray eyelashes that refuse to play nicely with my other eyelashes and really seem to revel in their rogue status. The only reason I can still call myself a blonde is because my hairdresser, Carla, regularly covers my hair in foil and chemicals. But oh my word, there's still so much I want to do and see. And with whatever time I have left, by diggity, I intend to do some living and loving and leading. I want to keep using my voice to make a difference.

Whether you're twenty-four, ninety-four, or somewhere in between, I hope with everything in me that the same is true for you.

Let's don't miss an opportunity to do some seeing, everybody.

Let's do some leading.

And let's keep going.

HOLD ON TO WHAT YOU'VE SEEN

AT SOME POINT IN THE EARLY '70S, my mama became deeply interested in yoga and calisthenics. It probably goes without saying, but the practice and discipline of yoga was not exactly the norm for a stay-at-home mama in Meridian, Mississippi. However, knowing Mama's relentless persistence in taking care of her health and preserving her personal sense of peace, there's not a doubt in my mind that the low-impact, contemplative element of yoga and calisthenics was a perfect fitness fit for Ouida Sims. She was self-taught and read everything she could get her hands on.

Mama's college degree was in health and physical education, and when I was around three, she began teaching ladies' exercise classes that enabled her to share what she had learned both in undergrad and through her own study of yoga and calisthenics. Since most of her classes were in the fellowship halls of local churches, Mama loved to teach exercise for an hour and then close with a short devotion and prayer for the ladies who attended. Several of her students were active and devoted members at the local Jewish synagogue, so Mama was

always mindful about having a devotion time that would be as meaningful to her Jewish friends as it was to her Christian ones.

The fact that I remember that all these years later kind of makes me want to cry. Mama would have never called herself a leader, but she was, and she wanted those ladies, who came from a variety of faith backgrounds, to feel welcome and at home in the churches where she taught. She wanted the women to know they were loved and respected, and she treasured her relationships with them.

In the summers, when I wasn't in school, I would accompany Mama to her classes and then roam the halls of the churches where she taught. Most days I would find an empty Sunday School room and draw on the chalkboard or practice my dance routines, but I would always make it back to the fellowship hall for the last ten minutes of class. That's when Mama would lead her classes through a relaxation exercise, and the ritual of it was pure comfort.

"Relax your toes," Mama would begin, her soft, Southern voice projecting across the room as she clearly enunciated every syllable. "Relax your insteps and your ankles. Relax the lower part of your legs, your calves, your knees, and your thighs. Bend one knee if your back is tired."

Mama would continue with her instructions—working her way through the abdomen, neck, and shoulders—and when she got to the part where she would remind everyone to relax their arms, I knew class was almost over. There were only a few more steps:

"Relax your jaw . . . relax your mouth . . . relax your eyes . . . now breathe all the way in—and breathe all the way out."

I can recite it from memory even now.

A couple of years ago our friend Joel offhandedly mentioned that we tend to carry stress in our hips, and something about that made me realize that I wanted to exercise in a way that would open my hips, that would remind me to breathe deeply,

that would help me to be strong for all the life that's ahead. So at the beginning of 2022, I decided I was going to try Pilates. Did I know exactly what a Pilates workout was like? I did not. But I knew Pilates involved a lot of stretching, and something about that sounded like it would be kind and healing for my body. Also hip-opening. Just what I was looking for.

So one Saturday in January, I went to an intro class at a Pilates studio not far from our house. We didn't do a full workout, but we did enough movements to remind me of my days in ballet classes, which made me more certain than ever that I wanted to give Pilates a try. Before I left the studio that day, I signed up for a membership and bought myself a pair of fancy grippy socks. I was ready for my new exercise adventure.

It was during my third or fourth class when I noticed that my instructors used language that took me right back to those long-ago mornings in Mama's exercise classes. As we prepared for our warm-up, they would remind us to breathe in deeply as we pushed back the Reformer carriage, then to breathe out deeply as we returned the carriage to the stopper. I'll never forget when one of my regular teachers, Amy, encouraged us to relax our eyes and our mouths when we were holding a position during our arm work. *Mama would have loved this*, I thought. Then I realized that I needed to wipe the tears from my eyes.

After I noticed the connection between Mama's exercise classes and what we were doing at Pilates, I couldn't unsee it. It was everywhere—in our balance work, in our mermaid stretches, in our bridges, in our leg extensions. And while these last two years at Pilates have absolutely been a way for me to take care of my mind and my body, I never anticipated that I would experience such a strong sense of connection to my mama—or that my classes would awaken such fresh appreciation for my mama's leadership.

Over the course of my last five or six years at school, I became increasingly aware of how much time I spent bending

and folding and contorting myself so that I could fit into a box that institutions and denominations created for me. If I wanted to keep the peace—and that is almost always my temptation and my preference—I had to mind my manners and fall in line, maybe most of all when I disagreed. To be clear, nobody *made* me do that; in my own way I was just trying to meet expectations that I believed to be without motive. That I even believed to be holy.

But the end result of all that twisting and knotting? Anxiety. Anger. Resentment. Self-medicating with food. Abandoning my freedom in Christ for the sake of keeping religion's rules.

What Pilates has done for me—more than anything else—is facilitate my unbending. My untangling. It has helped me work out the kinks that settle in when you're out of alignment. It has reminded me what it feels like to lengthen my spine, to strengthen my limbs, to literally stand all the way up. And what's been so incredibly special is that with every movement—in every class—I know that the person who laid the foundation of my love for what we practice in Pilates is Ouida Joyce Davis Sims.

Mama paved the way, and there are days when I get in my car after class and feel like I can hear her voice in my head: *I'm so proud of you, Sophie Sims. You're healing. You're better.*

I am. And in the most beautifully unexpected way, Mama has been teaching and loving and leading me through every bit of it.

• • • • •

It likely wasn't a shock to Moses—he was one hundred twenty years old and "no longer able to get about" (Deuteronomy 31:2)—but after forty years of leading the Israelites, he heard some very specific news from the Lord: "Your time to die is near" (Deuteronomy 31:14). The Lord also instructed Moses to write a song to teach to the Israelites, one they could remember long after his death. No one understood the Israelites'

struggles and fears and temptations quite like Moses, and while the tone of the song (Deuteronomy 32:1–43) reveals that Moses may have grown somewhat weary from dealing with the same persistent issues, he was as committed to teaching the Israelites as he had ever been. In fact, after he shared the song with them, he said, "This is no trifling matter for you, but rather your very life; through it you may live long in the land that you are crossing over the Jordan to possess" (Deuteronomy 32:47).

We don't have any way of knowing what Moses' long-term expectations had been for the Israelites. If there was a stone tablet somewhere with WILDERNESS GOALS etched on top of it, Scripture gives us no indication of that. My hunch is that when the Israelites refused to enter the Promised Land after the two-year mark, the following three-plus decades at least occasionally felt like an endless slog. Sure, there was enormous progress in terms of laws and procedures and policies, not to mention building a tabernacle, but the frustrations that naturally arise when you're leading and working with people can take a toll.

Then there was this: by the end of Moses' life, he knew that he would not inhabit the Promised Land, nor would he see the Israelites take possession of it. As I mentioned in the previous chapter, Moses didn't question God's punishment for hitting the rock at Meribah instead of commanding it, but from my very human perspective, it was a sad trombone moment. I'm not saying that Moses deserved to enter the Promised Land in a shower of confetti and fabulous prizes, but after giving one-third of his life to the deliverance of the Israelites, was he maybe just a tiny bit bummed? Discouraged? Sad?

Based on what we see in Scripture, Moses accepted his fate and used it as a teachable moment for the Israelites. In Deuteronomy, Moses told the Israelites this:

I am going to die in this land without crossing over the Jordan, but you are going to cross over to take possession of that good

land. So be careful not to forget the covenant that the LORD your God made with you, and not to make for yourselves an idol in the form of anything that the LORD your God has forbidden you.

Deuteronomy 4:22–23

And later, when God told Moses to go up Mount Nebo—where he would die—and "view the land of Canaan" (Deuteronomy 32:49), God reminded Moses that he could only "view the land from a distance" (Deuteronomy 32:52). What a gut punch, you know? But after all we've learned about Moses—after all we've seen—the way he responded in Deuteronomy 33 shouldn't surprise us at all.

Because in his last leadership hoorah, Moses didn't air his grievances or proclaim his resentments. Instead, he blessed Israel. He blessed the nation whose fate had completely consumed his life for the last forty years. He prayed specifically for the leaders of the tribes before he began his final charge to the Israelites: "There is none like God, O Jeshurun, who rides through the heavens to your help, majestic through the skies" (Deuteronomy 33:26).

(I'm pausing for a minute because I'm bawling my eyes out.)

(Please hold while I retrieve a box of tissues.)

(Thank you for your patience.)

It's the very last time that Moses exhorted the Israelites with his words, and in that one sentence from verse 26, he reminded the Israelites—and us—of the majesty and power of the Lord. It's remarkable, not to mention encouraging, that at the end of his time on earth, Moses still saw exactly who God was and is and will be forever: righteous, holy, faithful, powerful, and true. After the heartaches of Moses' life, the frustrations in the wilderness, the doubts and disappointments in himself, Moses still loved and trusted the Lord. He wanted the Israelites to do the same.

Moses then went up Mount Nebo—just as the Lord had instructed him—and he looked out at the land of Canaan. "I have let you see it with your eyes" (Deuteronomy 34:4), the Lord told him. After four decades of leading the Israelites and at the very end of his life, Moses finally set his sight on an unobstructed view of the "good and broad land" (Exodus 3:8).

On top of Mount Nebo, Moses finally completed all that the Lord had appointed him to do. And "Moses, the servant of the LORD, died there in the land of Moab, at the LORD's command" (Deuteronomy 34:5).

We first met Moses when he was a baby in Egypt, placed in a basket on the banks of the Nile. Then he was spotted by his sister, rescued by Pharaoh's daughter, raised by his mother, returned to Pharaoh's daughter, self-exiled to Midian, married to Zipporah, taught by Jethro, and chosen by the God of the universe to set the nation of Israel free. In the years that followed, he defied Pharaoh, witnessed miracles, mediated disputes, issued decrees, rebuked disobedience, fought battles, implemented order, led Israel, and followed the Lord until his very last breath.

Even his death was marked by obedience. And centuries later, we still know him as a fearless, selfless, trustworthy leader who never gave up on God's promise of deliverance.

Wilderness goals, right? All day long.

●　●　●　●　●

Way back in our very first chapter, I mentioned that I started writing this book after I read through the book of Exodus on a Southwest flight from Birmingham to Houston. I was on that flight because I was going to see my lifelong friend Marion for a few days. And listen, bless her for what she had to endure on that visit, because pretty much as soon as I got to her house, I launched into an overly animated account of Exodus and Moses

and *see*ing and how I thought all of these things had a lot to teach us about leadership both inside and outside the church.

Oh, I bet you can't wait to have me for a houseguest. I'm a real Old Testament party.

The next morning I woke up early, fixed myself a small vat of coffee, and settled into a corner of the couch in Marion's den because I wanted to read through Deuteronomy. I felt like I needed the account of the end of Moses' life to give me a fuller, better picture of all the things he teaches us, so I pulled out my blue pen and started marking my way through the fifth book of the Bible. We've already talked about some of what I noticed, but what really jumped out at me was Deuteronomy 34:7, which says this about Moses at the end of his life: "His sight was unimpaired."

OH. COME ON, NOW.

THAT'S A WHOLE ENTIRE SERMON.

So as we wrap up our time together, I want to encourage you with three takeaways from the end of Moses' life. These apply to any role where you're entrusted with authority over other people, and I think we'll all be better leaders if we take these things to heart.

1. We want to be leaders with unimpaired sight.

Since Moses' unimpaired sight is mentioned in conjunction with the fact that "his vigor had not abated" (Deuteronomy 34:7), I know that this was likely a description of his one-hundred-twenty-year-old physical abilities. However, let's not forget that a more figurative clarity of vision matters deeply when it comes to leadership. I talked about this at the beginning of the book, but I cannot overstate it: as leaders we have to relentlessly and persistently inventory whether our vision is clouded by anything that could hinder our integrity or effectiveness, whether that's hatred or pride or apathy

220

or disbelief or hypocrisy or a million other things that can jack up our sight.

2. We won't always witness the fruit of our labor.

It's difficult for us to consider that we can lead and invest and love and then not get to see the end result of all that. Here's what Moses' life teaches us: scatter seed anyway. Thank the Lord for the field he has given you. Trust that good things will grow there. God will harvest what he has promised whether you're there to see it or not, so your work is never in vain.

3. We want people to see God, not us.

It's interesting—and telling—that no one knows where God buried Moses. I imagine that if we did know, there would be a whole lot of us who would traverse Mount Nebo to pay our respects at Moses' grave. But we can't. What we can do, however, is thank God for the work he did through Moses, for the ways he has initiated the deliverance of his children—first through Moses and then through Jesus. We want the world to know them both. We can also honor Moses' legacy of God-focused leadership by becoming God-focused leaders. Writing this book has been such a reminder that humble, God-honoring leadership ripples in really beautiful ways, and it can ripple for a really long time. After all, if the lessons we pass on as we use our voices to lead are life-giving and true, then they'll always be worth remembering and repeating. As someone whose mama's leadership on a yoga mat in a church fellowship hall followed me all the way to a Pilates studio in Birmingham over forty years later, I say this with confidence. And not to put too fine a point on it, but we've spent twenty chapters discussing Moses' example—and he lived and led over three thousand years ago. That's a mighty fine ripple.

You can likely make a long list of the leaders whose leadership has rippled in your own life. No doubt those people have changed your perspective and pointed you in the direction of freedom over and over again. We never want to lose sight of their impact because we'll continue to learn from it. And, as believers, when we consider how certain people's leadership has changed us for the better, we'll likely see ripples of how Jesus loves and leads us: sacrificially, consistently, truthfully, intentionally, and redemptively. As leaders this is our standard. This is our bar. This is our aim.

I wish I could end this book by leading all of us through Mama's relaxation exercise, but we might fall asleep—not to mention that it's tricky to read and relax at the same time. However, if you don't mind, I'd love to follow Mama's lead and pray for you. It'll be difficult to replicate the distinctive echo of a fellowship hall, but we'll do the best we can.

Dear Lord—

Thank you for the friend on the other side of this book. Thank you for the unique gifts you've entrusted to her. Thank you for the hope she offers to the world through her willingness to lead, her generosity of spirit, and her commitment to care for others. Thank you for the challenges that have shaped her and equipped her to love people with empathy and compassion.

I pray that my friend will continually be strengthened and encouraged by your Word, your Spirit, and your Church. I pray that you infuse her words and her actions with kindness, honesty, and patience. I pray that you are always her source of joy, motivation, and contentment. I pray she will look to you as sustainer, redeemer, shepherd, and friend—and she will know you as the foundation of everything that is righteous and true.

Help her remember, Lord, how you have carried her and delivered her—and help her love others sincerely and deeply. Help her live without fear.

Mark the road ahead with your wisdom and your guidance.

Cover your child with your favor, your grace, your courage, and your peace.

Help her to clearly see you, your provision, your protection, and your people. Forever and ever.

In your merciful name—

Amen.

You, my friend, are a leader. Full stop. Not a single doubt about it. God has given you the most beautiful voice to love and lead in the direction of deliverance.

So with the good gifts God has given you, embrace every opportunity to make the best kind of difference in the world, to call people to higher and better.

You were made for it.

Can't you see?

●●●●●

But Mary stood weeping outside the tomb. As she wept, she bent over to look into the tomb; and she saw two angels in white, sitting where the body of Jesus had been lying, one at the head and the other at the feet. They said to her, "Woman, why are you weeping?" She said to them, "They have taken away my Lord, and I do not know where they have laid him." When she had said this, she turned round and saw Jesus standing there, but she did not know that it was Jesus. Jesus said to her, "Woman, why are you weeping? For whom are you looking?" Supposing him to be the gardener, she said to him, "Sir, if you have carried him away, tell me where you have laid him, and I

will take him away." Jesus said to her, "Mary!" She turned and said to him in Hebrew, "Rabbouni!" (which means Teacher). Jesus said to her, "Do not hold on to me, because I have not yet ascended to the Father. But go to my brothers and say to them, 'I am ascending to my Father and your Father, to my God and your God.'" Mary Magdalene went and announced to the disciples, "I have seen the Lord"; and she told them that he had said these things to her.

John 20:11–18

ACKNOWLEDGMENTS

From the time I boarded that Southwest flight to Houston until, well, right now, working on *A Fine Sight to See* has been a joy. Honestly, I don't know when I've gotten a bigger kick out of the writing (and researching) process, and I think a lot of that has to do with how much I love Moses. What a gift to dig into his life, his leadership, and his legacy. All these months in Exodus and Deuteronomy have taught me, encouraged me, and, in some unexpected ways, healed me. Moses was a prophet and a protector. He remains a really fine teacher. I'm so grateful that we all get to learn from him.

Thank you to Lisa Jackson, Jennifer Dukes Lee, Elisa Haugen, and the team at Baker / Bethany House for treating this book (and me!) with such kindness and care. Thanks to Melanie Shankle for reading every word of my first draft and offering such clear, honest feedback. Thanks also to Erin Moon, who always comes through as a human thesaurus. Here's to many more writing retreats in North Carolina ("DAAAAAD!") with Mel and Erin, and please, Lord, may they all take place during the College World Series.

Thank you to Retha Nichole for keeping me on track, holding me accountable, and telling me the truth even when I don't

want to hear it. What in the world would Melanie and I do without you?

Thank you to Kasey Mixon and Stephanie Coons for always listening, always encouraging, and always being game for a Culver's mini Concrete Mixer. Thanks to Heather Mays for post-Pilates class lunches and never tiring of conversations about the deep stuff.

Thank you to Beth Moore for blazing a trail, writing sentences that are a master class in active verbs, and loving Jesus more than her reputation.

Thank you to my daddy, Bobby G. Sims (remember, the *G* stands for GOAT), for setting a high bar and showing his children what it looks like to live a long life of leadership. We're the luckiest.

Thank you to Alex Hudson, who makes every day better just because he's in it (and who would excel in sarcasm if it were a category on the SPIRITUAL GIFTS INVENTORY), and David Hudson, who is hilarious and steady and true and my absolute safest place. Y'all are my favorites. I love you, Faith Family.

Last thing. Recently I told Alex that I was sorry he's had to witness some of the faith-related heartache and disillusionment I've experienced over the last six or seven years. It's not that I've worried about it, really, but certainly my hope has been that my struggles—which I've tried to deal with openly and candidly, especially within the walls of my house—haven't impacted *his* faith in a negative way. So we talked about it, and at the end of our conversation, I said something to him that I'm going to repeat to you.

There have been times over the last few years when the church—which has been a huge part of my life for my whole life—has felt almost like a stranger to me. I've seen hatred hiding in places I thought were sacred, and I've seen manipulation get all dressed up and pretend like it was God-honoring ministry. Finding my way to the other side of that has been

overwhelming sometimes. It's been heartbreaking. But through every bit of it, here's what I know that I know that I know: *Jesus holds*. He is our Anchor when everything else threatens to give way.

That's why I want to be sure to say this: thank you, Jesus, for your patience, your mercy, your grace, and your peace. Thank you for being my Savior and my Friend. You don't just see us— you love us—and that love changes everything. You are the Light that shows us the way. Help me to walk in your Light—to love and lead right there—for the rest of my days.

RESOURCES THAT HAVE BEEN HELPFUL

These resources have been helpful and instructive as I've considered women's roles in general and women's leadership in the church in particular.

You may not land where I've landed, and that is oh-so-fine. We all have to discern where our boundary lines are, and my prayer is that there's joy as you live and lead in those "pleasant places" (Psalm 16:6). I also pray that we would be willing to humbly examine and discuss differing viewpoints—as well as consider if we've been conditioned to fear more than we've been encouraged to learn.

You may look at this list and feel tempted to label me or put me in a box in terms of my personal opinion. I get it—but I promise you that I am way more interested in bridges than I am in labels and boxes. These voices cover a spectrum of denominational and theological perspectives. Enjoy them all.

Abuelita Faith by Kat Armas
All My Knotted-Up Life by Beth Moore
Baptistland by Christa Brown

The Blue Parakeet by Scot McKnight

Carved in Ebony by Jasmine L. Holmes

Jesus and Gender: Living as Sisters and Brothers in Christ by Elyse M. Fitzpatrick and Eric Schumacher

Jesus and John Wayne by Kristin Kobes Du Mez

"Let's get the girl." by Hannah Anderson in *Fathom* magazine

The Making of Biblical Womanhood by Beth Allison Barr

"Rick Warren Reflects on His Legacy" Russell Moore with Rick Warren on *The Russell Moore Show* podcast

"Stuff We Didn't Get in Sunday School: Paul's Letters with N. T. Wright" Erin Moon, Jamie Golden, and Evan Dodson with N. T. Wright on the *Faith Adjacent* podcast

"Who Says?" sermon by Sean Azzaro at River City Community Church in Selma, Texas, on July 9, 2023

"Why Honoring the Gifts of Women Is Relevant to Dechurching" Jim Davis and Michael Aitcheson interview with Jen Wilkin on the *As In Heaven* podcast

A Year of Biblical Womanhood: How a Liberated Woman Found Herself Sitting on Her Roof, Covering Her Head, and Calling Her Husband Master by Rachel Held Evans

NOTES

Chapter 1 Because I Hope Some Context Is Helpful

1. Scot McKnight, *The Blue Parakeet: Rethinking How You Read the Bible* (Grand Rapids: Zondervan, 2018), 139.

Chapter 2 A Clear Line of Sight

1. Carol Meyers, *Exodus*, The New Cambridge Bible Commentary, ed. Ben Witherington III (Cambridge: Cambridge University Press, 2005), 32.

2. Meyers, *Exodus*, 37.

3. Meyers, *Exodus*, 37.

4. William MacDonald, *Believer's Bible Commentary* (Nashville: Thomas Nelson, 2016), commentary on Exodus 2:1–2, accessed on Bible Gateway Plus.

5. *NIV Exhaustive Concordance Dictionary* (Grand Rapids: Zondervan, 2015), s.v. "yāda," accessed on Bible Gateway Plus.

6. Kenneth L. Barker and John R. Kohlenberger, *The Expositor's Bible Commentary (Abridged Edition): Old Testament* (Grand Rapids: Zondervan Academic, 2004), accessed on Bible Gateway Plus.

7. Mary Elizabeth Baxter, "Jochebed, the Mother of Moses. Exodus 1; 2," *The Women in the Word*, https://www.blueletterbible.org/Comm/baxter _mary/WitW/WitW09_Jochebed.cfm

8. Matthew Henry, *Matthew Henry's Commentary*, commentary on Exodus 2, verses 5–10, https://www.biblegateway.com/resources/matthew-henry /Exod.2.5-Exod.2.10.

Chapter 4 Sometimes the Bush Whispers, Sometimes It Burns

1. Henry, commentary on Exodus 3:1–6, https://www.biblegateway.com /resources/matthew-henry/Exod.3.1-Exod.3.6.

2. Barker and Kohlenberger, *The Expositor's Bible Commentary*, commentary on Exodus 3:1–4, accessed on Bible Gateway Plus.

3. David Guzik, "Study Guide for Exodus 3," https://www.blueletterbible.org/comm/guzik_david/study-guide/exodus/exodus-3.cfm?a=53004.

Chapter 5 A Good, Hard Look Is Helpful

1. Jerry Bridges, *Transforming Grace* (Colorado Springs: Navpress, 2008), 194.

Chapter 6 Fear Will Flat-Out Blind You

1. Meyers, *Exodus*, 55.

2. Timothy Keller, *The Freedom of Self-Forgetfulness: The Path to True Christian Joy* (Leyland, England: 10Publishing, 2012), 43.

Chapter 7 When You Just Can't See It

1. MacDonald, *Believer's Bible Commentary*, commentary on Exodus 5:2–15, accessed on Bible Gateway Plus.

2. Tony Evans, *The Tony Evans Study Bible* (Nashville: Holman, 2017), commentary on Exodus 5:22–23.

3. MacDonald, *Believer's Bible Commentary*, commentary on Exodus 5:15–23, accessed on Bible Gateway Plus.

4. Henry, commentary on Exodus 6, https://www.biblegateway.com/resources/matthew-henry/Exod.6.1-Exod.6.30.

5. Henry, commentary on Exodus 6:14–30, https://www.biblegateway.com/resources/matthew-henry/Exod.6.14-Exod.6.30.

6. Barker and Kohlenberger, *The Expositor's Bible Commentary*, commentary on Exodus 6:13–30, accessed on Bible Gateway Plus.

Chapter 8 The Things That Plague Us

1. Meyers, *Exodus*, 77.

2. Eugene Peterson, *The Message*, https://www.biblegateway.com/passage/?search=Exodus+7&version=MSG.

3. Tim Mackie, "If God Hardened Pharaoh's Heart, Did God Cause the Evil?," May 26, 2017, *The Bible Project*, https://bibleproject.com/articles/pharaohs-heart-grew-harder/.

4. The Bible Project, "Guide to the Book of Exodus," https://bibleproject.com/guides/book-of-exodus/.

5. Henry, commentary on Exodus 11:1–3, https://www.biblegateway.com/resources/matthew-henry/Exod.11.1-Exod.11.3.

6. Evans, *The Tony Evans Study Bible*, commentary on Exodus 12:29–30.

7. Henry, commentary on Exodus 12:29–36, https://www.biblegateway.com/resources/matthew-henry/Exod.12.29-Exod.12.36.

Chapter 9 When You Spy Some Brand-New Territory

1. *The Bear*, season 2, episode 6, "Forks," directed by Christopher Storer, written by Alex Russell, aired June 22, 2023, FX Productions, Hulu.

Chapter 10 Look at What God Has Done

1. Henry, commentary on Exodus 12:37–42, https://www.biblegateway .com/resources/matthew-henry/Exod.12.37-Exod.12.42.

2. Tammy Kennington, "What is the Feast of Unleavened Bread in the Bible?" February 15, 2022, *Crosswalk.com*, https://www.crosswalk.com/faith /bible-study/what-feast-of-unleavened-bread-bible.html.

Chapter 11 When You Have to Look over Your Shoulder

1. Charles Scudder, "Southern Baptist Leader Paige Patterson fired from Fort Worth seminary after 'new information' presented," *The Dallas Morning News*, May 31, 2018, https://www.dallasnews.com/news/faith/2018/05 /31/southern-baptist-leader-paige-patterson-fired-from-fort-worth-seminary -after-new-information-presented.

2. Barker and Kohlenberger, *The Expositor's Bible Commentary*, commentary on Exodus 14:1–4, accessed on Bible Gateway Plus.

3. Meyers, *Exodus*, 114.

4. Henry, commentary on Exodus 14:1–9, https://www.biblegateway.com /resources/matthew-henry/Exod.14.1-Exod.14.9.

5. Meyers, *Exodus,* 114.

6. Meyers, *Exodus*, 114.

7. Meyers, *Exodus*, 115.

Chapter 12 Behold the Teamwork Making the Dream Work

1. Eugene Carpenter and Wayne McCown, *Asbury Bible Commentary*, commentary on Exodus 13:17–15:21 (Grand Rapids, Michigan: Zondervan, 1992), https://www.biblegateway.com/resources/asbury-bible-commentary /1-red-sea-crossing-13-17-15-21.

2. "Miriam: The Woman Who Helped Save a Nation," Basilica of the National Shrine of the Immaculate Conception (blog), June 21, 2021, accessed July 23, 2023, https://www.nationalshrine.org/blog/miriam-the-woman-who -helped-save-a-nation/.

3. Phyllis Trible, "Miriam: Bible," *The Shalvi/Hyman Encyclopedia of Jewish Women*, December 31, 1999, Jewish Women's Archive, accessed July 22, 2023, https://jwa.org/encyclopedia/article/miriam-bible.

4. Trible, "Miriam: Bible."

5. Carol Meyers, "Miriam's Song of the Sea: A Women's Victory Performance," TheTorah.com, February 6, 2020, accessed July 22, 2023, https://www .thetorah.com/article/miriams-song-of-the-sea-a-womens-victory-performance.

6. Evans, *The Tony Evans Study Bible*, commentary on Exodus 15:20.

Chapter 14 Let's Get Ready to Grumble

1. Henry, commentary on Exodus 17:1–7, https://www.biblegateway.com/resources/matthew-henry/Exod.17.1-Exod.17.7.

Chapter 15 What You Never Saw Coming

1. Evans, *The Tony Evans Study Bible*, commentary on Exodus 17:10–11.
2. Meyers, *Exodus*, 134.
3. Paul David Tripp, *New Morning Mercies: A Daily Gospel Devotional* (Wheaton, IL: Crossway, 2014), November 10 reading.

Chapter 17 Examining Ye Olde Boundaries: Big Ideas & Modern Concerns

1. Brené Brown, "Dare to Lead: The BRAVING Inventory," accessed August 19, 2023, https://brenebrown.com/resources/the-braving-inventory.

Chapter 18 Are We There Yet?

1. Henry, commentary on Exodus 19, https://www.biblegateway.com/resources/matthew-henry/Exod.19.1-Exod.19.25.
2. Meyers, *Exodus*, 143.
3. Jon Collins and Tim Mackie, "Exodus 19–40 Q+R," *BibleProject Podcast*, April 4, 2017, accessed August 20, 2023, https://bibleproject.com/podcast/exodus-19-40-q-r/.
4. Meyers, *Exodus*, 156.

Chapter 19 Take a Look down the Road

1. Bob Deffinbaugh, "12. Israel's Failure at Kadesh Barnea (Numbers 10:11–14:45)," *Bible.org*, February 16, 2007, accessed August 18, 2023, https://bible.org/seriespage/12-israels-failure-kadesh-barnea-numbers-1011-1445.

SOPHIE HUDSON first started her blog, *BooMama*, way back in 2005, which basically makes her feel like the internet's mamaw. Blogging eventually led to book writing, an unexpected path that has turned out to be one of the great joys of Sophie's life. As someone who loves to laugh more than just about anything, Sophie hopes that women find encouragement, comfort, and connection through her writing and teaching.

Sophie speaks regularly to groups across the country, and since 2007 she has had the biggest blast cohosting *The Big Boo Cast* with her friend and fellow author Melanie Shankle. A graduate of Mississippi State University and the author of seven books, Sophie loves cheering like crazy at live sporting events, cooking her mama's recipes for a crowd of friends, and watching entire seasons of TV shows in record time. She lives with her husband, David, in Birmingham, Alabama, where they enjoy any opportunity to spend time with their college-aged son.

Connect with Sophie:

🌐 BooMama.net 📷 @boomama205

📘 @SophieHudsonBooMama ✖ @boomama

(Clearly somebody missed the day of social media class when everybody learned that all of your social media handles should match. Sophie hopes you'll find her anyway.)

And if you're in the mood for some lighthearted fun, be sure to listen to *The Big Boo Cast* with Melanie Shankle and Sophie Hudson, which is available wherever you like to listen to podcasts.